Creative Suite 3
Integration

Creative Suite 3 Integration

Photoshop, Illustrator, InDesign, Dreamweaver, Flash Pro, Acrobat, Bridge and Version Cue

Keith Martin

AMSTERDAM • BOSTON • HEIDELBERG • LONDON • NEW YORK • OXFORD
PARIS • SAN DIEGO • SAN FRANCISCO • SINGAPORE • SYDNEY • TOKYO
Focal Press is an imprint of Elsevier

Focal Press is an imprint of Elsevier
Linacre House, Jordan Hill, Oxford OX2 8DP, UK
30 Corporate Drive, Suite 400, Burlington, MA 01803, USA

First published 2007

British Library Cataloguing in Publication Data
A catalogue record for this book is available from the British Library

Library of Congress Control Number: 2007931141

ISBN: 978-0-240-52059-9

For information on all Focal Press publications
visit our website at www.focalpress.com

Printed and bound in China

07 08 09 10 11 11 10 9 8 7 6 5 4 3 2 1

Dedication page

*To Tony Tyler,
a friend who is missed by many.*

CONTENTS

Contents

Contents

FOREWORD

Integration … . for a lot of creative professionals that is a scary word. It's not something visual and not something tangible. Each time I speak to customers they tell me that integration of the Adobe tools is extremely important for them. But when I ask them to define 'integration,' it's really hard for them to tell me what exactly that means.

And that's why I'm so excited about Keith Martin's 'Creative Suite 3 Integration.'

When Creative Suite was first introduced in 2003, we wanted to highlight and really show how well the products 'played' together. Adobe offered a small 'Design Guide' that highlighted that integration. We took our first step with that release. But there weren't a lot of books out there that really talked about how the components of the suite work together.

For Creative Suite 3, we had an interesting challenge. This was going to be the first suite that integrated products that we got in our acquisition of Macromedia. We had some interesting technical challenges, but integration was the number one priority. After all, no matter if you work in print, web, interactive, or video, you don't really want your tools to get in the way of being creative, right? Being creative is about having fun. And you certainly won't have much fun if you are spending most of your time fighting your creative software.

This is why after reading Keith's book, I was so happy to see that we have a great resource/tool that really highlights the strides Adobe has taken to integrate these products. This book is so easy to follow and really targets the benefits and efficiencies gained by having all the creative tools work seamlessly. Keith really makes you feel like you are in his studio with him, watching him work, and learning about all the different products. It's almost a magical experience.

After reading this book, I know that you will continue to fall in love with all the new features the CS3 applications have to offer … . and perhaps learn some new things that you didn't know! I know I did.

Ginna Baldassarre
Sr. Product Manager, Creative Suite
Adobe Systems Inc.

INTRODUCTION

What happens when you take some of the world's best-known creative and production tools – Photoshop, Illustrator, InDesign, Dreamweaver, Flash, Fireworks, and more – and put them together? Yes, you get Adobe's Creative Suite 3. And as you should expect with programs like these the result is rather special. To put it simply, this is the world's most powerful software suite for graphic designers, publishers, web masters, multimedia producers, printers, video editors, and everyone else that needs to create compelling digital or printed media. The Creative Suite 3 is also far more than the sum of its parts, great though they are. The different tools are even better integrated now than with previous versions of the Creative Suite; you can take your work from one program to another, taking advantage of each one's unique abilities in the process.

But how are you going to get the most from this extraordinary collection of genre-defining tools? Knowing where to start with the various parts of the Creative Suite, let alone how to make them work well together, can be a daunting task. Adobe has spent a lot of time and effort making these programs work together, and those that take the time to learn the ins and outs of the suite as a whole will find themselves more productive and creatively effective than ever before. But with programs as diverse as these, few people have the time to become experts in the multiple disciplines, no matter how important that is.

Creative Suite Integration was written with one specific goal in mind: to help you become that confident cross-discipline practitioner we all need to be these days. It aims to help you put the whole of Creative Suite 3 to work by using it all more effectively in whatever you need to do. As well as the research and testing that has gone into these pages, I wrote it from my personal experience in the world of designs, print, multimedia, and web production, and from experience as a trainer and as MacUser magazine's Technical Editor. Adobe's Creative Suite 3 really is an extraordinary powerhouse, the sort of thing we could only dream of not so long ago. If you're relatively new to the industry you picked a great time to get going. And if you're an old hand who remembers the DTP wars of the 1990s or even slicing up typeset galleys and sending out for film steps, then welcome, come on in; this is where it gets fun all over again!

The first section of Creative Suite Integration looks at different parts of the workflow, production processes, and program features, from understanding how layers work across the different programs to the details of PDF production for screen, print, multimedia, and more. Color management,

the vital aspect of effective design and production that so many of us regard as a mysterious black art, is tackled in depth (although I hope in a more understandable form than in most publications). Project management in Version Cue is examined, the powers of Bridge are demonstrated, the ways that type is handled in everything from InDesign to Dreamweaver is demonstrated and discussed, and so on. This part of the book is intended to serve as both a detailed introduction to the workings of Creative Suite 3 and as a practical on-going reference for real users.

The second half of the book is devoted to practical projects designed to show how to get the most from the different programs, all working together in a number of common projects. These range from poster and magazine design tasks to web banner and site creation and production.

It doesn't stop there; the Creative Suite Integration CD that accompanies this book contains examples and media files to help readers work their way through the projects as they appear in the book. Sample images, partially completed layouts and graphics taken from the projects themselves, and links to useful online resources are all tucked away in this digital treasure chest.

Speaking of online resources, the Creative Suite Integration site, found at www.creativesuiteintegration.com, provides extra downloadable files, information on the latest bug fixes from Adobe, and a reader's forum where you can share tips, suggestions, and questions and answers with other readers and me. If you have questions about Creative Suite 3 or Creative Suite Integration, this is the place to ask. And if you unearth further secrets, come here to share them so that we all can benefit.

There should be something for everyone in this book, whether you're into print or pixels. I hope you find this book as much fun to use as it was for me to write. But that's enough time spent on the introduction. With something as good as Creative Suite 3 installed on your computer and this book in your hand don't you think it is time you grabbed your mouse and got stuck in?

Keith Martin

ACKNOWLEDGEMENTS

Projects like this can suffer from all sorts of setbacks without any help, and when beta software is added to the mix things can get a little hairy at times. Still, things usually work out well in the end, and this project was no exception.

The people that deserve my particular thanks for their support are Stephanie Barratt from Focal Press, for her calm handling of ever-shrinking timescales and her well-judged balance of encouragement and prodding, and Ginna Baldassarre, Senior Product Manager for the Creative Suite at Adobe, for reading draft chapters whenever and wherever she had the time. My wife and family also deserve thanks and applause for their patience and understanding, as do my colleagues at the London College of Communication: David, Des, Gill, Les, Lorraine and Simon from the School of Printing & Publishing, and the one and only Biggles from the School of Graphic Design.

The Programs

Little fluffy clouds, signalling mixed weather ahead

Adobe's Creative Suite is now in its third major version, and it contains the leading tools for virtually every major creative and publishing industry. Each version of the Creative Suite has brought more integration between the different tools, helping its users get more and more from the program partnerships. Although the Creative Suite 3 is certainly more than the sum of its parts, the parts themselves are impressive.

In recognition of the different kinds of work that its different customers do, Adobe now offers the suite in a number of different flavors: Design Standard and Design Premium, Web Standard and Web Premium, Production Premium, and Master Collection. Some programs come with every suite, others are only found in specific ones.

The Creative Suite 3 Design Standard edition includes InDesign, Photoshop, Illustrator, and Acrobat 8 Professional, plus Bridge and Version Cue; all the core graphics and print publishing tools together in one box. The Premium edition swaps Photoshop for Photoshop Extended, and adds Flash CS3 Professional and Dreamweaver CS3 – everything a busy cross-media designer could need.

The Creative Suite 3 Web Standard edition has a slightly different mix: Dreamweaver, Flash, Fireworks and Contribute, and Bridge and Version Cue for professional file and project management. Web professionals after the ultimate package will want the Web Premium edition, as this adds Photoshop Extended, Illustrator and Acrobat 8 Professional.

The Master Collection comes with everything in all these editions plus the complete contents of the Production Premium version of Creative Suite 3, aimed at video and multimedia professionals.

ADOBE CREATIVE SUITE 3 DESIGN STANDARD	
InDesign CS3	Version Cue CS3
Photoshop CS3	Adobe Device Central CS3
Illustrator CS3	Adobe Stock Photos
Acrobat 8 Professional	Acrobat Connect
Adobe Bridge CS3	

ADOBE CREATIVE SUITE 3 DESIGN PREMIUM	
InDesign CS3	Adobe Bridge CS3
Photoshop CS3 Extended	Version Cue CS3
Illustrator CS3	Adobe Device Central CS3
Flash CS3 Professional	Adobe Stock Photos
Dreamweaver CS3	Acrobat Connect
Acrobat 8 Professional	

ADOBE CREATIVE SUITE 3 WEB STANDARD	
Dreamweaver CS3	Version Cue CS3
Flash CS3 Professional	Adobe Device Central CS3
Fireworks CS3	Adobe Stock Photos
Contribute CS3	Acrobat Connect
Adobe Bridge CS3	

ADOBE CREATIVE SUITE 3 WEB PREMIUM

Dreamweaver CS3	Contribute CS3
Flash CS3 Professional	Adobe Bridge CS3
Photoshop CS3 Extended	Version Cue CS3
Illustrator CS3	Adobe Device Central CS3
Fireworks CS3	Adobe Stock Photos
Acrobat 8 Professional	Acrobat Connect

NOTE: NOT COVERED IN THIS BOOK:

ADOBE CREATIVE SUITE 3 PRODUCTION PREMIUM

After Effects CS3 Professional	Adobe Bridge CS3
Adobe Premiere Pro CS3	Adobe Device Central CS3
Photoshop CS3 Extended	Acrobat Connect
Flash CS3 Professional	Dynamic Link
Illustrator CS3	Adobe OnLocation CS3
Soundbooth CS3	Ultra CS3
Encore CS3	

ADOBE CREATIVE SUITE 3 MASTER COLLECTION

InDesign CS3	Soundbooth CS3
Photoshop CS3 Extended	Encore CS3
Illustrator CS3	Adobe Bridge CS3
Acrobat 8 Professional	Version Cue CS3
Flash CS3 Professional	Adobe Device Central CS3
Dreamweaver CS3	Adobe Stock Photos
Fireworks CS3	Acrobat Connect
Contribute CS3	Dynamic Link
After Effects CS3 Professional	Adobe OnLocation CS3
Adobe Premiere Pro CS3	Ultra CS3

Photoshop CS3

Photoshop CS3 is the most widely used tool in the Creative Suite, and probably the most widely known as well. It is well suited to handling everything from print graphics to digital photography to web production, and in the Professional version found in the Premium suites it extends its scope to video editing, 3D graphics, and scientific visualization and measurement.

The standard Photoshop is a major enhancement from previous versions. The new non-destructive filters let different effects be tested without committing your work to a specific direction, and the all-important selection tools have been enhanced with ways to make image selections faster and more easily and also to refine them afterward.

Its enhanced compositing controls help align layers automatically, moving, rotating and even warping different layers to align matching details. Use this to make your ideal composite images from multiple shots of the same subject or stitch together broad, high-resolution panoramas, and large image panels from a collage of individual photos or scans.

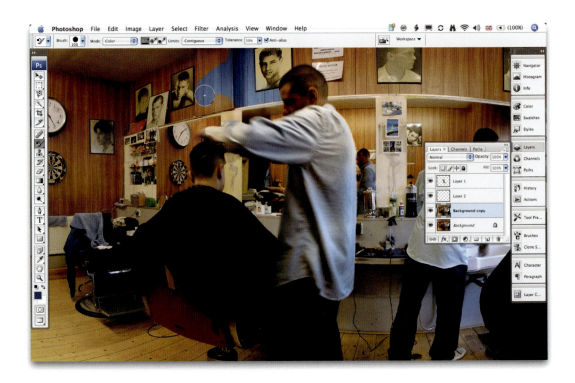

Photoshop's scope can be daunting, but the software has been refined over many years. With Photoshop CS3 any busy creative professional will benefit from the customized workflow options, the better print controls, and the improved integration with Bridge CS3.

InDesign CS3

InDesign CS3 provides the hard-core print production end of the suite. It is the premier program for countless designers and publishers around the world, being used to turn out all kinds of work – from magazines and books to brochures, posters, and more. Its core strengths lie in assembling the content produced using other programs in the Creative Suite, but it has considerable abilities for making original content on its own as well.

InDesign's abilities go much further than just print. It is an invaluable part of the PDF production workflow, whether the destination is to be prepress or screen, print or digital multimedia. It can produce rich multimedia content incorporating video, audio, and interactive elements. For those that

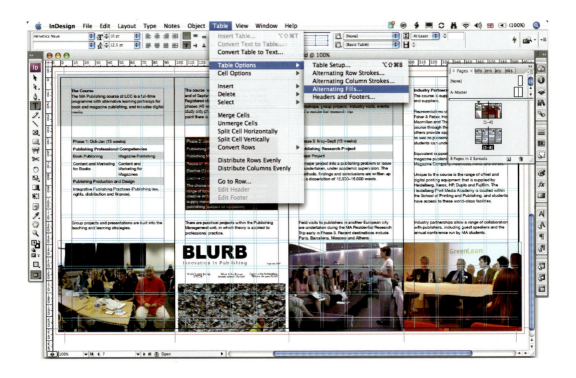

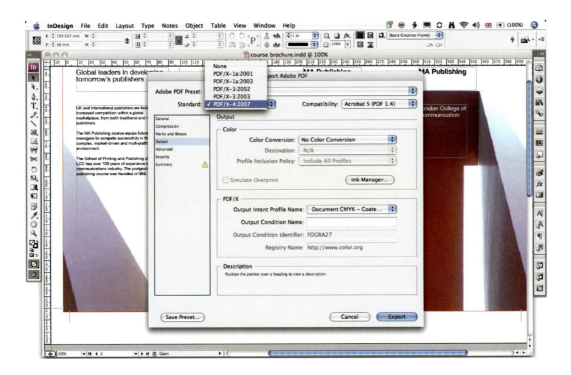

are working with more complex digital workflows it can also turn layouts into XML and XHTML, preparing content for cross-media publishing, for Dreamweaver, and for Adobe's new Digital Editions e-publishing technology.

High-powered typographic control, powerful style sheet features, enhanced control over transparency (including separate control over different aspects of a frame and its contents), and the ability to import native Illustrator and Photoshop documents without file conversion make it the premier tool for serious document design and production work.

Illustrator CS3

Illustrator CS3 is the most mature product here. It started life back in the 1980s and has become more and more sophisticated with each new version. It excels at specialist graphics production and single-page layout needs, and it works very closely with Photoshop to provide high-resolution vector graphics artwork that can be embedded in Photoshop images, and vice versa.

It has excellent type handling, although its controls and features are focused more on graphic production than the long document typographic control found in InDesign. What it is most famous for, however, is its PostScript vector drawing tools. These are the heart of its powers, although this is far from the only thing that makes it what it is. 3D effects, gradient mesh fills, variable data printing, the vector art brush, color variations, and closer

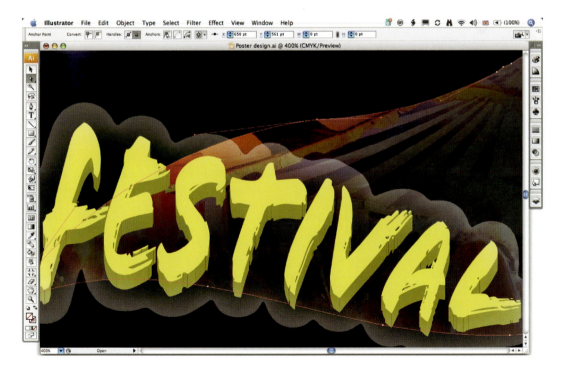

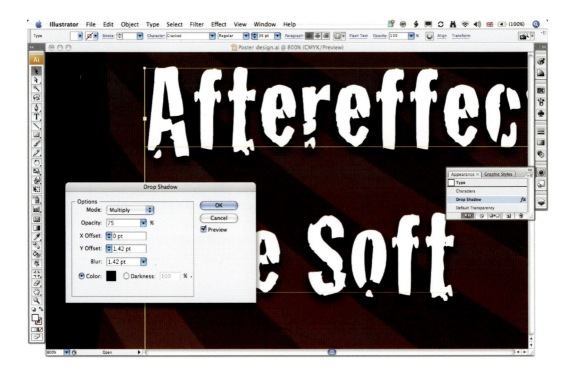

integration with Photoshop, InDesign, Flash, and Acrobat – these are some of the other things that make Illustrator so popular among graphic designers and digital artists. Illustrator has established itself as the number one drawing program, and the latest version has helped cement this position.

Fireworks CS3

Fireworks CS3 is a newcomer to the suite, but its pedigree is well known in the web design and production world. For the more specialist web graphics tasks Fireworks is a better choice than anything else, even Photoshop. Rollovers, animated graphics, and layout prototypes can be made in Fireworks and exported straight to Dreamweaver.

Fireworks allows graphics to be designed using vector objects and bitmap painting, together in one editing environment. It can open native Illustrator and Photoshop documents, retaining layers, group and color information, layer effects, and blend modes. It is an ideal visual prototyping tool, whether for simple web pages or complex 'rich Internet applications'.

Its new Pages support means multiple page states can be stored in a single document, so anything from graphic variations to multi-page site mockups can be created in a single document.

Its export options are impressively broad. As well as the obvious, exporting to Dreamweaver with structural HTML and Cascading Style Sheet (CSS) code if required, it can also export to layered Photoshop files, Illustrator, and Flash in SWF format. Going beyond the Creative Suite walls, it also exports to Director, FreeHand 10, GoLive, Flex as MXML, and even FrontPage for those that find themselves faced with that software. Many of these options also include a Copy command that helps copy and paste work more smoothly with the chosen external application.

Flash CS3

Flash CS3 Professional is the result of bringing world's leading interactive web content production tool into the Creative Suite. As well as having a smart new interface upgrade to bring it in line with the new core Creative Suite 3 look, its new partnership means you can import and optimize graphics directly from Photoshop CS3 and Illustrator CS3 documents, with layers and objects kept intact.

Timeline animations can be converted to ActionScript code-driven productions so that developers can make more effective use of animation sequences.

ActionScript, the scripting language embedded in Flash, has reached version 3.0, bringing better performance and a more comprehensible

approach to development. And for those who prefer not to write ActionScript code themselves, the software's new User Interface Components give customizable interface components that can provide ready-made ActionScript features while being modifiable with just the standard Flash drawing tools.

Dreamweaver CS3

Dreamweaver CS3 is the world's best known website editor program. It provides code production tools that can keep even the fussiest website programmer going, and yet it manages to provide decent visual design abilities as well. Its integration with Photoshop, Fireworks and Flash makes it exceptionally flexible, and linked images can be edited in their parent application and updated on the page with even more ease.

Dreamweaver CS3 adds new ways to make rich, dynamic 'Web 2.0' sites using Spry components, Adobe's AJAX-based code libraries that provide drag-and-drop implementation and editing of tabbed navigation, collapsible panels, repeating regions, validating form elements, and so on.

When it comes to direct code editing itself most would agree that Dreamweaver isn't for the faint hearted, but its built-in code view is even more useful and helpful than before.

Contribute CS3

Contribute CS3 takes the well-known companion to Dreamweaver to even more sophisticated levels. This gives clients and others without access to Dreamweaver the option to edit existing site pages and even create new ones. Rich media management is made simpler too, right through to incorporating Flash video Using Contribute CS3, content can even be published directly from the Windows version of Microsoft Office, although curiously not from the Macintosh version. It makes life easy for its users and safer for the site creator, as different sections of a page can be locked down or made editable for different users.

But Contribute CS3 is good for more than just client updates; it also helps edit and manage blogs as well as websites. Editing can be started from within Internet Explorer 7 on Windows or in Firefox on both Macs and PCs, although you're handed across to Contribute for the real work.

Acrobat 8 Professional

Acrobat 8 Professional is the only major tool in the suite not to be given the CS3 label, partly because it has its own development cycle. It is a major upgrade in its own right, however, and those who buy any Design edition of Creative Suite 3 or the Web Premium edition or, of course, the Master Collection will get this powerful PDF editing, authoring and publishing tool in the box.

Acrobat 8's interface has been enhanced, both visually and functionally. It presents a much more cohesive way of working, and it packs in even more tools for efficient, professional optimizing, editing and annotating of PDF documents, as well as PDF form data handling, document sharing and reviewing, and real-time collaboration using Acrobat Connect.

Version Cue CS3

Version Cue CS3 is Adobe's answer for everyone with project management needs. It maintains and tracks document versions automatically as you work, and it provides timestamps, rating aids, and version comments. Check files in

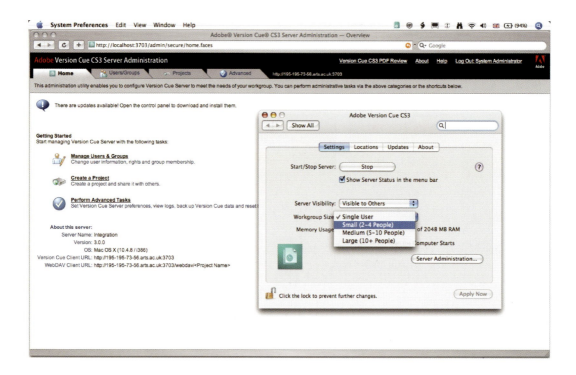

and out to prevent accidents in busy workgroup environments, and use it to keep track of files and file versions even if you work on your own. It has no real interface of its own, using your web browser for configuration and the various Creative Suite applications for the file saving and opening access. Version Cue's aim is to help coordinate projects and their myriad components without forcing Creative Suite users to learn new and unfamiliar software or even step outside of their familiar design environment.

Bridge CS3

Bridge CS3 is the hub of the Creative Suite. Bridge isn't a creative tool in its own right, but it is a very important part of the Creative Suite all the same. It provides the best way to browse, categorize, and group the many different files that you'll be dealing with as you work. It is a flexible media management tool that has an almost symbiotic relationship with the other parts of the suite. A few features of interest are the web-based conferencing features, quick Exchangeable Image File (EXIF) data access and Extensible Metadata Platform (XMP) metadata tagging, quick stock photo access and purchasing, the group stack feature for grouping documents together, and the new loupe tool. The loupe lets sections of image previews be magnified without disturbing the overall view. Bridge CS3 contains improvements throughout the program, and it makes a worthy central management and access point for the suite as a whole.

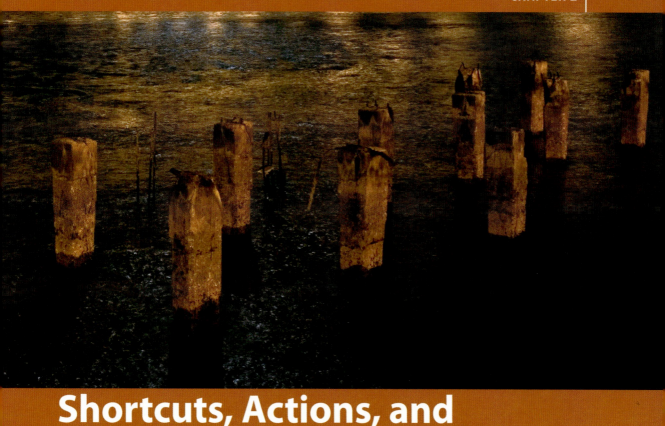

Shortcuts, Actions, and New Features

Old steel and concrete piles in the San Francisco bay

Shortcuts

Keyboard shortcuts are essential to the efficient use of any major program, and the different parts of the Creative Suite 3 share many of the same shortcuts. By this we mean more than just the standard shortcuts that are common to almost all your software; most commands that have close equivalents in other parts of the Creative Suite are the same across the board. For example, typing ⌘ *alt* **O** *ctrl* *alt* **O** in Photoshop, InDesign, Illustrator, Dreamweaver, or Flash will launch Bridge. There's no point in Bridge itself having a Launch Bridge command, so there the shortcut takes the user to Photoshop (regardless of what kind of file is selected at the time).

Photoshop, Fireworks, and Flash all offer single-key shortcuts for selecting tools. As all the three programs aren't meant for large-scale text editing this works well, but InDesign users need to be careful about accidentally typing content instead of switching tools. The panning shortcut in InDesign remains slightly schizophrenic; depening on whether text is being edited or not, the shortcut to switch to the Hand tool temporarily is the *alt* key or the *Space* key.

Photoshop's Actions can have custom keyboard shortcuts assigned to make them easier to trigger. InDesign has a similar approach with its paragraph and character styles; each can have its own custom keyboard shortcut assigned for quick application. The difficulty with doing this in InDesign CS3 is the lack of available shortcuts; almost every sensible combination of modifiers, function keys, and character keys has already been used for the standard commands.

Switching temporarily to the Zoom tool in Photoshop, Illustrator, and InDesign is done using the Adobe standard ⌘ Space ctrl Space shortcut. The programs in the Creative Suite 3 that don't do this are the newcomers to the Creative Suite. Dreamweaver and Contribute both don't support zooming anyway, while Flash and Fireworks both select their Zoom tools with the letter Z and use ⌘ + or − ctrl + or − for a completely keyboard-based zoom.

In general, the tools in Creative Suite 3 fall into two camps: those from previous versions of the Creative Suite and those that are new to this version. The old hands have shortcuts that are more generally unified, but the newcomers still have many of the shortcuts from their days as Macromedia products. This doesn't present as much of a problem as this may seem, partly because the two sets of programs tend to be used for two different kinds of work: design and production for web or for print. Photoshop is the program that most clearly straddles the two disciplines, and cross-media design incorporating print and screen-based work is a major requirement, so this shortcut duality is likely to be rationalized in the future. But for now, just get comfortable with the parallel sets of shortcuts.

Preferences

Photoshop	⌘ K ctrl K
Illustrator	⌘ K ctrl K
InDesign	⌘ K ctrl K
Bridge	⌘ K ctrl K
Dreamweaver	⌘ U ctrl U
Fireworks	⌘ U ctrl U
Flash	(no shortcut)
Contribute	(no shortcut)

Zoom

Photoshop	⌘ + − ctrl + −
Illustrator	⌘ + − ctrl + −
InDesign	⌘ + − ctrl + −
Bridge	(no shortcut)
Dreamweaver	(no shortcut)

Fireworks	⌘ + − ctrl + −
Flash	⌘ + − ctrl + −
Contribute	(no shortcut)

Pan

Photoshop	Space
Illustrator	Space
InDesign	Space or alt
Bridge	(no shortcut)
Dreamweaver	(no shortcut)
Fireworks	Space
Flash	Space
Contribute	(no shortcut)

Import

Photoshop	(no shortcut)
Illustrator	⌘ D ctrl D
InDesign	⌘ D ctrl D
Bridge	(no shortcut)
Dreamweaver	(no shortcut)
Fireworks	⌘ R ctrl R
Flash	⌘ R ctrl R
Contribute	(no shortcut)

New Features

InDesign

New features within InDesign have turned it into both a master of production and a creative dream. Transparency options now allow separate control over the opacity of frame contents (text or graphic), frame fills and frame strokes, not to mention Photoshop-style blending modes and special effects.

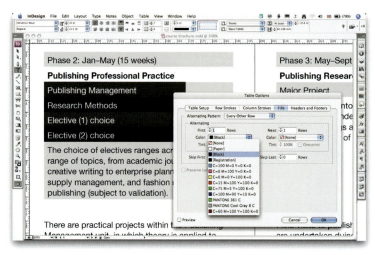

Table and table cell styles help make tabular data look better and be more informative. The options available allow quite sophisticated formatting to be applied, and regional styles can be applied to cells separately to add individuality or call attention to different areas.

As well as multi-file placing of graphics including native Photoshop and Illustrator files, InDesign's import abilities now extend to other InDesign documents. Rather than recreate work that's already laid out in a different InDesign document, just place it into a page as a new item. Linked images in the placed document remain intact, and when changes are made to the placed file you'll get notification of link updates.

InDesign's find/change features have been given a major boost. As well as working across multiple documents, it is possible to search across master pages, footnotes, and hidden layers. More interestingly, although also more dauntingly, General Regular Expression Parser (GREP) based pattern searches can be used to track down complex conditional instances of specific text data and styling. For the majority of us who don't understand GREP well or at all, there are a number of ready-made editable searches that make use of this feature without demanding that you understand it from the start.

Continuing on this theme, if you're a whiz at JavaScript, AppleScript, or VBScript or you know someone who is, you can use those scripting languages to automate repetitive tasks. Take this further by attaching scripts to menu commands so that they are run when the command is used. A selection of sample scripts is included to help get people started.

Long document support is better in InDesign CS3; synchronized master pages, advanced numbering controls and numerous other features help manage complex, multiple-file document layout and production.

Photoshop

One of the big news items about Photoshop CS3 is the Smart Filter feature. After converting a layer for Smart Filter use, filters can be applied all you like without making any destructive, one-way changes to the layer.

RAW file processing for handling high-end digital photos has been improved once more. The new Fill Light helps restore photos that may have otherwise been discarded, and the Dust Busting feature is something that every digital SLR owner will want to try. The range of supported cameras has increased to over 150 models, although while proprietary RAW formats are still used by camera manufacturers this will remain a constant game of catch-up.

Another photographer-pleasing new feature is the Black & White conversion control. Convert color images to grays with complete control over how the different hues are converted to grays. Pick from presets or make your own using the hue sliders and the tint controls.

Packaging and architectural mockups will benefit from the enhanced Vanishing Point controls. Build multiple planes within an image and connect them at arbitrary angles, then wrap any Photoshop content around them.

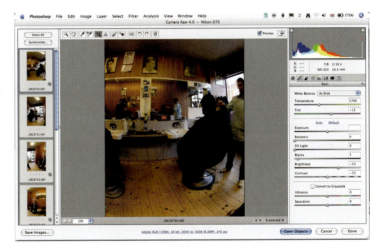

High-dynamic range (HDR) image editing is now properly supported. Photoshop's enhanced image processing abilities support 32-bits per channel (96-bit RGB) images, allowing multiple bracketed exposures to be combined into single high-bit-depth images that preserve the complete dynamic range. This is aided by the advanced compositing controls that automatically align multiple images together, tiling, rotating, and distorting as necessary to make things fit.

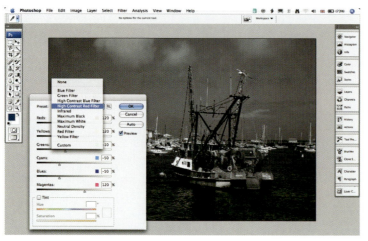

If you get one of the Premium editions of the Creative Suite then you'll have Photoshop CS3 Extended instead of the standard version. This includes video and animation features lifted from the now-discontinued ImageReady and enhanced to provide the options necessary to do rotoscoping and compositing of video sequences in Photoshop. You can paint and clone across multiple video frames using Photoshop's standard tools. As well as a regular frames view the new Animation panel can work in a timeline mode that's reminiscent of the powerful time-based object property controls in After Effects.

The extended version of Photoshop also includes support for 3D modeling and imaging for graphics and architecture, including the ability to open 3D models in a range of industry-standard interchange formats and even edit existing 3D textures. On top of this, engineers and architects will benefit from the precise measurement features, even in 3D perspective, and medical and scientific professionals have image analysis controls and file format support that fits their needs and specialist systems.

Illustrator

Illustrator is the oldest product in the suite, but it still has its share of new features to keep people on their toes. Many Illustrator users will agree that Illustrator CS3's new Live Color tricks alone are worth the upgrade. The colors in graphics can be edited all at once, using Live Color sets of swatches. Pick from tints, shades, and a large number of other color combinations or set up your own if you prefer. This isn't a substitute for developing good color awareness and understanding how color works in print and on screen, but it makes color selection surprisingly intuitive.

The graphic shapes drawn with Illustrator's pen tools are easier to make. Anchor point selection is better, as is Illustrator's performance with complex gradients and shapes. The Eraser tool handles rubbing out parts of vector elements as easily as Photoshop's eraser rubs out pixels, with similar control over the eraser's effect and scale.

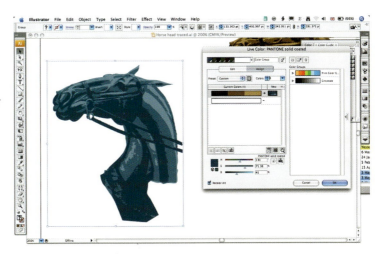

Crop areas define sections of your artwork for both print and screen-based uses. Some preset crops are available for standard web page and video format sizes. This makes setting crop marks simple, and with multiple crop areas set in a page Illustrator's limit of a single page per document becomes even less of a restriction than before.

The new Isolation mode takes the crop area output concept and applies it to the editing environment. Use this to edit objects within a group without messing with the object stacking order, lock state, or visibility of other elements.

Illustrator's integration with Flash CS3 Professional is a major step for designers working with screen media. Set up and use graphic symbol objects in Illustrator, each with its own name and other attributes. When this is imported into Flash all these properties will be preserved and turned into the native equivalent in Flash. Although Flash CS3 Professional has improved graphics tools, this lets web designers use the best vector graphics program to create their interactive, online artwork.

Dreamweaver

The most obvious new thing about Dreamweaver is its integration with the Creative Suite. Among other benefits, it now has the very useful ability to take content pasted straight in from Photoshop, handling the web conversion virtually automatically as this happens. Its in-page cropping and re-optimizing

and direct edit links to original master graphics in Fireworks and Photoshop round this off neatly.

There are a number of advances now for creating complex code structures, but one of the most exciting for general users is Adobe's new Spry components. These allow relatively simple implementation of AJAX-driven dynamic page elements, making 'Web 2.0' designs less painful to produce. This shows a promising direction of development for Dreamweaver, helping to make increasingly complex and sophisticated interactive web technologies become more accessible and easier to implement.

Flash integration is good, of course, and the Flash video format that is created by the bundled Flash CS3 Video Encoder utility is handled very well. This can be used to create YouTube and Google Video-style content, but using the layered playback controls and content optimizing settings of your choice.

Layouts exported as XHTML from InDesign can be reformatted in Dreamweaver using Cascading Style Sheets (CSS). Dreamweaver's initial view of the code may not fill you with confidence, but every element is structured and tagged with CSS-ready IDs and classes. It just takes some CSS rules to turn the linear data stream into a web-focused edition of the InDesign layout. Okay, this can still take some work to achieve, but it is ready for the process. It is also distinctly simpler than it was to attempt this in GoLive back in the previous version of the Creative Suite.

Contribute

Contribute CS3 is often overlooked as part of a web developer's toolkit, but it has been given as much attention as the rest of the products in the suite. Its new features help simplify the maintenance and editing of existing pages and sites, and the creation of new ones, even without actually launching Contribute itself. The software's integration with the Microsoft Office suite as well as Adobe's Creative Suite means users can publish content directly from within Office applications using ready-made Dreamweaver templates.

Flash Video can be added to pages, even by just dragging and dropping into the Contribute page. The media is uploaded along with the page when Contribute publishes the content. By working with Acrobat, Office documents can be turned into Portable Document Format (PDF) files and inserted into pages.

Blogs are also embraced by the new Contribute. The software's visual editing tools let the user work intuitively and add images and rich media and then publish directly when finished.

For a client to get the most from Contribute's site maintenance features the site designer still needs to set things up in Dreamweaver to define the object and page areas that can be edited and the ones that can't.

But for more free-form work, Contribute has reached the point where it is a perfectly viable website authoring solution.

Flash

One of the biggest advances in Flash CS3 Professional is the support for importing native Photoshop and Illustrator files. Layers and object structure is preserved, and the results can be optimized during the import process. This will make a tremendous difference to the workflow of Flash designers.

Regular timeline animations can be converted to Flash ActionScript-driven animations instead, a step that makes them more controllable and reusable by developers. Once in script form, the animation instructions can be applied to other objects as well. Other developer-friendly advances include an improved ActionScript debugger in general as well as better consistency with Adobe Flex Builder 2 debugging.

Drawing control, always a difficult process in Flash compared to programs such as Illustrator, is now much easier. Unsurprisingly, this was managed by adding an Illustrator-like Pen tool to Flash's tool panel, a step which will have Flash users cheering in the aisles. But if you still prefer Illustrator's mature graphics drawing tools then carry on working there and simply copy and paste your work into Flash when you're done.

Fireworks

Fireworks has offered basic layers and frames for a long time, but its graphics content organizing has improved thanks to the new hierarchical layer structure. Fireworks CS3 allows content to be nested in group-like layer sets in a very Photoshop-like way. The Pages panel adds support for multiple pages within one Fireworks document, each with its own slices, frames, layers, and so on. Use this to create working mockups of websites and visitor interaction. This kind of layout prototyping is helped further by the option to export to Adobe Flex format with graphic position and styling data preserved. Another export option produces popup menu structures using CSS and HTML code, ready to use in Dreamweaver.

Photoshop-style blend modes improve graphics production as well as helping preserve the look of content imported from Photoshop documents. These are in addition to Fireworks' own extensive set of blend modes.

The Assets panel provides a graphic library for storing Fireworks layout elements as self-contained, reusable items. Other sections of the Assets panel are Styles, for rich graphic settings presets, URL, for tracking and reusing addresses, and Shapes, for vector artwork including simple rotatable 3D objects, a settable clock face, and a dynamic calendar.

Finally, there's the program's integration with the other tools in the Creative Suite. It links with Bridge provides an efficient workflow, and being able to copy and paste graphics straight into Dreamweaver is a major time saver too.

Bridge

Bridge CS3 provides the hub, the connection point for all the different programs in the Creative Suite. Its new features include a new filter-based way to search for files more efficiently, a fully customizable interface that can be set up according to your own preferences and saved as interface presets, and 'stacks' for grouping-related files together or setting up batch processing in Photoshop or Illustrator.

Image previews can be scaled right up to full screen, but the new Loupe tool provides a quick zoom preview that can be dragged around the image to examine it in detail.

As well as helping to find and organize your work, Bridge CS3 works with Acrobat Connect to manage real-time interactive web conference meetings. Use this to run design reviews and share your Bridge Content panel with the

attendees. If you plan to design content for mobile devices then Bridge can help preview your work in Device Central, Adobe's database of mobile phones.

Device Central

Developers interested in designing online mobile applications using Flash and Dreamweaver will appreciate the integration with Adobe Device Central. This shows how content will appear when viewed on different mobile devices, from the smallest 128 × 160 pixel displays to the pocket-bursting 480 × 640 screens. It also stores information about the capabilities of the different devices.

The data that Device Central contains about the different devices and carriers has some blank spots regarding European companies, but that's not a major flaw. The process of designing content for mobile devices is a difficult one, mainly because there are so many different items to consider. Device Central provides an excellent way to get over this particular hurdle, so use it to test anything that you want to be deliverable on mobiles.

Accessing Programs with Bridge

A hummingbird hovering by an orange tree in the Hearst Castle, California

Introduction

Bridge CS3 is the center of the Creative Suite, the tool that helps tie all the others together. Bridge is a standalone program that is installed along with the other parts of the suite, but its job is to help you manage your documents using sophisticated searching and grouping features, document previews, and tracking recently used files.

Bridge CS3 does more than just file management-related tasks. One very important feature is the ability to synchronize color management settings across the different programs in the whole suite. This is a vital task for professional design and production work, so don't overlook this step. We'll cover it in more detail in a moment.

Interface

Although Bridge uses a single window with no floating panels, a little like Contribute CS3, the Bridge interface really isn't like anything else in the suite. It presents the different sections of the window as individual resizable and repositionable panes.

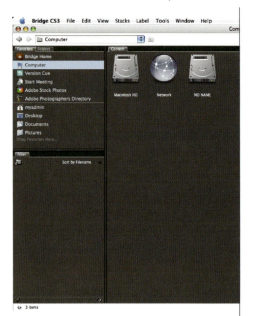

The first impression will be that the Bridge window is dark, very dark. This is something that you can change, but the default background color for both the main interface and the central content pane itself is a dark gray. This works well for most image viewing requirements, but if it is too dark for you – or perhaps not dark enough – the tone can be changed in the Bridge preferences window's General section.

The Bridge window's appearance can be changed in many more ways than just the background tone. Each pane is a draggable, dockable item in its own right. You can't drag one out into its own floating panel, but you can rearrange the different panes to suit your own requirements. Before you try manual adjustment, see whether Bridge's saved workspace layouts provide what you want. These are found in *Window > Workspace*, and also in the three workspace preset buttons at the lower-right end of the window.

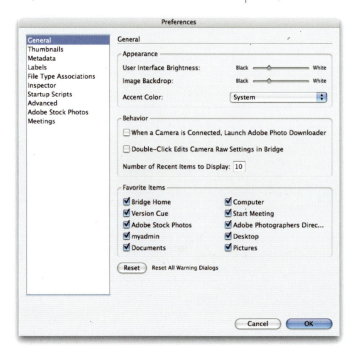

After you get more used to Bridge you'll find that adjusting the sizes of different panes helps your particular workflow. Drag the divider bars between different panes to change the sizes, and double-click a pane's tab title to collapse it and let the others above or below it have more room. If a pane has nothing above or below it ready to expand then it won't collapse, which is a very logical way to behave.

It isn't always convenient having the full Bridge window on view all the time, which is why the Compact mode can be so useful. The button in the top-right corner of the Bridge window toggles between Full and Compact view modes, and the Compact mode defaults to staying

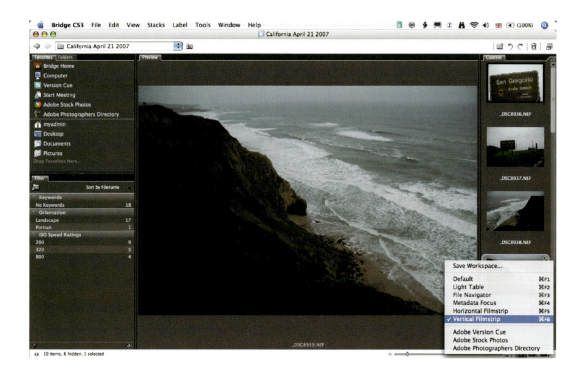

in front of all other windows. This setting can be turned off using the menu button that appears in Compact mode, but it is generally very handy.

The Bridge window in Compact form becomes a very handy media-centric preview browser. But if the regular Compact view size is still too much for you there's an 'Ultra-Compact' option that can be used instead. This collapses everything down to just the window titlebar and top row of tool buttons. This is rather extreme, however, and leaves you with absolutely no visible information. In practice you'd generally be better off simply minimizing the window to your Windows taskbar or Macintosh Dock instead.

Navigation

Navigating through your disks is essential to using Bridge properly. To do this, use the Favorites pane in the upper-left of the Bridge window. Click on the Documents or My Documents folder to open it up, and look through its contents using the main Content pane in the middle to browse your own documents. The Computer icon in the Favorites list shows the different disk volumes that are available. If you insert the media CD that comes with this book you'll be able to browse the project support files that have been included.

The other items in the same Favorites section as the Computer icon give access to Bridge Home, for browsing information about the products within Creative Suite 3, Version Cue, the network-ready project management and file versioning part of the Creative Suite, the Acrobat Connect-based web-based virtual conferencing system, and the Adobe Stock Photos and Photographers Directory image library and practitioner access.

For more free-form browsing, the Folders tab, found next to the Favorites tab in the default Bridge arrangement, gives you a tree-like hierarchical view of every disk that's available, plus a quick browse item for Version Cue. This Folders navigation method can be more efficient if you need to drill down

through a number of cluttered folders. Bridge only updates the Content panel when you actually select a folder in the Favorites or Folders panes. Clicking on the disclosure arrows to the left of a folder expands to show the folders inside it, but it doesn't ask Bridge to start rendering any of the documents that might be there as well. When you get in to the folder you want, select it to see its contents in the Content pane.

When navigating the folder structure of your disks, there are times when it would be more useful to be able to see all the files within a folder including items that are nested deeper in sub-folders. The Filter pane offers a small folder icon in its upper-left area, just below the tab title. Clicking this toggles the Content panel's view between normal folder-by-folder navigation and showing all contents of the selected folder regardless of how deeply nested it is. It may not be obvious why the icon is in the Filter pane, but this is what controls what's shown in the Content pane. Using this option also prevents you from seeing and using the filter tally of different types, dates, and so on in the Filter pane. It can also take Bridge a little time to show all nested files in large, complex collections, especially if the media is optical rather than a fast hard disk, but despite these small quibbles it is a very useful option to have.

Searching

When looking through large collections of files, the Filter pane can help find just the files you want by showing all the different properties and optionally filtering out those that don't match specific criteria. The Filter pane lists a large number of different specialist file properties as well as keywords, labels, ratings, camera-related details for digital photos, dates the files were created, and so on. The list is fairly long, and every entry shows how many files in the current view match that particular value. As well as being a report, each item can be used as filter-style searches; click an entry in here, any entry, and all items that don't match that parameter are hidden. Click others to expand what's shown to include those parameters or values as well. It is deceptively simple, but it can also help you to find just the files you want, very quickly and with minimal effort.

For searching through locations in a more traditional way the Edit menu's Find feature has a lot to offer. Choose the source (the location to search) and the criteria (the properties to search for), and choose some fine-tuning options for how results are to be handled. If you find that you use this regularly for the same searches then save the settings as a 'collection'. The search parameters

are saved in a named .collection file that is stored wherever you choose. In Bridge, browse to that and open it to see the current results of the search. If you would like to have it more conveniently placed, drag it to the Favorites pane so it can be selected from there.

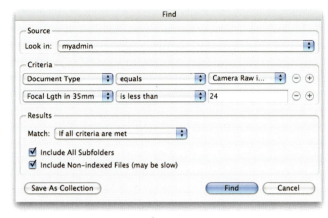

When you've found the files you want you can open them directly in their default editor simply by double-clicking them. Bridge CS3 has a long list of file type associations that define what software deals with what file types, with Creative Suite 3 applications being given the priority where logical. These can be customized in the Bridge CS3 preferences, but the Open With option in the File menu offers a more free-form approach that's better suited to occasional use.

Of course, you won't always just want to open the files you find; often you'll want to place them into documents in different programs. With your chosen document selected, go to *File > Place* and choose where to send the file; Contribute, InDesign, Photoshop, Dreamweaver, Flash (or a Flash Library), or Illustrator. If it isn't easy to drag an image from Bridge into an InDesign document because there's not enough room on screen (even with the window in Compact mode) then the Place command in Bridge is just the ticket.

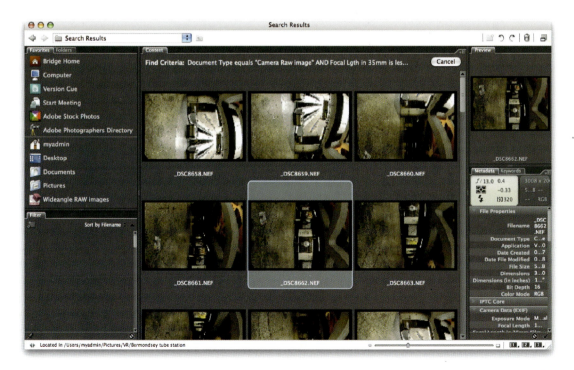

Placing a single image into InDesign will put the graphic into a selected InDesign frame if there is one, otherwise it will create a new one for the job. If more than one graphic is placed at once, new frames will be made for each item whether there's a selected frame or not. Choosing *File > Place > In InDesign* with more than one item selected uses Bridge CS3's 'multi-file place' feature, loading the cursor with multiple items at once.

Color

Bridge CS3 provides an utterly invaluable feature for Creative Suite users; it can take any saved color settings from any of the other programs in the suite and set that to be the color settings used by all the other programs. Not all of the programs in the suite actually use sophisticated color management settings. Dreamweaver, Flash and Fireworks are so web oriented that they've never needed to worry about details such as CMYK conversions, dot gain and press conditions. But Photoshop, Illustrator, InDesign, and Acrobat 8 Professional all follow Bridge's lead.

Start by going to either Photoshop or InDesign and open its color settings controls by going to *Edit > Color Settings*. Acrobat 8 Professional also has controls for managing its color handling, found in the main preferences window in the Color Management section instead. Don't try using these controls however, as there's no option to save your efforts as a named color settings file.

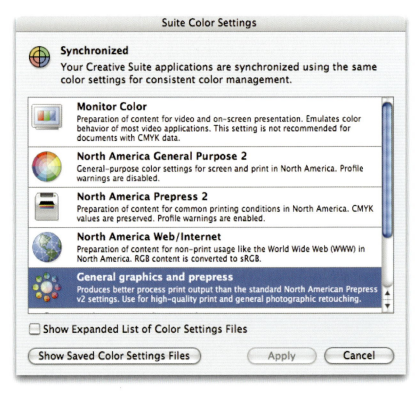

Set up the color options in Photoshop or InDesign to match your output needs, preferably after consulting with your printer or prepress expert, and then save this with a recognizable name. Then turn back to Bridge, choose *Edit > Creative Suite Color Settings* and browse the list of color settings files. Click the checkbox to show the complete list of all available settings rather than just the core set.

Automation

Thanks to a collection of automation scripts, Bridge can be used to drive a range of different processes in Photoshop, InDesign, Illustrator, and Fireworks. Contact sheet production can be run in both Photoshop and InDesign, using selected images as the source. Illustrator CS3's Live Trace feature can be invoked from the Tools menu in Bridge and the results are either shown in Illustrator for manual adjustment or saved directly to a new document, using any of the Illustrator's Live Trace presets.

Photographers in particular will appreciate scripts such as Merge to high-dynamic range (HDR), used to generate high-dynamic range images from

multiple photo exposures, not to mention the PhotoMerge process that aligns a set of images based on analysis of their content. This can be used to produce a large, high-resolution composite image from a set of scans of an oversized document or tiled photos of a broad scene. True panoramic images can also be generated if the viewpoint of the tiled photos wrap around to take in a broad area.

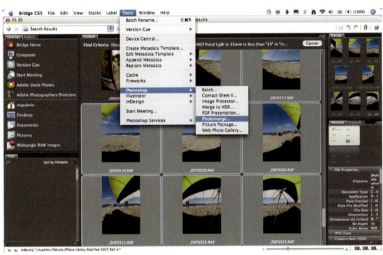

Batch Rename is another automation feature you'll find in the Tools menu, and if you ever need to do this then Bridge CS3 can save you a lot of time and effort. Rename the original files *in situ* or as they are moved or copied to a new location, applying up to four different criteria at once. Naming options include date and time stamps, metadata (which itself includes more than a dozen options from aperture value to urgency), and sequence numbering or lettering. The original file name can be preserved as a new entry in the file's XMP metadata so it can always be checked and restored if necessary.

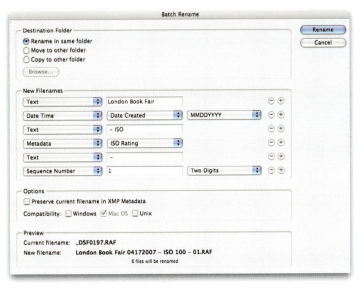

Formats

Bridge handles far more than just images. Every one of the Creative Suite programs' native formats is handled here, of course. As well as the obvious bitmap graphic formats handled by Photoshop and Fireworks, InDesign and Illustrator documents get document previews. Sensibly enough, each page in a Portable Document Format (PDF) can be previewed (although in the initial version of Bridge CS3 the magnifying glass still previews the first page). Unfortunately, Dreamweaver and Flash documents do not get previews.

As you'd expect from something designed to help keep track of everything that might go into a Creative Suite production, other kinds of files are handled by Bridge as well. While word processor and spreadsheet documents just show their standard icons, video and audio files play in the Preview pane.

Camera RAW

As we've said already, serious photographers will generally prefer to shoot their digital images in RAW format. This means you can take the maximum possible data from the camera's sensors and get the most flexibility and quality later on when post-processing the shots. Bridge CS3's Camera Raw support now covers over 150 different RAW file formats, so you're unlikely to hit a format that can't be read.

Opening one or more images by choosing *File > Open* in Camera Raw ⌘ R ctrl R shows the selected images in the Camera Raw window. If multiple files were chosen, a scrolling column of thumbnails is shown as well. All the photo's original settings are shown in the multi-tabbed section on the right, where overall image adjustments from exposure and color temperature to curves, fill light and other appearance controls can be adjusted.

Multiple images can be 'synchronized', applying the edits of one to all other selected images. Finally, the optimized images can be saved directly to disk as new documents, opened in Photoshop for further work or just updated where they are. This means that you have digital photo batch processing features at your fingertips, in an environment that both understands every aspect of digital photographs and is tuned for working with large numbers of files at once.

RAW images don't have to be processed all at the same time in Camera Raw. The Develop Settings option in the Edit menu applies Camera Raw settings to images without leaving the Bridge window at all. The settings in any RAW

image can be copied and applied to any other, the 'previous conversion' used, the Camera Raw Defaults chosen instead, or all edits removed so the selected image or images go back to how things were when first shot.

More Photoshop-like corrections can be done using the tools arranged across the top of this window. Cropping and straightening are useful standards, but the Heal

tool is an impressive clone-based devect removal tool, and you should ever need it the Red Eye Removal tool is actually surprisingly effective. At this point you may be asking yourself why you would want to do this sort of task here rather than in Photoshop. The answer is actually very simple: doing these adjustments while working with the original RAW image data ensures the best possible quality results, which is why you shoot in RAW format in the first place.

Photo Downloader

Getting the images from a camera in the first place is also tackled by Bridge, or at least by a dedicated program that comes with it, called Photo Downloader. This can be set to take over when a camera or camera memory card is connected and download the contents to a designated folder. Sub-folders with automatically applied names including the shot date in some format can be created in the process, and RAW files can be converted to Adobe's DNG (digital negative) format in a variety of ways. Combine this with Bridge CS3 as the way to browse the results and pass selected items along with Photoshop or other programs in the suite, and you have a highly streamlined and well-integrated way to acquire, manage, and use digital photos.

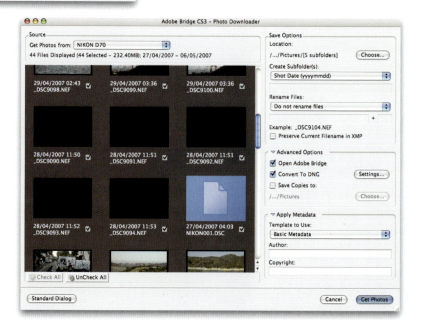

Stock Photos

When you don't have time to take photos yourself or you want a wider range to choose from, Adobe's Stock Photos gives search access to a number of different commercial image libraries at once. Track down the right image for a project and download an unwatermarked 'comp' version to try out in your work. Buying an image downloads it and makes it available immediately. If this search fails or you want to get something more individual, the photographer's directory next to the Stock Photos favorite is a good way to get in touch with different specialists.

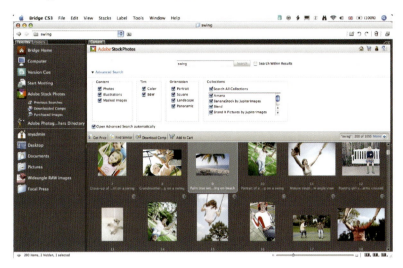

Stacks

Keeping items findable is what file management is all about. Bridge CS3 makes it easy to track down items by using filter searches, but sometimes it is best to be able to link individual documents together more directly. The Stack feature creates a virtual stack of files and treats them as one in the Content pane. A stack shows with a double outline and a small number badge in its top-left corner showing how many items it contains. Clicking this toggles the stack from closed to open mode, where all its contents are shown, and back again.

You can group folders as well as files into a stack.

Double-clicking a stack acts like double-clicking on all the files inside the stack at once; they'll all open in their default parent applications. If you've grouped different formats then each relevant program will launch in order to open its file, so be sure you have enough memory before double-clicking a stack with many different files inside.

Presentation

Use Bridge CS3 to show your work as well as find and manage it. The Light Table workspace option is useful for your own browsing when you want to concentrate on a number of different files, but that's not so good if you need to make a quick presentation of your work. To do this, select a number of images and choose *View > Slideshow* or type ⌘ L ctrl L. The screen will fade to a gray backdrop and show each file in turn. Choose *View > Slideshow* Options or type ⌘ Shift L ctrl Shift L to customize the slideshow behavior, but be aware that the options there are best described as adequate rather than extensive.

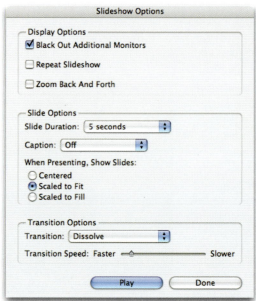

Meetings

If you can't present your work face to face then why not use Bridge to start a web conference meeting and show your work on everyone's screens at once? You'll be able to collaborate with others without being anywhere near them. You'll need to sort out an Acrobat Connect or Acrobat Connect Professional account to do this, and if you're outside of the US only the Professional version is available. What you get with an Acrobat Connect web conference is a virtual meeting room that is effectively always on, with screen sharing, video links and teleconferencing, and virtual whiteboards. Probably the best point, however, is the simplicity. This brings together the features that people want without needing separate unfamiliar software. Okay, it isn't that familiar but it is easy to find and use.

Screen sharing can be limited to certain windows or programs or the entire desktop. The whiteboard feature is integrated; just use the whiteboard tools and draw directly on the screen, regardless of what is being shown at the time. Text chats can be sent to individuals or all in the meeting, and the whole panel-based interface can be reordered to suit how you want to work.

Version Cue

Finally, Bridge provides the closest thing Version Cue has to an interface, at least once the basic server setup has been established. Although you can do a little bit of browsing directly from regular Open, Save, and Export file dialog windows, it is best to reserve your main Version Cue interaction to Bridge where you get much greater control and freedom.

When using Bridge's Version Cue favorite to browse any Version Cue project, you can view all the different versions of a file that have been saved. Files with multiple versions show the number of versions below the file name in the Content pane's Thumbnail view. Choosing *Tools > Version Cue > View* Versions shows all the file versions in the main Content pane, complete with any comments each one might have. This is best shown in Details rather than Thumbnails view, with smaller previews but the complete text on display. Any of the versions can be opened from here, and any can be 'promoted' to become the new current version. For more on Version Cue turn to page 49.

Managing Assets with Version Cue

A valiant attempt to manage a large private library

Version Cue CS3 is the project management part of the Creative Suite. It is a server-based document and project tracking and management system, designed to provide network-based workgroup collaboration and file-versioning features from within your design environment. What this means in practice is that you'll be able to work on complex projects along with other members of a team without worrying about whether someone else is trying to work on the same document that you want to edit or whether you're using the latest versions of everything. Despite these impressive abilities it really isn't complex to set up and use, but there are aspects to Version Cue that should be understood so that you can get the most from it.

Put simply, projects in Version Cue are what people use to store their work; a project functions as a form of managed folder. As well as being invaluable for preventing busy teams of designers and production staff from stepping on each other's toes, a Version Cue project can be useful for even the smallest production and solo users. The versioning abilities keep older copies of important files accessible but not confusingly in view.

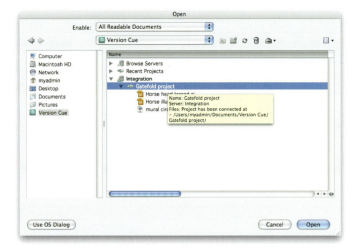

Version Cue has virtually no interface to speak of, and it doesn't operate as a standalone program like the other parts of the Creative Suite. Instead, Version Cue projects are set up and accessed using Bridge or the Adobe Dialog when opening or saving files in Photoshop, Illustrator, InDesign, or Acrobat. Although the options in the Tools menu in the Adobe Dialog view are quite functional, using Bridge gives the most control over general Version Cue project management.

At this stage in Creative Suite 3 Dreamweaver and Fireworks don't have the Adobe Dialog option in their file dialog windows. Flash doesn't either, at least by default, but clicking the Enable Version Cue checkbox in its General preferences removes this limitation and also adds File menu check in abilities as well.

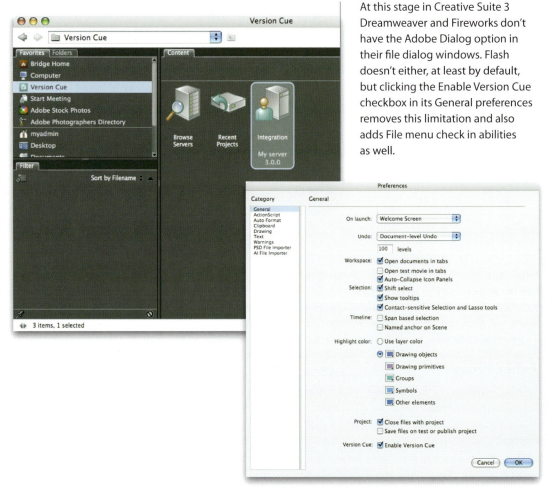

Installation Decisions

Despite being designed to be deployed from a server over a network, you can run it perfectly well – for light to moderate network workloads – from your own computer. Remember that it will only be available on the network when your computer is running, so if you're part of a busy workgroup it may be better to devote a machine to the task instead. On the other hand, you can use it entirely on your own computer without providing any network access to other people. Version Cue is designed to help network-connected workgroups, but its document management and versioning control can be invaluable for solo users as well.

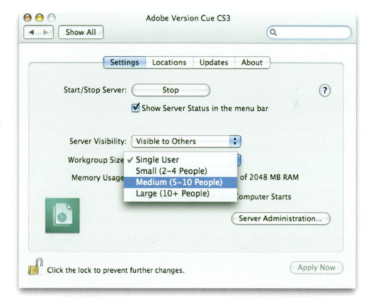

When Creative Suite 3 is installed without customization the Version Cue Server is placed on your computer along with everything else, but it isn't turned on. If you want to run it from a dedicated computer on your network, run the Creative Suite 3 installer on that machine and customize the options so that only Version Cue CS3 is installed. (Check the license agreement and instructions to be sure that you do this correctly.)

When Version Cue is installed on a Macintosh it is placed into Library/ Application Support/Adobe/Adobe Version Cue CS3, and in Windows it is placed into Program Files/Common Files/Adobe/Adobe Version Cue CS3/Server. Unlike most software installations, these locations can't be changed. If Version Cue CS3 is installed on a Windows PC with an active firewall, you will need to open TCP ports 3703 and 5353, and 3704 if SSL is enabled, for others to communicate with the Version Cue CS3 server software. Allowing access to Version Cue from outside the local network will also involve opening the appropriate ports in the firewall gateway; speak to the network administrator about this or find the documentation for your network's Internet router or gateway device.

Server Setup

Before putting Version Cue CS3 to use for the first time the server software itself needs to be turned on and some basic settings have to be made. There are a couple of ways this is done. One is the Start My Server option in the Adobe Dialog windows in Illustrator, Photoshop or Acrobat or in Bridge. The other is the Version Cue CS3 icon found in System Preferences in the Macintosh and in the Control Panel in Windows, where a number of other core server-focused

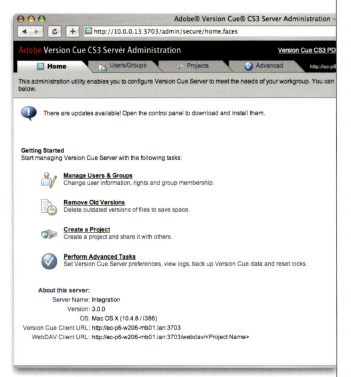

options can be found as well. The rest of the core setup process is done in your computer's default web browser. Although day-to-day use is done using your regular Creative Suite 3 design and production tools, any Version Cue server administration is performed using a web browser interface.

A system administrator password will need to be set to go with the 'system' admin name. Do not forget this; the only way to deal with a forgotten system administrator password is to reinstall Version Cue CS3 from scratch. Although it is not a good practice to write down passwords, having a list held securely offsite somewhere can be a worthwhile backup. Consult with your system administrator if you have one, and take steps appropriate to the level of risk and level of importance of the work you do.

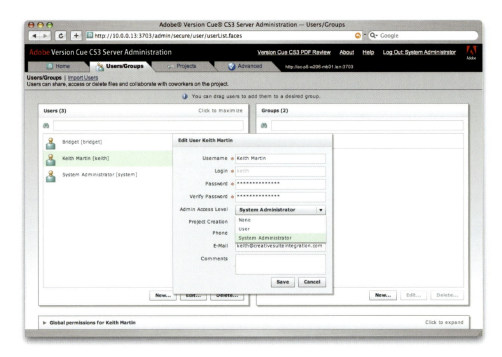

The server name must be given and the server's visibility option set. The name is for the whole server, not any individual project. Projects are managed by the server and get their own names. If a server is set to be private then it can only be used from your own computer; if this is meant for workgroup rather than solo use it must be set to be visible to others. Once the server is running it will remain available for use.

User access is another part of the Version Cue CS3 server setup, and this controls how others can access the server and its projects. The Automatic User Creation option allows anyone to log in, creating a new user account with an empty password when a new user connects for the first time. This open access approach is very easy for everyone concerned, but before you choose this make sure you know who is able to look around your network. The Manual User Creation setting requires users to be set up by an administrator before they can log on; more work but more secure.

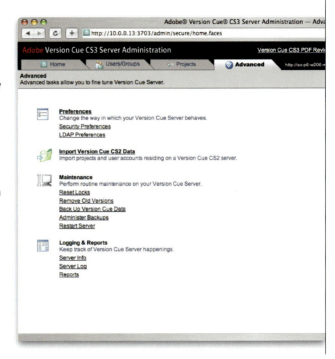

Project Setup

Setting up a Version Cue project to be served by Version Cue must be done before files can be managed. In Bridge CS3, this is done using *Tools > Version Cue > New Project* to start the process. To do this from one of the other Version Cue-enabled programs from the Creative Suite you'll need to be in one of the file dialogs, saving, exporting or opening your work, and it must be in Adobe Dialog rather than OS dialog mode. Click the Tools icon above the file listing section and choose New Project. (If you are asked to log in, use the administrator user name and password or a user that has been granted project-creating powers in the Version Cue CS2 server setup.)

Version Cue's New Project window is actually very simple, largely because the Version Cue server is already up and running, ready for use. The

project location will be within the Version Cue server setup location. Name the project and give it a decent description, then decide whether the project will be accessible to people logging in with different names and whether to make it compatible with people running the previous version of the Creative Suite. The compatibility option makes it work with the older Version Cue 2.0 methods of communication and management as well as Version Cue CS3. Use this if any of the workgroup are still using Creative Suite 2, or if you intend to use Acrobat 8 Professional directly with Version Cue projects; Acrobat's Version Cue support is still based on the previous Creative Suite's abilities.

That's it; the project is made. From that point on the project will be available for use by those with the appropriate login details, or anyone at all on the network with Creative Suite 3 installed if open access to the server was allowed.

Version Cue Projects in Use

To save a document into a Version Cue project just choose *File > Save*, make sure the dialog is in Adobe Dialog mode, and pick the Version Cue project. Log in with the appropriate user name when requested, then save into the project folder as normal. As well as saving a copy to disk, this creates the first Version Cue-tracked version of the layout document. Saving a document into a project creates a new version. From then on, saving the document creates a temporary copy of the file into Version Cue.

If someone else views the Version Cue-managed file they will see the most recent proper version, not the more recent interim copy. To update the final accessible version of the file and make that available for others it must be checked in again, and a new comment detailing what stage it is at can be added. Even if it is closed and opened again, until it is actually checked in – by choosing *File > Check In* – it remains checked out, marked as in use.

This two-level approach to file storage and handling is the key to how Version Cue helps keep busy workflows under control. The checking-in process isn't truly automatic; if someone forgets to check their work in it remains marked as being in use. It is still accessible, but when someone tries to open it they will be told that it is checked out already and given the option to close again or continue opening the file. Editing and then saving a document that's checked out elsewhere also prompts alerts, in this case to warn about possible version conflicts.

Pretty much the only weakness lies with the users, and even this isn't a major problem. If they forget to check work back in when finished, when someone else tries to edit the documents they'll be shown alerts warning that the document is in use and asking them whether they want to continue or not. They won't see the most recent changes until it is checked back in, but this doesn't mean people can end up locked out of a document.

If a project needs to be synchronized so that all the possible latest versions of files are available, the Synchronize button or Version Cue menu option in Bridge CS3, or the equivalent option in the Tools menu in the Adobe Dialog, does the job. It can't do this with files that are still in use and being edited, but other items will be brought back in sync with their last saved copies and new versions set for each of them.

One small apparent wrinkle to the otherwise streamlined process comes when working with files from programs that don't have a Check In option in their File menus, whether that's Dreamweaver or Fireworks, or third-party programs such as Microsoft Word or any other software. (Remember, Flash CS3 can work directly with Version Cue if that option is enabled in its preferences.) Adding files works in exactly the same way; just save the document into the Version Cue project folder, generally by navigating as normal to the Version Cue location in your Documents folder. Alternatively, just drag the files there manually in the Macintosh Finder or Windows Explorer. This adds them to the project and makes them visible in Bridge CS3's Version Cue view on the same computer. However, at this point the files still aren't actually checked in. They don't yet have an established version that others can see, so they won't be visible to anyone else browsing this Version Cue project across the network.

The solution is simple and entirely logical once Version Cue CS3's workings are fully understood. In Bridge, after files have been added, select *Tools > Version Cue > Synchronize*. This checks in any outstanding files (that aren't currently open), asking the user to provide comments for files that will be generated as new versions. The new files will be checked in, and they'll appear within moments in any Version Cue view of the project anywhere else on the network.

Viewing and Versions

Bridge CS3 offers two different view options for the contents of a Version Cue project, just as it does for every other folder it browses. The Thumbnails option shows the thumbnail preview-centric view, with relatively little text shown. This is good for finding files visually, but long file names are truncated and details such as creation and modification date left out. All this information is shown in the Metadata panel for a selected item, but the Details view presents this beside each file all at once. For browsing many files and using details such as dates and full file names to track down items, use the Details view instead.

When browsing a Version Cue project in Bridge CS3, files that have multiple versions available are shown with the number of versions listed below the rest of the text. Almost all of the time the latest version is the one that's required, but checking back through previous versions is easy. Choosing *Tools > Version Cue > View Versions* or clicking the View Versions button at the top of the Content pane shows all the file versions in the main Content pane, along with any comments each one might have. This is best shown in Details rather than Thumbnails view, sacrificing preview image size in order to get the complete text on display. Any of the versions that are shown can be opened directly, and any older version can be 'promoted', using *Tools > Version Cue > Promote* to Current Version or the Promote button at the top of the Content pane, to become the new current version if necessary.

Files checked in by others since the Version Cue project was last synchronized on your computer will be flagged with the line 'Newer version on server'. Synchronizing the Version Cue project (or indeed choosing *Tools > Version Cue > Download* instead) synchronizes your local view of the project and acquires a locally managed copy of the new files.

Summary

In practice, what Version Cue CS3 does is make the process of working on shared files over a network as transparent as if everything was on your own computer. Browse the Version Cue project using Bridge, double-click a file to open it, save as you edit, then check it back in again when you want to save a specific version. In day-to-day use it doesn't matter whether the project starts its life on the same computer or elsewhere on the network, full versions of files are copied to everyone's own Version Cue project folder when synchronized, and they are browsed and accessed in exactly the same way. Behind the scenes, when a file in a Version Cue project is opened it is copied to the user's computer. The Version Cue server software manages the information about file versions and locations, and makes sure the latest full version of each file is available for all users to get at.

The Workspace

London's skyline at night, viewed from the Elephant & Castle

Introduction

Adobe's Creative Suite 3 uses a mature and largely unified interface across all its products. Photoshop, Illustrator, InDesign, and Flash all use a new dock-based approach to panel management that makes life easier than before, both when working intensively in one program and when moving between different environments. The Dreamweaver and Fireworks interfaces remain less fully integrated into the CS3 style, but they are not all that different in the broader sense.

All these major applications start off with the same Welcome Screen interface when launched. This helps users create the kind of new document they want or open a recent piece of work in a manner that's consistent across the main programs.

Bridge and Version Cue are a little different. Bridge is more of a browsing and searching tool, a dedicated alternative to digging for files using the Macintosh's Finder or Windows' File Explorer. Of course, this description doesn't really do it justice; it is so well tuned to handling and sorting media

files that many people find that Bridge quickly becomes an indispensable part of their workflow.

Version Cue is actually a document and version management system that operates behind the scenes rather than a program you interact with directly. It works in conjunction with the other programs, providing a check in/check out process to help group different files into logical project groupings and also allow managed multiple user access to project elements across networks. Version Cue is aimed more at design and production teams than at individual users, but it can be a useful way for anyone to manage projects.

One of the best ways to really learn a program is to explore the options it offers throughout its workspace, and the best way to do that is with guides such as this book. This chapter describes the workspaces of the different parts of the Creative Suite 3 and looks at the key aspects, similarities and differences of each program's interface.

Photoshop

Panels

Photoshop has always made extensive use of floating panel windows, and Photoshop CS3 introduces a new sophisticated panel management system to help tame the myriad of different panels that are available. As in previous versions of Photoshop, the main ones are the Tools panel, now in a single slimline column by default, and the Options panel, which sits beneath the menus and provides quick access to the features and parameters of the selected tool.

Surrounding most panels is a translucent dark gray box, the new panel docking feature. Click the top of the dock to collapse or expand its contents; the Tools toggles between the single column mode and the traditional two-column layout, and the main panel dock on the right toggles between the regular panel display and a compact icon view mode where individual panels are shown popped out beside the dock.

If you've pulled the panels around a lot and want to get back to Photoshop's clean, original arrangement, this is done by choosing *Window > Workspace > Default Workspace*. On the other hand, if you've come up with the perfect custom arrangement for your workflow then choose *Window > Workspace > Save Workspace* to name and save your panel setup.

The main document window can be switched between four different 'Screen' modes; the Standard mode, where each document is a separate floating window that can be shuffled about easily, the Maximized screen mode, where the document and the panel docks all stretch to fill the available screen space, and two Full Screen modes, one with and one without the menu bar. Most

people stick to the Standard mode, but there are advantages in using the other modes on occasion. For example, an image can be scrolled partly out of view in the Full Screen modes, which can help when dealing with rotation handles projecting past image boundaries.

When exploring Photoshop CS3, what's less obvious at first is the depth to which you can customize Photoshop's panel setup and in particular its menu commands. The Keyboard Shortcuts and Menus dialog, found in *Window > Workspace*, can be used to customize every single keyboard shortcut that Photoshop offers and add new ones to menu items that don't have any. If there are menu items that you don't want to show for some reason you can hide them here, and you can also pick out important ones by marking them with a color. Any changes you make can be saved as a preset for quick reuse. More importantly, there's a simple way to reset everything back to the Photoshop defaults, clearing any experiments you've made. We don't recommend changing shortcuts or hiding menu items for the sake of it, but this can be a very useful ability if you want to set up a workstation for training a novice user, for shortcut-driven batch processing, or other specialized requirements.

One very useful way the new menu coloring feature has been used is to show users what items are new to Photoshop CS3. Choosing *Window > Workspace > What's new in CS3* will mark every new menu item, whether currently available or not, in a color. You'll still need to explore the features these provide, but this helps point out the fresh options among the many standard menu items.

When working with multiple image windows, Photoshop's Arrange tricks can come in handy. In *Window > Arrange*, there are options to cascade your images into a neat, offset stack of windows or to tile them all either horizontally or vertically so that you can see more than one at once. The Match Zoom, Match Location, and Match Zoom and Location commands make all windows take on the same magnification scale and scroll location as the front-most document, which can be another useful timesaver.

Illustrator

Illustrator's panel handling has been moved even closer to Photoshop's approach than in previous versions of the Creative Suite. The new panel dock, shown as a translucent dark gray box surrounding panel groups, is used to hold sets of panels together and keep the interface tidy. The main panel dock on the right toggles between icon mode and full expanded mode. In expanded mode each panel set is shown as normal, with tabs to switch between different panels. Individual panels can be dragged out by their tabs and turned into floating panel windows in their own right and dragged back into a set to tidy it away again. Click the dock's top bar to toggle between expanded and icon view, or, with the Tools panel, to switch between the traditional two-column and space-saving one-column arrangement.

The arrangement of panels and the dock display settings can be stored for later reuse, so you're able to set up different arrangements of panels for different kinds of work. Illustrator CS3 comes with three predefined workspace setups: [Basic], [Panel] and [Type], listed in *Window > Workspace*. If you make a preferred panel arrangement of any sort, choosing *Window > Workspace > Save Workspace* will allow it to be named and saved for later reuse. You can manage these custom-made workspaces in *Window > Workspace > Manage Workspaces*, but you're not able to edit or remove the three predefined ones.

Curiously, Illustrator allows the user to change the brightness of the various panel windows with a slider in the User Interface part of its Preferences window. This doesn't do much except interfere slightly with legibility, so we suggest leaving it at the brighter end of the scale.

The Illustrator document itself can have its view state saved, which makes stepping between different zooms and focus locations extremely simple.

Outline	⌘Y
Overprint Preview	⌥⇧⌘Y
Pixel Preview	⌥⌘Y
Proof Setup	▶
Proof Colors	
Zoom In	⌘+
Zoom Out	⌘−
Fit in Window	⌘0
Actual Size	⌘1
Hide Edges	⌘H
Hide Artboard	
Show Page Tiling	
Show Slices	
Lock Slices	
Hide Template	⇧⌘W
Show Rulers	⌘R
Hide Bounding Box	⇧⌘B
Show Transparency Grid	⇧⌘D
Hide Text Threads	⇧⌘Y
Show Live Paint Gaps	
Guides	▶
Smart Guides	⌘U
Show Grid	⌘"
Snap to Grid	⇧⌘"
✓ Snap to Point	⌥⌘"
New View...	
Edit Views...	
Swash closeup	
Typography	
Main table	
fine print	
Full display	

The New View and Edit Views options in the View menu store a particular window state and manage multiple 'views', and any that you've added are listed at the bottom of the View menu.

Each panel – apart from the Tools and Options panels of course – has its own popup menu to the right of the panel tabs containing many different controls and options. With some such as the Stroke and Gradient panels, the list is very simple. Others are rather longer; Layers has over 20 items relating to modifying layer sets, layer visibility states, and settings. Familiarize yourself with the options in whichever panels are most useful to you so that you'll know where to turn when you're working.

The Options bar changes its contents according to the current tool and selected object. At the far right there's a shortcut button that launches Bridge and a drop-down menu listing all the things that the Options bar can show, plus where it should be docked. If you prefer to have this along the bottom of your screen rather than at the top, set it up here.

Many of the icons and text for many of the things shown in the Options bar are more than just labels. Of the text labels, the ones that have underlines are clickable triggers that pop open floating panels with a number of related settings and even popup menus for refining how these settings behave. Unlike the regular panels, these panels disappear when anything else is clicked, keeping the document view uncluttered.

Illustrator's many keyboard shortcuts are open for customizing in its Keyboard Shortcuts dialog, accessed from *Edit > Keyboard Shortcuts*. Shortcuts for both the menu commands and the tools in the Tools panel can be edited. There's no alternative set supplied, but if you do customize this and decide that you want to get back to normal, the Illustrator Defaults set is always on hand.

InDesign

InDesign's workspace is very similar to Illustrator's, just with a few more items in its standard list of panels. These are stored in the new CS3 panel dock on the right of the document window, the translucent gray box that toggles between the expanded mode showing the active panel panels and the compact icon view. Clicking a panel icon shows the panel itself, attached to the side of the dock. This stays open until you close it directly or open another docked panel – unless Auto-Collapse Icon Panels is checked in the InDesign preferences, in which case it closes as soon as you click outside the panel itself. To keep one open you can drag it away from the dock, and dragging a panel into the dock will include it in the list.

When dragging the panels in and out of the dock, watch for the blue marker that appears. When it shows as a line you'll be adding a new separate panel group to the dock, but when it shows as a box around an existing group you're about to add the new item to that existing set. Having separate panel sets with related items inside helps to group different panels together logically, and it makes life easier when scanning through for the appropriate one.

The InDesign document Screen Mode can be changed from the Normal view mode, which shows the non-printing pasteboard surrounding the page, to Preview, Bleed, or Slug modes instead. Preview hides guides and crops off anything outside the page boundaries, giving a preview of what the final printed page will look like. Bleed and Slug act like Preview, but show the bleed or slug area as well. Design work is generally done in Normal mode, with the others used to demonstrate the appearance of the page artwork or final print. Switching between these different view states is done through *View > Screen Mode* or the bottom icons in the Tools panel.

The Control panel is a horizontal toolbar-like window that is normally docked just below the menubar, although it can be used as a free-floating panel or docked at the bottom of the screen instead. This last option may appeal to users migrating from QuarkXPress, as the context-sensitive controls it shows are the closest equivalent to that program's Measurements panel.

The keyboard shortcuts in InDesign can be altered if you prefer different ones, although this isn't something to tinker with without thought. Choose *Edit > Keyboard Shortcuts* to see all the options available. What's more useful than just tinkering with individual shortcuts, especially for those coming from using QuarkXPress or PageMaker, is the option to swap out all the standard InDesign keyboard shortcuts for those based on the menus and functions in QuarkXPress 4 or Adobe PageMaker 7. Equally usefully, any item in the main menus or InDesign's many panels that doesn't have a command can be assigned one, although you'll probably have to use combinations of modifier keys and f-keys to find enough that aren't already in use. Save custom sets so that you can turn them on and off easily, and click the Show Set button to open a text file showing a complete summary of all the current shortcuts.

Just below the Keyboard Shortcuts command, *Edit > Menus* allows full menu customization, including contextual menus and popup menus in panel panels. Individual menu items can be hidden if they're not relevant or marked with one of seven different colors if they're particularly important. This feature can be very helpful when training new users or preparing for a long production session. It is also used very well as a way to show which menu items are new or enhanced in InDesign CS3. This works in exactly the same way as in Photoshop CS3, as a custom Workspace setting found in *Window > Workspace*.

Dreamweaver

Dreamweaver CS3's workspace is still a little unconnected with the interfaces in Photoshop, Illustrator and the other long-term Adobe products. It isn't all that different, of course, and it has been refined through a number of years. The main document window sits between the Insert toolbar along the top and the Properties panel at the bottom. Most of the commonly used panels are open as standard in a grouped set of panel panels down the right of the screen. These are docked together so that they move as one, and dragging one of the section titlebars adjusts the height of the panel section within the group. Some sections also show secondary tabs for switching between panels.

Drag the 'thumb' part of a panel's blue titlebar to pull it out of a docked set, and drag a free-floating panel the same way across other panels. You'll see a blue horizontal line when it will dock as a new section and a blue rectangle when it will be inserted into an existing panel set as secondary tabs.

As with Photoshop and Illustrator, there's a Workspace Layout item in the Window menu where you can pick existing panel arrangement presets and save your own preferred configuration. If you work with two screens you can use the Dual Screen configuration, which puts all but the Insert and Properties windows out of the way on the second display.

The document window shows the visual layout, the code-only view, or the well-known Split view which shows the page code in the

top section and the visual layout in the bottom. At the base of the document window there's a menu offering different resolutions. These resize the design view section of this window to specific dimensions that relate to common viewable web browser window sizes. Working with the appropriate document window size applied will help ensure that you create work that will fit well in the target audience's typical browser window.

Keyboard shortcut customizing is as easy in Dreamweaver as it is in the other programs in the Creative Suite. You should think carefully before making changes to the standard ones that work similarly across other programs, but only because you'll end up forgetting which commands are for which program. Choose *Dreamweaver > Keyboard Shortcuts* to begin. You have a selection of presets to choose from, based on whether you're more comfortable with Dreamweaver's standard or MX2004 shortcuts or prefer those in BBEdit or HomeSite instead.

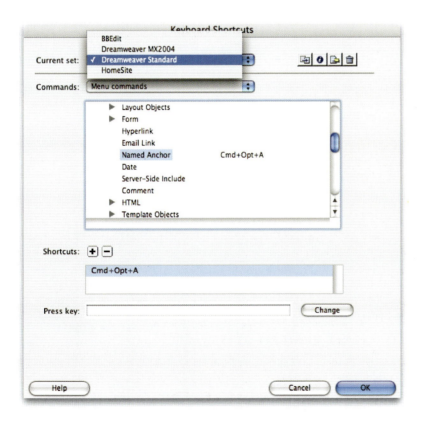

If you do come up with your own custom set you can save this and call it up again. Equally useful is the Export as HTML button; this creates a formatted HTML table that contains every shortcut in the current set. Print this out for easy reference.

Fireworks

Fireworks CS3 has followed Dreamweaver's lead, in that the interface has improved from its previous incarnations, but it doesn't really toe the line as regards the core new Creative Suite 3 look and feel. Still, the windows and controls are logical and easy to use; anyone used to the previous versions will find this both understandable and an improvement.

There are essentially three different panel windows that provide the various visible tools and controls. The Tools panel, normally found on the left, the context-sensitive Properties panel placed by the base of the screen, and the multifaceted collection of tabbed and docked panels that stretch the height of the screen on the right. Other than the Tools and Properties items, every one of the panels listed in the Window menu can be found here, at least until it is dragged out to be a self-contained floating panel instead.

The Fireworks workspace arrangement of its visible and hidden panels can be switched quickly by choosing one of the four presets, each designed with a different screen resolution in mind. On top of this, choosing Save Current from the *Window > Workspace Layouts* menu lets you store your own panel

arrangements. This doesn't have quite the same scope as the workspace controls in some of the other programs in the suite, but it is very useful all the same.

Contribute

Contribute CS3 is not quite the same kind of tool as the rest of the products in the Creative Suite. This is largely aimed at the day-to-day maintenance and upkeep of a website, often by the site owner rather than the designer, but it has grown from being a clever but relatively simple tool into a quietly sophisticated management and editing program for both websites and blogs.

The interface is very different from Dreamweaver, Fireworks, InDesign, and all the other programs apart from the pane-based Bridge CS3, in that it uses a single window with built-in sections; not a panel in sight. This works very well for its main user base, and the 'How Do I…' section in the sidebar to the left of the main document pane provides a compact but very informative way to find task-related instructions.

As well as managing existing content, new pages and even complete sites can be built from scratch – or rather, from editable templates. Although it isn't in Dreamweaver's league at all, Contribute CS3 can operate as a perfectly usable site authoring tool if required.

Keyboard shortcuts are comparatively minimal. Although they exist for a fair number of commands, this is a program that's meant more as a point and click editing tool than a keyboard-driven production engine.

Flash

The Flash method of working is different from all the other programs in the Creative Suite. Its timeline workflow means the main document window has two main sections; the stage, where the graphic elements are laid out, and the timeline, where the playback sequence of the document is organized.

The Flash panels are now more in line with the Creative Suite 3 way of doing things; the dark gray translucent dock is apparent behind the Tools panel on the left and the various controls panels on the right. Clicking the dock bar at the top toggles the Tools between single-column and two-column layout, and switches the main panel dock from expanded mode to icon mode, just as in Photoshop and Illustrator. Panels can be pulled out of the dock and used as regular floating items if preferred, and docking them back again or adding new items to the dock is handled by dragging the panel over and watching for the tell-tale blue line (for adding a new panel section) or blue box (for adding a new tabbed item to an existing panel) to appear.

Flash's Properties panel is another dockable floating window, attached to the bottom of your display unless you want it floating free. Finally, the *Window >* *Hide Panels* command puts every single panel, panel and dock away and expands the main window to fill the extra space.

In Flash, panel management is handled through the Window menu's Workspace item. This shows saved workspace setups that you've added to the

list, along with a Default workspace for sorting things out if you're not sure where things are. Your own saved workspaces can be renamed and deleted, but the Default one can't be tampered with.

The Maximize Mode option in *Window > Workspace* puts Flash into a view state very much like Photoshop CS3's own Maximized Screen mode. The docks extend the full height of the monitor and the main document window expands to take all the available space that's left.

Like Photoshop, Illustrator, and InDesign, when you undock a panel or open one not already in the dock, dragging it around will show it as a transparent overlay until you let go. Experienced users may find this a little odd, but it is a handy trick when you're dealing with a lot of items at once.

Although Flash still has a real abundance of panels available, enough to fill your screen and more, all these intelligent dock and panel management features makes the Flash work environment a much tidier and more manageable place than it has been for years.

Like Dreamweaver and the other programs, Flash has comprehensive keyboard shortcut editing controls. Six different presets are there from the start, catering for old Flash-using traditionalists as well as fans of the new Adobe Standard set. Should you want to explore making your own customizations, the various different kinds of commands are presented in logical groups – Drawing Menu Commands, Tools Panel, Timeline Commands, and so on.

On top of this, the entire main section of the Tools panel can be altered, should you find this necessary or useful. Choose *Flash > Customize Tools Panel*, then replace or add to the items in the panel from the scrolling list of all available tools. The Restore Default button is likely to come in useful unless you're very careful here.

Bridge

At first look the interface customizing controls in Bridge don't appear to be as extensive as in some of the other programs, but in fact there's a surprising amount that can be done to tweak how it looks and behaves. First of all, the panels within the Bridge window can all be resized; just drag the borders. If one panel is redundant for your needs then remove it by unchecking its name in the View menu, and if you want a panel elsewhere just drag its tab title to the new spot in the layout. Switch between a number of predefined view setups with the three Workspace buttons in the window's bottom-right corner, and press and hold any of these to assign a different workspace preset.

One of Bridge's most underrated tricks is the ability to synchronize color management settings across the different parts of the Creative Suite. It doesn't matter which product you prefer to use to establish your ideal color management settings; Photoshop for photographic output, InDesign or Illustrator for calibrated press output, use the one that fits your needs and understanding best. Once configured you can name and save those settings

and then use Bridge to apply them to all the other color management-aware programs in the suite.

Do this by choosing *Edit > Creative Suite Color Settings* and selecting the option you want. If you prefer, choose from the included list of options; check the Show Expanded List of Color Settings Files option to see the complete range that comes with the Creative Suite. Make your selection and click Apply – that's all there is to it. Now the color workflow for each applicable program in the whole suite will follow those settings and deliver more consistent color across the suite as you work.

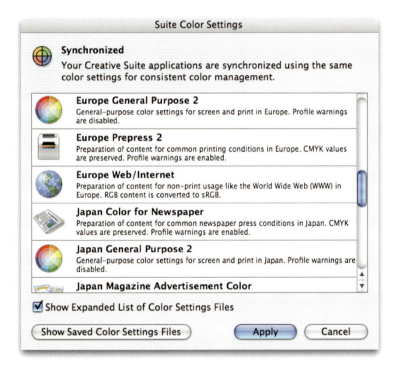

Browse your disks using the Favorites panel or the drill-down approach of the Folders panel. If there's a particular location you want to return to without tunneling through nested folders you can add it to the Favorites list by choosing *File > Add to Favorites*. It is then available for one-click navigation as a favorite rather than buried deep inside a stack of project folders. When you're examining the contents of a folder, hide different files from the Content list using the Filter panel, and pick different sorting options to order the items by name, document kind, date created, dimensions, resolution, and so on.

The thumbnail images can be resized to show more detail or more items within the Content panel. The Thumbnails preferences options allow high-quality thumbnails to be created on the fly as you browse, a useful

option as long as your machine is relatively fast. If you deal mainly with very high-resolution images you may prefer to leave this option off, although you can control the maximum size of file that Bridge will tackle when making new high-resolution thumbnails.

The window itself has a Compact mode as well as its default Full mode, shrinking it down to a fraction of the normal size. This is handy if you like to keep it open and visible while working in other applications, especially as it automatically floats above other windows in other programs. This makes Bridge more like a handy, accessible media-focused file finder than a standalone search and browsing tool, but it also removes all but the Content panel from view.

The default gray background of the Bridge interface is good for viewing images in a

color and brightness-neutral environment, but you can choose a lighter or darker backdrop for the content or the interface panels if you prefer. This is handled in the General section of the Bridge Preferences window *Bridge > Preferences or Edit > Preferences*.

For even more viewing options, the Slideshow feature *View > Slideshow* presents images in sequence with no distracting clutter whatsoever, which can be a real boon when showing work to clients or co-workers.

Bridge also lets you browse more than just your own disks. The Adobe Stock Photos item in the Favorites panel links you to over 20 different royalty-free image libraries. Browse by individual stock library or cross-library categories and use low-resolution comps instantly, and when you find what you want you can buy items directly and then download them straight away. Alternatively, browse the Adobe Photographers Directory instead to find the portfolio and contact details of someone who can create original imagery for you.

Finally, Bridge provides some features that aren't so file and image oriented, too. It acts as an interface for setting up online virtual meetings and web conferencing using Adobe Acrobat Connect and as the way to launch Version Cue, Adobe's integrated document management and version control system.

Version Cue

Version Cue is really a network-accessible document versioning system database rather than a regular desktop program. Because of this, there's not much to the Version Cue interface; you configure the server using your web browser, you use Bridge to browse projects and servers, and you use the Open and Check In commands in Photoshop, InDesign, and Illustrator to access and add or update files in Version Cue-managed projects.

Working with Layers

Overhead text sculptures at the glade festival, summer 2006

Layers are a vital part of design work. Layers are, in the simplest sense, a way of grouping things together to aid the design and production process. They allow design elements to be held in logical sets, separate from other sets of elements. Adobe has done a very good job of presenting basic layer control and functions in similar ways across the different parts of the Creative Suite. Despite this, however, the precise meaning and function of layers differs depending on what kind of design environment is being used; layers in Photoshop are rather different in practice to layers in Illustrator, and so on. This is an unavoidable state of affairs, dictated by the fundamental differences between certain programs.

Similarities and Differences

At the basic level, the Layers panels in Photoshop, Fireworks, Illustrator and InDesign and the timeline layers section of the document window in Flash all provide the same basic functions; they hold different elements within the document in separate planes, and each of these can be hidden or shown

while working to help keep complex productions under control. But when examined a little more closely, it is clear that there are a number of different kinds of layer handling going on across these different programs. InDesign and Illustrator treat each layer as a complete new 'design plane' where multiple objects can be stored. Photoshop's layers are similar, except that each layer contains one separate element; bitmap, text, or vector object, there's a separate layer for every item. However, it is the newer members of the Creative Suite that have the most differences, so those will be looked at first.

Fireworks

Although Fireworks handles many parts of its graphics as vector-style objects it is a bitmap editing tool at heart, and you might expect its Layers pane to work like Photoshop's. However, the Layers pane shares aspects of both Photoshop and Illustrator and InDesign, mixing together a bitmap and a vector object approach to dealing with layers, much like the rest of its featureset.

Layers in Fireworks are presented as folders in the pane, with each different graphic element – brushstroke, text, box, and so on – as an individual layer 'object' within its enclosing layer folder. Each new document starts off with two layers: the initial 'Layer 1' for the graphic objects that you draw, and a Web Layer. This layer is used for hotspot and slice objects rather than graphics. Anything drawn with the Hotspot or the Slice tool will be created in this layer as individual objects.

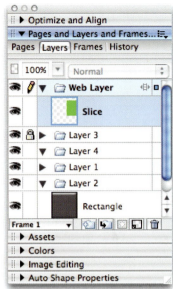

The result is an approach to layers that works both like Photoshop and like Illustrator and InDesign. In Photoshop terms, the Fireworks layers are equivalent to Photoshop layer groups, and the individual objects are like Photoshop's layers. Fireworks can read layered Photoshop files and translate layers to objects and layer groups to Fireworks layers very effectively. It can also save documents in layered Photoshop form and offers Photoshop export options to control how text objects and different effects are to be handled. The biggest problem you're likely to have is remembering to switch the terminology as you go between Fireworks and Photoshop.

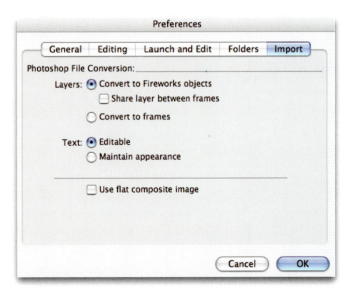

Fireworks CS3 adds a further ingredient to the mix. Pages provide yet another way to organize sets of content, but these shouldn't be treated the same as layers. Whereas layers let you break up the different elements of your graphic and hide, show, and shuffle them around to alter the appearance of the overall image as you work, pages are completely separate views within the document. Like pages within an InDesign document, these allow completely different graphic layouts to be made and stored within a single Fireworks document. Each page has its own set of layers, so a single Fireworks document could store a complete set of graphic designs for a job. This can help keep everything in one place, but keep in mind that there is no way to view more than one page from a single document at once.

Both individual object 'layers' and whole layers themselves can have different opacity settings and overlay modes assigned. This kind of visual control is now a standard approach across the Creative Suite, wherever it is practical, and offers designers a lot of creative freedom.

Flash

Flash doesn't use a separate panel for layers. Instead, these are tied up with its timeline view, which is a central part of how Flash works. There aren't many functional similarities with the way layers are handled in the rest of the Creative Suite, but it isn't entirely alien. Layers can be shown or hidden as well as locked or unlocked directly from the layer title section of the timeline, and clicking the 'Outline Color' chip there toggles the layer's display mode to outline and back. Double-clicking the page icon in a layer title or choosing *Modify > Timeline > Layer Properties* opens the Layer Properties window, where the full range of options can be set.

Using layers when handling Flash graphics can be fairly important. With regular editable graphic elements, objects will merge and slice each other when they touch, a little like moving bitmap selections or adding paint strokes in a single Photoshop layer. Converting a Flash graphic object to a

symbol makes it behave more like a vector object in Illustrator, but it changes the object's behavior in other ways as well. Using different layers helps to keep items safely separate as you work.

Graphics imported or pasted in from Illustrator can be made as Flash bitmaps or produced using the AI File Importer preferences. These import settings, found in the Flash preferences window, define how graphics are to be treated when copied and pasted from Illustrator. The controls cover how text, paths, and placed images are to be dealt with, and whether to make layers into bitmaps or movie clips. When pasting from Illustrator there's a last-minute option to maintain layers or not; maintaining them will create all the new Flash layers that are necessary, otherwise just one new one will be made.

Photoshop import presents a preview of all the layers in the image file, and can import just the ones you want. Layers can be converted to individual Flash layers or keyframes during import. Image layers

can be handled as flattened bitmap images, which turns soft transparent areas into 1-bit cutouts, or as bitmap images with editable layer styles. This option preserves Photoshop's 8-bit layer transparency.

Flash layers are good for more than just keeping elements separate. Selecting a layer in the timeline will select each object that it contains, and tweened animation is done within individual layers. Planning how content is to be handled with regards to layers is more important than you may realize when you first start exploring Flash CS3 Professional.

Dreamweaver

Dreamweaver's concept of layers is the most obviously different one out of all the programs in the Creative Suite. The closest thing to layers that Dreamweaver has to offer are 'divs', HTML code structures that define 'page divisions'. These are self-contained parts of a web page structure that can be shuffled about independently of other parts of the page.

Divs offer a lot of power for web designers. They allow layer-like stacking and reordering of structures, and the visibility and position of individual divs can

be set and even changed on the fly in the web page. On top of this, they offer a good hook for Cascading Style Sheet (CSS) object position and style control. A div can be controlled entirely by a CSS rule that defines its position, scale, padding and margins, default content styles, background image and color, and so on.

What is lacking in Dreamweaver is any form of Layers panel, so there's no way to get a simple overview of all the divs in a page. These can be selected directly, both in the design view by clicking a div edge and in the code view by selecting the div structure in the code. But this isn't really a layer control as handled in the other programs in the suite, it is more a form of individual object and group selection and editing.

Illustrator

Layers in Illustrator and InDesign work in the classic desktop publishing and graphics manner, acting as different design layers where the various design elements can be placed. This is a tremendous help when dealing with complex multi-part graphic constructions in Illustrator; different parts of a layout can be put on different layers and hidden or shown as required. InDesign layouts can benefit just as much from using layers, especially if the production involves different options such as language variations. Different language content can be put on different layers, and the appropriate ones hidden or shown when the artwork is generated.

Illustrator CS3's Layers panel shows layers with disclosure triangles; open up a layer to see the objects it contains, each in its own line and with a small preview icon. Text objects are named using the text they contain. (The first 99 characters in fact, but that's more than enough.) Graphic objects on the other hand are all named <Path> or, for imported graphics, <Linked File>. Give these more useful names by double-clicking the object's line in the Layers panel or picking Options from the panel's popup menu.

Object groups are shown as layer-like containers; open them in the Layers panel to see their contents. Clicking the small target circle to the right of any item's name, whether layer, group or object, and it will be selected on the page. A small square appears to the right of this when an item is selected in that layer – larger if everything on the layer is selected – and dragging this to another layer is the simplest way to move some artwork between layers. Of course, dragging the whole layer in the list will change the stacking order of the layers, giving another way to effect 'bring forward' and 'send backward' operations.

Illustrator's layers themselves have a few more options available. Double-click one or select it and choose Options from the panel's popup menu. As well as renaming it there are other options available. The Color defines the outline color that shows when items are selected. Having a different color for each layer helps show what layers they're on as you work. Illustrator picks a new color for each layer as it is made, but you can choose your own if there's not enough visual contrast between the selection box lines and your graphic elements.

The Template checkbox simple sets some of the other options; the Lock and Dim Images options are turned on as is Show and Preview, and Print is turned off. (Dim Images applies to placed graphics rather than native Illustrator objects. This helps when using images as tracing templates.) The Show and Lock options can be set directly for each object and layer in the Layers panel itself.

The Print option in the Layer Options window can be used to set a complete layer as a non-printing entity, good for notes or experiments that need to be kept but not printed. Of course, this can be overridden in the Print dialog's General section. This means reference prints with all elements can be made, but make sure this isn't left to All Layers for regular output. For quick reference, non-printing layers are shown in italics in the

Layers panel. When saving PDFs from an Illustrator layout there's no option for last-minute control over hidden and non-printing layers, but Acrobat PDF layers can be made from non-nested (top-level) Illustrator layers as long as the PDF output compatibility is set to Acrobat 6 (PDF 1.5) or higher.

The Paste Remember Layers option in the Layers panel's popup menu helps keep items in the right layers when copying and pasting between documents, creating new layers if necessary. But in order to move items between layers by copy and paste this option should be turned off.

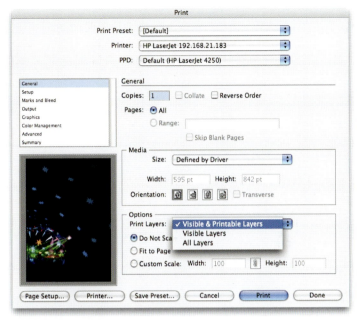

Layers can be created by redistributing all the items in one layer into individual sub-layers, either in sequence or as a 'build' with each successive layer containing more items. The new layers takes the place of the original objects. This is done specifically to simplify the production of animated content in Illustrator when the destination is Flash or Fireworks. When importing an Illustrator file to Flash, for example, individual layers in the Illustrator document can be converted to keyframes or Flash layers.

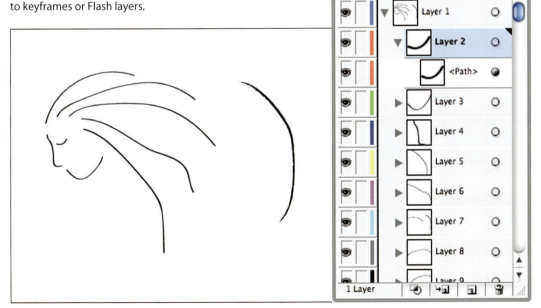

Transparency and blend settings aren't handled at the layer level as they are in Photoshop and Fireworks. Both of these are done at the object level using the Transparency panel instead.

A shape in a layer can be set as a clipping mask for that layer. With a frame of any shape selected, pick this option from the Layers panel's menu. The object's fill and stroke will be hidden and everything on the same layer that lies outside the object will be masked off. All the objects on the page remain editable, but nothing will show outside the mask region.

Another item in the Layers panel's menu allows unused layers to be deleted, a step that can help simplify documents that end up with many layers after prolonged design and production work. The Flatten Artwork command in the same menu does a similar thing but much more dramatically; it merges all layers into one. If any layers are hidden you'll get the chance to choose whether to discard their contents or include them in the new single layer, but use this with caution. It can simplify a heavily layered document, but the flexibility of having different elements on different layers will be gone.

InDesign

InDesign's layers handling is very similar to Illustrator's, although the Layers panel's display and its range of menu options are rather simpler. This is focused more specifically on layer control, leaving object selection and handling rather more up to the user. Layers are used to organize different parts of layouts, and they work across the whole document, not just one page. When planning how to use layers in an InDesign layout consider the whole production; split the different kinds of content across different layers in the most logical manner, with efficiency kept firmly in mind. If a document

contains many frames placed over other items, put them on their own layer so it is easy to get them out of the way and work on the objects underneath. If alternative language versions of a document are needed, put the main text frames onto one layer and then duplicate the whole layer. Name it appropriately to save confusion layer, and use that for the second language. Even if both are to be used at once, this would help keep the management of the different sets of frames and text flow under control.

Double-clicking a layer or picking the Layer Options item from the panel's popup menu shows the different controls that can be applied. The Show Layer and Lock Layer items can be set from the Layers panel anyway, by clicking the icon squares to the left of a layer's name in the list. The Show Guides and Lock Guides choices can also be controlled using keyboard shortcuts and the *View > Grids & Guides* menu, but there are two more that aren't found elsewhere.

The Print Layer option is fairly straightforward; use this to prevent a layer from printing. This is best for on-screen instructions and notes rather than dealing with content that prints in some configurations of a layout such as alternative language settings. Those circumstances are simpler to control simply by hiding and showing layers.

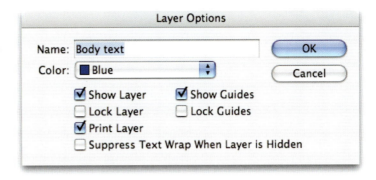

When printing, the options in the Print dialog's General settings default to printing only visible and printable layers, with non-printing objects left out as well. However, just as with Illustrator, the print/don't print settings of layers can be overridden if necessary, and non-printing layers are listed with italic titles in the Layers panel. If non-printing layers are used for content that's not meant for the final version of a layout make sure the Print Layers option here doesn't get left at All Layers or the output will include more than you bargained for. The same goes for PDF production as well; bear in mind that hidden and non-printing layers can be included or not during the output process.

Moving a selected object from one layer to another is simple; like Illustrator again, InDesign shows a small square in the current layer's line in the panel, and dragging this to a different layer transfers the selected items to the destination. Alt-dragging this item duplicates the selection to the destination.

InDesign's Layers panel has the same Paste Remembers Layers option as Illustrator, so pasting content from other documents will put the items onto existing layers that have the same name or, if there aren't any that match, create new named layers as necessary. Having this option turned on can be a little awkward if you want to paste items to different layers within the same layout, but it is invaluable when mixing and matching complex arrangements between different documents.

Photoshop

Photoshop CS3's layers are among its most important features. Whether the program is used for photo retouching, graphics assembly or full-scale montage work, using different layers to manage the work marks the difference between a casual user and someone who knows how to get what they want from the software.

Layers are so fundamental to Photoshop's workflow that there's an entire main menu devoted to layer options and control. This menu contains far more than is found in the panel's own menu, so sometimes it makes more sense to use that menu rather than the panel one. There are only a couple of items in the panel's menu that aren't elsewhere; the Palette Options item at the very bottom of the menu and the Animation Options, only available in Photoshop CS3 Extended, for hiding or showing an extra set of animation-specific controls. The one reason why this menu remains fairly useful is the reduced number of items and options, something which makes it a little simpler to use in a hurry.

Photoshop's layers are generally used to hold fragments of an overall composite image. This can be used to build up an illustration with brushstrokes going on different layers to provide maximum long-term flexibility, a photo-editing session with selections floated from the original to make trial edits easier to compare, a collaged image made from multiple images shuffled and warped to fit, a composite of smart objects, beziér pen paths and text layers, and just about anything else that can be imagined.

It may seem a minor point, but one of the first options to consider with Photoshop's Layers panel is the size of the layer preview icon. The Layers Palette Options window,

opened by choosing Palette Option in the Layers panel's menu, can switch the thumbnails from small to almost excessively large. Most users find the medium size to be a good compromise between showing lots of detail and fitting many layers in the panel's view at once.

Making layers is something that happens automatically in Photoshop whenever anything is pasted into an image. In fact, there's no way to avoid this happening, although it is simple enough to merge a layer down to the next one below afterward if necessary. Turn selections into layers with the Layer Via Copy and Layer Via Cut commands. Layer Via Copy is particularly useful for making experimental edits, as the image data is left intact in the original layer.

Any layer – other than the background layer, shown in italics in the Layers panel – can have transparent areas, showing the underlying layers and the transparent background checkerboard. This makes montage effects of all kinds easy to do. But rather than erasing areas in a layer, deleting the image data forever (or at least unless careful work with the history is done), it is usually better to add a layer mask and paint into that instead. Layer masks are

8-bit channels that mask the image where grey and black areas are painted. The lighter area in the mask, the more opaque the actual image is. Choose *Layer > Layer Mask > Reveal All* to add a mask filled with white, or *Hide All* for a mask filled with black. Paint into the mask – the block next to the image layer's thumbnail – to hide or show sections of the image.

Each layer has its own transparency and blending mode settings that determine how the visible pixels in one layer work with the ones underneath. These default to 100% opacity and the 'Normal' blending mode, both changeable at the top of the Layers panel. (Photoshop has one small trick up its sleeve that the other Creative Suite programs don't; you can click and drag on the opacity title to change the settings directly without typing numbers or opening and dragging a popup slider.)

Layer groups are a useful feature for organizing many different layers within the Layers panel. A layer group is simply a folder in the Layers panel that can contain one or more layers or groups. Yes, a group can hold other groups as well as layers, so nest groups within groups if that helps organize a large, complex layered Photoshop document.

Photoshops layer groups are more than just a simple layer organizing scheme. These all start their lives having 100% opacity and a 'Pass Through' blending mode, but these settings can be changed for groups just as if they were individual layers. Any changes to these settings affect all the items they contain. Opacity changes are cumulative; they are applied on top of any opacity settings the individual layers and sub-groups may have. Blending mode settings are a little different; if a layer group is set to anything other than Pass Through, it overrides any blending modes applied to the items it contains. Be aware of this, and leave group blending modes set to Pass Through unless you have a specific reason for doing this at group level.

Photoshop CS3 Extended includes Import Video to Layers, a feature that makes use of layers in a new way. Importing a video file turns the clip's video frames to Photoshop layers, with control over frame skipping and the range to grab. The video frames can be put straight into Photoshop's new Animation panel as animation frames as well, although this is simple to do from the Layers panel after some Photoshop work has been done.

File Compatibility

Photoshop's native image format stores layers, transparency, and mask data intact. InDesign, Illustrator, Fireworks, Flash, and even Dreamweaver can all import native layered Photoshop images and make sense of masked areas is whatever way is most appropriate. Flash has to convert the graphic into something it can deal with on its own terms, and Dreamweaver demands that it is optimized as a GIF (with 1-bit cutout transparency), JPEG (no transparency), or PNG (optional 8-bit transparency) in the process. Fireworks converts the Photoshop layers into its own equivalent, while Illustrator and InDesign place the image as it is, with any transparency, on the page.

Illustrator files are vector graphics, so transparency is something inherent in their structure – assuming the destination knows how to deal with it. Fireworks isn't so proficient at this, so export from Illustrator in Photoshop format instead, keeping layer data intact. InDesign is perfectly happy at importing native Illustrator files, as is Photoshop. In fact, InDesign's Object Layer Options feature allows layers and layer comps in native Photoshop files to be hidden and shown individually. Flash has an Illustrator import feature, but Dreamweaver needs the image to be exported in a different format before it can be used.

The other native Creative Suite formats aren't designed with import quite so firmly in mind. Fireworks files can be imported to Flash as editable items, but the other programs only see them as simple graphics. Dreamweaver can use them as image source files, but it converts them on the fly to web-optimized

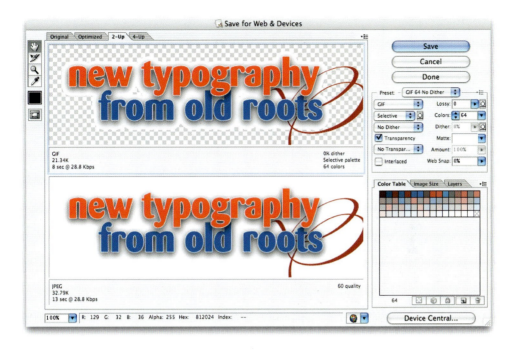

content. Flash content is meant for use in Dreamweaver, and it works exceptionally well there. InDesign can use Flash SWF files in multimedia-enabled PDFs to a limited extent, but Flash files can't be used by the other programs at all.

As for InDesign itself, its native layout files can be imported as original artwork into other InDesign documents. In addition, copying and pasting objects from an InDesign page into Photoshop produces vector smart objects complete with transparent areas, object styles, and effects. This can be useful on occasion, but always remember that InDesign is really meant as the final assembly tool rather than the graphics content originator.

Using layers and transparency in the Creative Suite is without a doubt one of the keys to working efficiently and creatively, whatever program you're in. Knowing which file types can be moved smoothly between the different programs without having to go through export routines is also useful. The different abilities of each program means that the layering abilities are a little different across the different programs, even those programs that are generally quite similar. Fortunately, a lot of what you learn in one program does translate across to the others, at least to an extent.

Managing Color

Amy Winehouse in concert at London's Astoria, February 2007

Managing Color

Color management is a subject that gets many people very nervous. It is something that we know we all should use as we work, but it tends to be regarded as something shrouded in mystery, too complex for mere mortals to fathom. In fact, it is not all that hard to put into practice, especially with the new abilities of Creative Suite 3. Yes, delving too deep into the intricacies of color management can land you in the realms of advanced color science theory, but this really isn't necessary for day-to-day print or web design and production work. It isn't even required when setting up a unified color management system for the Creative Suite.

The color settings controls in Photoshop, InDesign and Illustrator are all found in *Edit > Color Settings*. In Acrobat the color settings are found in the Color Management section of its preferences window, but there's no way to save custom selections. This makes it entirely unsuitable for customizing color (your efforts can't be saved for use outside of Acrobat), so it is generally best not to bother with those controls. Photoshop's Color Settings controls are the most comprehensive, so use these to get everything set up correctly.

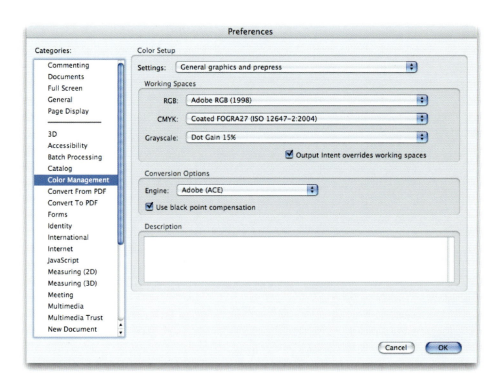

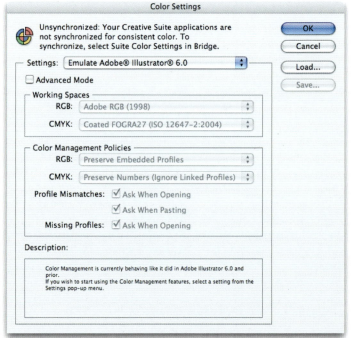

Picking the right options in the Color Settings window can be challenging, but it is really largely a matter of thinking through what your requirements are. The main thing to consider is what kind of work you will be doing, as this determines the appropriate overall settings to use.

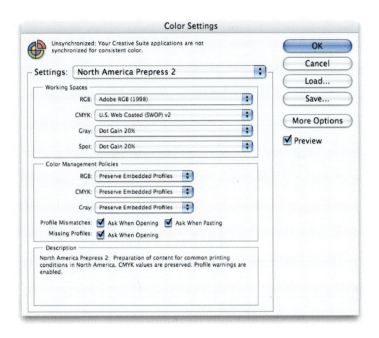

For print-based work, North American Prepress 2 is a reasonable preset to choose. The options in this preset are tuned for a standard form of high-volume print, although it is by no means right for all print work. The RGB working space is set to Adobe RGB (1998), the CMYK to US Web Coated (SWOP) v2, gray is set to the print-oriented 20% dot gain, and so on. For a web-oriented workflow (that's 'world-wide web' rather than web press), North American Web/Internet is better. The RGB working space is set to sRGB and the gray to the PC-oriented Gamma 2.2. (The gamma of print, or the way different printed lightness values work with typical dot gain effects, is closer to 1.8.) In a pinch, those two presets will do. If you're pushed, the North American General Purpose 2 preset could even serve for both press and web, although I really don't recommend using this for important print or general photographic work because of its sRGB setting.

The RGB working space defines how RGB color is handled when an image is shown using the defaults rather than whatever embedded profile it might have, or when an image is originated from scratch rather than being brought in from elsewhere. Adobe RGB (1998) is a good choice for high-quality printed output. It has a particularly wide gamut, or color range, and works well with general photographic retouching as well as standard print production work. The sRGB space is best used with content destined for online delivery. This has a smaller gamut than Adobe RGB (1998), so while it fits within the color-rendering capabilities of the average computer display it is not so great for professional image retouching for non-web use.

The CMYK working space defines how color is handled for CMYK print production. The US Web Coated (SWOP) v2 preset is tuned for standard American process color inks used in web-offset print on coated stock, with a maximum ink coverage of 300%. This is a fairly safe limit that won't cause specific problems, but for sheetfed rather than web (paper roll) output the US Sheetfed Coated v2 preset will allow a higher level of ink coverage, 350%, to deliver slightly denser deep, solid colors.

If you're feeling adventurous you can choose Custom from the CMYK Working Spaces menu and set up your own options from scratch. If you know what you're doing then feel free, but this is generally a step too far for almost everyone.

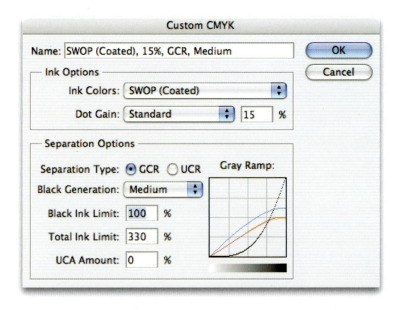

Be aware of the stock that your work will use. If you print on uncoated paper the total ink coverage must be lower than for coated paper to counter the greater absorbtion and spread; US Sheetfed Uncoated v2 has a limit of 260%, a full 90% less than for coated. If you're not sure, speak with the printer, paper buyer, or production specialist that will be handling your work.

Those in different parts of the world may prefer CMYK working space options that fit international standards better. The options in the CMYK working spaces menu include ones for process printing standards in Japan and some FOGRA ISO choices that are widely considered to be the best general international standards. Clicking the More Options button gives access to further options, but for the CMYK working spaces menu this is just legacy Euroscale and Photoshop 4 and 5 settings. Wherever possible, it is best to speak to the printer that will be handling your work to make sure you pick the best settings.

Dot gain for gray and spot colors takes into account the tendency for halftone dots to spread, especially at certain densities and on more absorbent stock. In the Color Management Policies section, it is best to have Preserve Embedded Profiles set for RGB, CMYK and gray, and all of the 'ask' boxes checked.

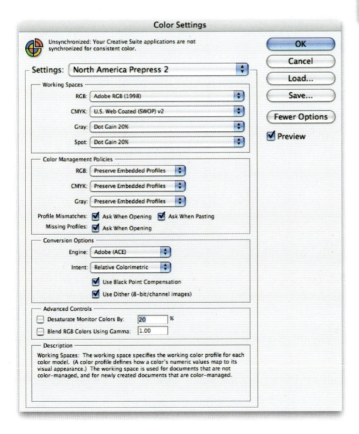

When the settings are ready, click Save to store the custom preset with an appropriate name. Add a description of the settings to help explain what it is for in the Description box.

At the top of the Color Settings window there's a note that says 'Unsynchronized', meaning the settings in the different key programs in the Creative Suite are not the same. Unsynchronized color settings will produce different results as you go from one program to another, so it is important to get the settings synchronized. To do this, turn to Bridge CS3.

For most of my print-based work I use a customized variation of the North American Prepress 2 settings. For photo editing and for commercial printing with sheetfed coated paper, the RGB working space is set to Adobe RGB (1998), CMYK to Coated FOGRA27 (ISO 12647-2:2004), and gray and spot both to 15% dot gain. In Color Management policies, all options are set to preserve embedded profiles, and all the 'ask' checkboxes are ticked so that I'm always consulted if anything doesn't match my requirements. For offset printing on uncoated stock the CMYK working space is changed to Uncoated FOGRA29 and the dot gain to 25%, although all these things are double checked with the printer where practical.

For web-specific work a different custom preset is used, one with RGB working space set to sRGB and gray to Gamma 2.2. The CMYK working space is set to the same Coated FOGRA27 option, but the sRGB and 2.2 gray gamma working spaces mean that this is better suited to general screen work than to print. All the other options are as the customized print presets.

Bridge

Bridge CS3 can operate as a central control point for color management settings, applying a single saved set of color settings values across the whole range of Creative Suite 3 programs – or at least those programs that use color management directly. This excludes the web-oriented Dreamweaver, Contribute, Flash and Fireworks; they've never needed to handle details such as CMYK conversions, dot gain and press conditions. However, this is still relevant for web design. Color management is crucial for print-oriented work, but it is important not to dismiss its value for screen-based work as well. Having the appropriate color settings assigned is still vitally important, otherwise the color settings that are used in Photoshop and Illustrator when creating and preparing web graphics won't necessarily reflect how things are likely to look when deployed online.

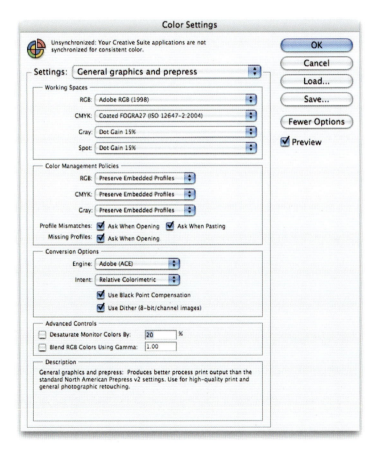

First, however, make sure that color management has been enabled in Bridge CS3 in the first place. Open the Preferences window, *Bridge > Preferences* in the Mac OS and *Edit > Preferences* in Windows, select Advanced, and make sure the Enable Color Management in Bridge option is checked. This won't

affect its ability to synchronize color settings across different Creative Suite 3 programs, but it will help maintain color consistency when dealing with files directly in Bridge in any way, for example when using Camera Raw.

In order to apply a single selection of color management settings across everything in Creative Suite 3 that can use it, choose *Edit > Creative Suite Color Settings* from the Bridge CS3 menus. Browse the list of color settings files that are shown. If you want to use one that isn't showing up in the list, click the checkbox marked Show Expanded List of Color Settings Files. The list will expand to show a great many more options.

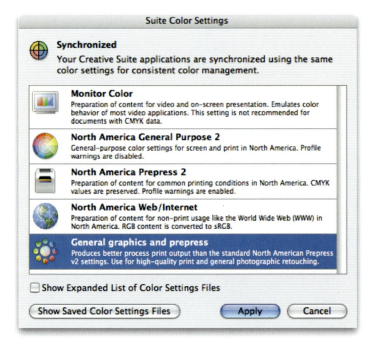

Select the most appropriate one (this may be a custom one that you created earlier) and click Apply.

Any saved custom color settings can be distributed to others in your team so that everyone is working to the same set of color standards. In the Bridge CS3 Creative Suite Color Settings window, click the button marked Show Saved Color Settings Files. This opens the folder that contains the saved document. Make this ava ilable to all those that need it. It can be emailed, placed on a server for simple access, or even added to a particular Version Cue project if this is a project-specific collection of color settings. Don't forget to synchronize the project after adding the color settings file so that it is available to the other team members.

Calibration and Profiling

If you care about color accuracy – and if you're reading this book you should – then you should do more than just adjust and synchronize the Creative Suite 3 color settings. In order to have a good idea of how your color work will look when it is printed, and just to be sure that your displays are operating as they should whether you design for web or print, it is important to both calibrate and profile your displays. This goes beyond the Creative Suite itself, but it is a vital part of professional, responsible color management. Once done, not only will your Creative Suite 3 programs all be working with the same color destination in mind, your display will be able to show you as accurately as it can how your work is going to look. You'll never be able to get around the fundamental differences between RGB (screen-based 'additive' color) and CMYK (commercial printed 'subtractive' color), but with a moderately priced display calibration device you'll come close.

Use a hardware calibration and profiling device to measure your screen's output, adjust it to its optimal settings, and then measure and document any weaknesses it may have in certain hue and brightness areas. The calibration part is the adjustment of the display to the best brightness and contrast levels for accurate viewing, and the profiling step is when the device measures the screen's output against a set of absolute values and records any differences in an International Color Consortium (ICC) profile document. Once saved, the display profile is used by a color management system, for example Apple's ColorSync, to adjust the way color is sent to that device in order to counter its slight weaknesses and end up with an accurate image on screen.

Adding a color settings file that someone else supplies is simple when you know where it is to go. Mac users should go to ~/Library/Application Support/Adobe/Color/Settings and copy the file into there. (The ~ indicates the user's home folder, although the file can go in the equivalent folder in the top-level Library folder if preferred.) Windows users should go to the root of their home directory and copy the file into/Application Data/Adobe/Color/Settings instead. Bridge makes it easy to find your way through to the right spot; in the Suite Color Settings window, click the Show Saved Color Settings Files button and you'll be taken straight there.

Using Color

Swatch Panels

Once the Creative Suite is set up for proper managed color output you'll be faced with handling color in the different programs and using color consistently within your work. Most of the programs in the Creative Suite 3 collection use Swatches panels with predefined sets of colors. In fact, only Dreamweaver and Contribute don't; they use popup color panels with web color swatch sets and an eye dropper color sampler tool instead. Fireworks and Flash actually offer both tricks; a popup sampler panel and a more regular Swatches panel as well. However, the real division is, logically enough, between the programs that are based in print and general-purpose graphics and the programs that are meant specifically for web production work.

Fireworks, Flash, Dreamweaver, and Contribute all default to the regular 'color cubes' set of swatches, the so-called web-safe palette. Although it is not generally a serious requirement these days, this palette does give web designers a color-picking standard to start from at the very least.

Illustrator and InDesign both have Swatch panels aimed at print graphics as well as screen graphics use. Illustrator's Swatches panel defaults to the Small Thumbnail View, a highly compact, no-name display of color chips. InDesign defaults to the list view-style Name mode familiar to DTP professionals, but it can approximate Illustrator's swatch thumbnails with its Small Swatch view. Both formats have their advantages; one shows more colors swatches at once, while the other makes it easier to browse for named colors.

Setting the fill and stroke color in Illustrator involves either the Control panel (which looks more like a toolbar above the document window) or the Tools panel. Like Photoshop's foreground/background color controls, this toggle sits

at the base of the Tools panel rather than in the head of the Swatches panel. If you switch to and from InDesign frequently this is a point to remember, as InDesign packs those controls into its Swatches panel.

Creating tints of colors is not the same as changing an item's fill opacity, even though the effect may look the same when on a white page background. InDesign make applying tints of a color easy, using its Tint slider in the Swatches palette itself. This doesn't store a color tint as a new swatch, but it is a very direct approach; just select an object with a fill or stroke color and use the Tint control to reduce the color strength. For repeatable use, set up the correct color tint using type or object styles. Changing the color that the tints are based on will of course change the tints as well. Double-click the swatch in the Swatches panel or select it and choose Swatch Options, then use the sliders to adjust the color.

When mixing colors in InDesign you don't have to stick to the standard CMYK or other color models. If there are spot colors already defined that you'd like to put together, choose New Mixed Ink Swatch from the Swatches panel's menu. Pick two or more inks from the ones presented and set their percentage strengths. These source colors can be spots or process – yes, you're mixing spot colors together – and the results can be set as process, spot (producing a new spot color for output) or Mixed Ink. When output, this option use tints in the related spot color channels to recreate the spot color mix on the page. In other words, the separated artwork will use the original spot colors to create everything.

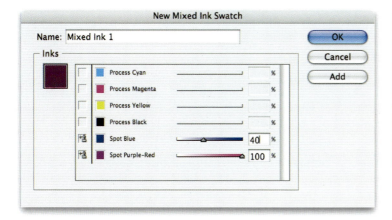

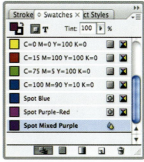

InDesign treats tints as new swatches. These can be made from regular process colors by selecting one and then choosing New Tint Swatch from the Swatches panel's menu. Making tints of spot colors is almost as simple: select it (or an object that uses it) and open the Color panel. Rather than the regular sliders for remixing the color, you'll see a single tint slider. Set the tint, then choose Create New Swatch from this panel's menu if you want to use it again later. (The only problem you'll have is when doing this to a Mixed Ink color, as shown here; those can be set as tints, but the tints can't be saved as swatches.) These are named with the original color's name plus the percentage tint value, and they are linked to the original color. By opening that parent color's Swatch Options window it can be changed with the color sliders, and the linked tints will follow suit.

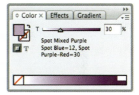

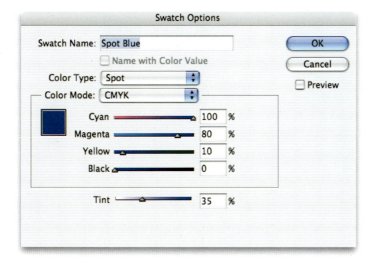

Tints in Illustrator are also fairly simple. The base color must be either a 'global' process color or a spot color; double-click a swatch to check. Then open the Color panel and use the tint slider that it provides. Choose Create New Swatch from this panel's menu to put the tint into the Swatches panel. Like InDesign's tints, any tint swatches will be linked to their parent colors, so changing the original will change the tints as well.

Illustrator's extensive swatch libraries help with the task of finding sets of colors. These are libraries of grouped sets of colors, sorted by theme and made available from the Swatches panel menu. They can be used directly from their own floating panels or added to the core list of swatches as new groups of colors.

Opacity

Opacity is a different matter. In both Illustrator and InDesign this is an object attribute setting rather than something directly related to swatches. In Illustrator this is set with the Opacity panel, while InDesign uses the Effects panel instead. This offers more sophistication in one place than Illustrator's Opacity panel provides; the blend setting and transparency of the overall object can be set, and so can the blend and transparency of the fill and the stroke. Both transparency and blend effects are compounded if overall object and also fill or stroke attribute effects are applied, so watch out for doubled-up transparency and similar pitfalls. Illustrator's Opacity panel offers transparency and blending mode controls, but it only controls whichever object attribute is currently 'in focus', the fill or the stroke, as defined by the Tools panel's settings. Click the fill or stroke icons or type X to switch.

Transparency in Illustrator graphics are preserved when imported into InDesign, Photoshop, and Flash. Fireworks doesn't preserve Illustrator transparency when it opens those files, so to take such items into that program it will be necessary to export the Illustrator graphic in Photoshop format first, or open the native Illustrator file in Photoshop and save it out again. Dreamweaver can't import Illustrator files at all, so the Photoshop intermediary trick is useful here too.

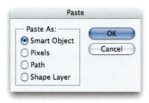

Even the simple copy and paste process can be useful across many programs in the Creative Suite. Illustrator graphics can be pasted into InDesign, and they appear as a grouped set of native InDesign objects. Pasting into Photoshop works just as well, and gives a choice of formats from pixels through to Smart Objects. Pasting into Fireworks isn't as successful, although it does produce a bitmap image of the copied objects, but Flash handles this surprisingly well, creating a set of objects from the pasted items. Copying and pasting from InDesign behaves almost the same as doing this from Illustrator, creating useful objects in Flash, Smart Objects (no options offered) in Photoshop, simple bitmaps in Fireworks, and arriving as native objects in Illustrator.

Photoshop's Swatches panel looks pretty similar to Illustrator's, and even InDesign's when it is in Small Swatch mode, but in practice it behaves more like the Swatches panels in Fireworks and Flash. This is used to sample and store colors to be used in Photoshop's painting and image editing tools. Unlike Illustrator and InDesign (and Dreamweaver and Contribute, for that matter), there's no on-going link between an object and a swatch color; once a color is painted, that's simply what color the image pixels are.

After mixing a color in the Color Picker window (click the color swatches in the Tools panel) or sampling color from an image, click in the unused part of the Swatches panel to add this to the list. To name the color, add it by choosing New Swatch from the panel's menu instead; hover over the swatch to see its name, or use the panel's menu to pick the list view mode instead. **alt** click an existing swatch to remove it. In Fireworks and Flash, **⌘** click **ctrl** click a swatch to delete it.

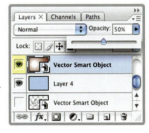

Tints in Photoshop, and Fireworks and Flash for that matter, are handled in the optical sense, painting or filling with a reduced opacity rather than mixing a different opaque shade. That approach is possible, but it involves messing with saturation and brightness values. Object-level opacity is done at the layer level (each distinct image element always lives in its own layer), using the Layer panel's opacity slider or layer masks.

Photoshop's Swatches panel menu provides quick access to a large list of ready-made color libraries, including the full Pantone ink-matching range. Picking any one of these libraries will either add sets of colors to the existing swatches or replace them entirely.

Sharing Swatches

Once a set of swatches has been built up in one program it doesn't make sense to have to start again when moving across to another program. What is needed are ways to have colors made in one tool be available in the others, and there is more than one way to achieve this in the Creative Suite.

With spot colors in Illustrator documents, the quickest way of getting them into InDesign is simply to place the Illustrator document into the InDesign page. Any spot colors it contains will appear in the InDesign Swatches panel. Process colors are just different mixes of the same CMYK inks, and those aren't imported as new swatches.

When a job is more complex and has to go through a number of different stages and people it is generally better to create a complete color library of special named swatch mixes. This can be saved in ASE (Adobe Swatch

Exchange) format and shared between InDesign, Illustrator, or Photoshop; the other programs don't (yet) read the same swatch library formats. In any of these three programs take a look at the Swatches panel contents. If the goal is to create a color library tailored to a particular client or project, consider clearing out the existing swatches first to keep things more manageable when importing the end results.

Save a set of swatches in Illustrator by choosing Save Swatches as ASE from the panel's menu; the option to save swatches as AI creates a library that's only compatible with Illustrator itself. InDesign's Swatches panel menu simply shows Save Swatches and only includes the currently selected swatches, so it isn't necessary to remove other items first to produce a specific library. Photoshop has two swatch-saving options. Save Swatches creates the traditional Photoshop .aco file, while Save Swatches for Exchange creates the newer cross-program ASE format.

This swatch-sharing process isn't perfect yet. Illustrator has more swatch options available than the other programs can read so gradients, tints, and patterned swatches are ignored when read into other programs. InDesign has similar restrictions. Fireworks saves swatch sets in the ACT (Adobe Color Table) format, while Flash can save in ATC or its own Flash-only CLR (Flash Color Set) format as well. Neither Illustrator nor InDesign can read the ACT format, but

because Photoshop can be used as an intermediary. Unfortunately, there isn't yet a way to take colors the other direction other than by filling a document with samples then opening it and sampling the colors into new swatches. These issues aside, this is an excellent way to share sets of custom swatches between the different Creative Suite programs and between co-workers as well. You can even share swatch groups with people by going to kuler.adobe. com, a CS3 'community' site run by Adobe and dedicated to sharing color resources.

Spot Colors

Spot colors can be used in Photoshop files, but the image has to be handled in a particular way. Start by converting an image to grayscale. In a single-channel image, duotones (and tritones and quadtones) can use separate inks for individual output color channels. The different strengths of each color in the different brightness levels of the image are controlled by the channel curve settings. Save the file as a native Photoshop file or an EPS and the results will import to Illustrator or InDesign with the specified ink arriving in the Swatches list automatically.

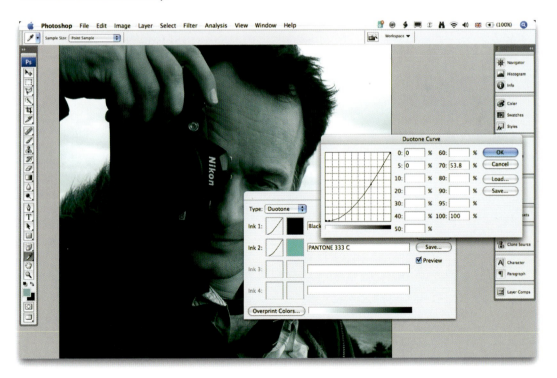

Another way to use spot colors in Photoshop is as spot color channels added to CMYK images, by choosing New Spot Channel from the Channel panel's menu. These can be set to any ink and behave just like regular color channels. Changing a CMYK image into a multichannel one allows the individual

channels to be changed, for example, to turn the magenta plate to Pantone 032. By adjusting the levels of the different channels the image can be readjusted to look similar to the original, but it will now work where a special red, perhaps matching a corporate logo, is used in place of magenta in an otherwise regular four-color print job. This is almost never used in magazine publishing, but it is an idea that packaging designers will be familiar with. If the document is saved in Photoshop DCS 2.0 format (not DCS 1.0) the spot channels will be preserved, imported to Illustrator or InDesign, and output as separate artwork channels.

Type

Graffitti artwork in action in London's South Bank

Fonts are a vital part of most designers' lives. Everyone will have their favorites, the workhorse fonts they turn to for job after job, as well as the quirky, idiosyncratic faces that sit there untouched until the perfect project comes along.

Handling fonts and setting type in Creative Suite 3 is just the same as handling fonts in any other program – at the basic level. But some of the CS3 programs have rather more capabilities than most, and some work in unusual ways. It is possible to produce the most elegant or powerful or functional typography in any of the Creative Suite 3 programs, but this also involves making the use of type effective. That requires a good understanding of a number of things including the target audience, the medium and format that's being used – magazine, book, poster, signage, corporate logo, website, multimedia kiosk, video, and so on – and of the creative needs of the particular design plan as well.

In every program in the Creative Suite the type tool works in effectively the same manner: click and type, or click-drag to define a specific rectangle and

then type. (The only exception is Dreamweaver and Contribute, which work in fundamentally different ways – but more of that later.)

When browsing the font menus in Illustrator's Character panel, Photoshop's Character and Options panels, and InDesign's Character and Control panel, you'll get previews to help you pick the right face. Illustrator shows the font names themselves in their own faces, which can pose some legibility issues with quirkier fonts, but its Control panel that normally sits above the document window includes a font menu that shows the list in the standard menu typeface. The menus in Photoshop and InDesign all show the font names in regular type and the word 'Sample' next to each one. Although Fireworks and Flash are generally a little less typographically sophisticated, they both go one step further than the generic 'Sample' text, previewing the first 15 characters of the current selected text in a panel beside the typeface menu when it is being browsed.

Flat-out...

Words and t[

Paragraph Composer

Not surprisingly, InDesign's typesetting abilities outshine those in the other programs in the Creative Suite. When handling paragraphs of text, InDesign normally uses a feature called the Paragraph Composer, sometimes referred to as the 'multiline composer'. This takes into account all of the words and lines in a paragraph when determining the overall word and letter spacing and line breaks in order to produce text that feels well balanced throughout all of the lines. This level of control is quite sophisticated, but you'll probably find that it can affect copy editing, particularly when trying to cut text to fit. Deleting or adding a word in a line won't necessarily make everything wrap around as you might at first expect. Instead, the rest of the type may be quietly adjusted

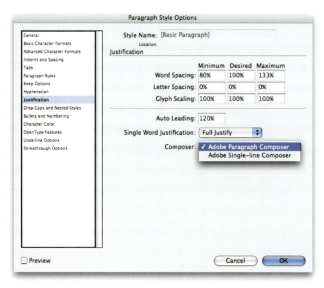

to accommodate the change with as little impact as possible. Although this can take a little getting used to for those more familiar with the single-line composing methods of other layout programs, the end results are almost invariably better. However, if this is not what's wanted then just change it to Single-Line Composer for any selected paragraph. This can be done with the Paragraph panel's menu or with the menu option at the far right end of the Control panel, and it can also be built into paragraph styles as part of the Justification options.

Photoshop has the equivalent of InDesign's Paragraph Composer, although it is called Every-Line Composer instead. The odds are that you won't be setting paragraphs of text in Photoshop very often, but it is good that it has basic typographic feature parity with the other design tools.

Kerning and Tracking

Kerning and tracking controls are found in the Character panel in Illustrator, InDesign, and Photoshop. Type will automatically have its built-in kerning, the adjusted spacing between specific letter pairs, applied invisibly, but this doesn't affect applying kerning values manually. Photoshop applies a tracking value of -50 to text by default, producing slightly more tightly set text than you will get without additional tweaking in Illustrator or InDesign – or in Fireworks or Flash, for that matter.

Copying and pasting text between these programs doesn't always work quite as you might expect. Pasting a text object from Illustrator into InDesign creates embedded vector graphics, while going the other way turns text into single-line runs and converts some items to outlines if special OpenType settings were involved. Pasting from either into Photoshop works well. Coming from Illustrator, you're given the usual options of creating a smart object, pixels, paths, or a Shape Layer from the data. Pasting from InDesign creates a smart object automatically, which is the most flexible choice.

In both Fireworks and Flash, kerning and tracking are done in the Properties panel using the same controls. Click between a pair of letters and drag the vertical slider to set the kerning, or select a range of text to change the tracking. Note that the kerning/tracking values in Fireworks and Flash have a more dramatic effect than in the other Creative Suite programs, so don't try to use the same values to create the same effect. In Fireworks, tracking is misleadingly referred to as 'range kerning', and the whole process is called

'letter spacing' in Flash. (In Flash, individual pair 'spacing' isn't preserved when the spacing of a whole selection is changed, so plan your adjustments accordingly.) Both programs include an Auto Kern checkbox, which is on by default, that uses the font's embedded kerning table data. This adjusts the standard built-in typeface kerning of character pairs to produce optically better results, particularly at small sizes, and its results are applied separately from those produced by manual adjustments.

Pasting text objects from Fireworks to Flash works very well. There's no need to use Fireworks' Copy as Vectors command, just the regular copy process. Pasting into Flash calls up the Import Fireworks Document window with the option to keep all text editable or to import as bitmaps to preserve the precise appearance. Kerning is preserved, thanks to the similarities in type handling and the improved copy and paste integration between the two programs. It doesn't work well going the other way, so avoid having to copy from Flash to Fireworks, or from Flash to any other program for that matter, if you can.

OpenType

OpenType is a font technology that takes computer type setting far beyond what has been possible before, even with Multiple Master fonts. With OpenType fonts, the control and finesse that can be applied to typesetting tasks rivals the very best that hand-set typography could manage. This won't prevent type from being set inappropriately, of course, but the abilities are available for those that want them.

OpenType fonts can contain far more than the maximum 256 different 'character slots' of traditional formats, up to 64,000 in fact, although few fonts go quite that far. The numerous glyphs – the actual elements that represent the different characters in a typeface – can be used with a degree of automatic intelligence, for example substituting different versions of a character when it appears in certain positions in a word or a line. With ligatures enabled, typing certain letter pairs in the right fonts will produce the combined design instead. InDesign's main Ligatures setting in the Character panel's menu handles the regular fl, fi and similar combinations, while the

more unusual ones such as st and ct fall under the OpenType menu's Discretionary Ligatures' control. Illustrator and Photoshop handle both sorts as specific OpenType options. On top of this sort of automated use of different glyphs, there are often many extras in an OpenType font are not automatically invoked, for example decorative initials and dingbat objects. These can be used by browsing through InDesign's Glyphs panel and double-clicking the chosen item to insert it into the current text.

There is a divide between the programs that can make use of OpenType's extra abilities and those that can't. InDesign, Illustrator and, to an extent, Photoshop can all use OpenType's discretional ligatures, automatic fractions, contextual alternates and a number of other features. Fireworks, Flash, and Dreamweaver have a full range of normal typographic abilities, but for graphic text elements built with special OpenType features you should use one of the three programs that offer proper control when you create the graphics.

The three OpenType-savvy programs provide different levels of control. Photoshop's options are the simplest; the OpenType option in the Character panel's menu contains the most important features, so headlines can be set with as much typographic control as would be expected in an image-editing environment. InDesign and Illustrator pack rather more in. InDesign actually provides the most OpenType options by a long chalk, but it can be a little fiddly using the OpenType submenu in the panel's menu all the time. The best way to use OpenType controls efficiently within InDesign is to experiment with the options in the OpenType menu to find the right settings and then set up style sheets ready to apply to all your text as required. (Curiously, the items in the menu that aren't applicable to the current font are shown in square brackets rather than being dimmed as they are in Photoshop and Illustrator.) The Character Style section of the styles window contains all the options that can be found in the panel's OpenType menu set. As InDesign will be used to set far more body text than headlines, and as using style sheets really is the key to productive InDesign work, this approach makes sense.

Illustrator is more of a graphics and headline-creating tool by comparison, and its OpenType controls reflect this. There's no OpenType option in the Character panel's menu. Instead, there's a complete OpenType panel, with quick-access buttons as well as the panel's regular menu for setting the various options. These aren't as comprehensive as InDesign's, but because they're presented in this manner they are significantly easier to use.

Not all fonts you'll have will be OpenType fonts by any means, but it is very easy to see which are regular TrueType, which are traditional PostScript, and which are OpenType, simply by looking in the Font menus of InDesign, Illustrator, or Photoshop. The icons to the left of the font names show the format; a double T for TrueType, red lowercase 'a' for Adobe PostScript Type 1, and an O for OpenType fonts. (Don't be too quick to judge a font by its format. TrueType has had bad press in the past, but that's really down to the poor technical quality of cheap knock-off fonts, which could cause memory problems in imagesetters. Professionally produced TrueType fonts are fine, and in fact OpenType is based on features of both TrueType and PostScript Type 1 formats.)

Not all OpenType fonts have extended character sets, of course, so you'll have to see what you have available on your own system.

Font Utilities

One way or another, designers will end up with more fonts than they'll want to see all the time in their font menus. With particularly large libraries such as the Adobe Font Folio collection, having everything installed at once will make font menus unmanageably long and even lead to computer speed and stability problems. Taming large collections means using a font manager tool to enable or disable groups of fonts at will. At the simplest level something like Mac OS X's bundled Font Book utility will help keep things under control, but third-party commercial tools such as Suitcase Fusion and FontAgent Pro can make the process much more streamlined. Predefined font sets (nothing to do with font sets in Dreamweaver) can be created for different clients or projects and enabled or disabled all at once. With the right plugins, fonts that are under the management tool's control can even be turned on automatically when an Illustrator or InDesign document that needs them is opened.

Professional font management tools can generally take charge of typefaces that are installed in the operating system in the traditional manner, but they are really best at handling font collections stored in separate folders instead. These tools also allow management of font libraries across networks, so a font library can be hosted on a single computer and used by a team of people, assuming the font library license allows this.

Finally, font management software can produce font sample printouts and attempt to repair damaged typefaces, a problem that can otherwise cause havoc with design jobs.

Dreamweaver and Web-Font Issues

Dreamweaver and its smaller sibling Contribute are the odd ones out here. This isn't because these have no typographic abilities; far from it. The issue is that the font features required for web design and production are somewhat different, certainly in detail, from those needed in print and general graphics tools.

Type shown in websites can be produced as part of a bitmap graphic, set as part of plugin content such as Flash media, or as plain HTML text teamed with formatting instructions provided for the web browser to interpret.

Graphic type is made outside of Dreamweaver or Contribute. It is normally made in Photoshop, Fireworks or Illustrator, and generated as a web graphic – usually in GIF format – at some point in the production process. This means that all the typographic controls of the graphic software can be brought to bear on the design – but the end result is always a simple bitmap image. When it is in the web page it can't be selected as text, it is invisible to search engines, and it is no help to those with accessibility requirements.

Standard Flash media can include custom text as well as animations, video, and interactivity, but it is made using Flash or exported from Illustrator. Flash Text on the other hand is a feature Dreamweaver provides to make it easy to create simple headlines and custom typographic links in any typeface without leaving the web page layout environment. Choosing *Insert > Media > Flash Text* opens the controls for generating the Flash Text content. The controls are basic, but any

font currently installed in your computer can be used. Pick a color and rollover color, and add a link if that's its job in your page. Flash Text doesn't have a transparent background, so if this is to match your page or container color you'll need to pick that as well. Use the eye dropper color sampler tool from the popup colors list to sample the appropriate color from the page layout.

Unlike bitmap graphics, Flash Text media can be scaled to fit the space on the page. It won't look quite as clean in Dreamweaver as if you'd picked the right size in the Flash Text window in the first place, but it looks fine in web browsers.

HTML type is plain text in the HTML document that is formatted by the web browser following HTML or CSS instructions. Unlike graphic images of type, this is extremely flexible and transfers very quickly. The downside is the relative lack of typographic control, although this is something that web designers have to learn to accommodate.

Old and New Techniques

There are two main ways to format HTML type in Dreamweaver: the old-fashioned way and the modern way. The old-fashioned way simply applies basic formatting instructions to the type itself using font tags. The code this creates is straightforward, but it is not particularly efficient or flexible. In addition, it is described as 'deprecated' in the web design world; declared outdated and more-or-less phased out. In contrast, the modern method uses CSS (Cascading Style Sheets) to apply control over both type and objects, and it is this method rather than font tags that will be produced automatically by Dreamweaver when type is styled.

CSS formatting of type provides the web designer with almost the same range of controls that are available for basic print typesetting, although some of the terms are different and everything works at a cruder, pixel-based level. Letter spacing provides an approximation of InDesign's tracking controls, and this can be found in the Block section of the CSS Rule Definition window along with word spacing, horizontal and vertical alignment, and other controls. But unlike the way basic formatting is normally set up in InDesign or Illustrator, it is generally used one step removed from the text itself. The style sheets are set up to affect certain named parts of the web page structure, and whatever falls inside those items takes on the formatting.

Font Size

Font size in web design is a topic that can cause a lot of confusion and even argument in web page production. There are many different ways to specify the size of type, from the absolute size of pixel-based scaling to the slightly more variable points and ems, right through to the powerful but entirely relative and flexible method of scaling using percent values. Fonts defined in point sizes in Dreamweaver will be relatively larger (by a factor of a third) compared with fonts set in InDesign, Illustrator, Photoshop, Fireworks, and

even Flash. Sizing can be set to be relative to the size set for the containing element, so it is possible to set up fairly sophisticated scaling relationships that all hang off one initial starting point. Doing this properly is very different from scaling fonts in print and bitmap documents. Although there are times when setting type in pixels to get near-absolute control over size is a good design choice, experienced web designers will know how and when to use the different methods of type size control.

Font Sets

With formatted HTML text you can request for type to be shown using a particular typeface, but you can't be sure that's what will be seen by everyone. If a particular visitor's computer doesn't have that font it will have to be shown in a different typeface instead, and without further typographic instructions that will be the rather screen-unfriendly Times New Roman.

This problem is tackled by using font sets instead of single font names. Font sets are strings of typeface names that are applied instead of just one font choice. For example, setting some HTML text in Dreamweaver's Georgia font set will ensure that if Georgia isn't available then Times New Roman will be the second choice, followed by Times, and then the last-ditch request for any serif font. Dreamweaver provides just six font sets, not counting the simple 'default font' option. While they are practical they're not terribly exciting, and they certainly don't offer much variety.

The point about font sets is that they list typefaces that are widely available on both Macintosh and Windows computers and, to an extent, Unix and Linux systems as well. The different items in a font set are chosen because they look similar both in general character appearance and in the space they use for a run of text. Fortunately, with the widespread use of Microsoft Office and similar tools and the font collections that these include, it will have to be shown in a different typeface instead, and without further typographic instructions that will be the rather screen-unfriendly Times New Roman.

Choose *Text > Font > Edit Font* List to create a new font list. Scroll through the list of fonts and move chosen ones across. For fonts that aren't on your computer but need to be listed for other operating systems, type them in (accurately) and move them into the list. For example, make a new serif font set that consists of Book Antiqua, Bookman Old Style, URW Bookman L, and then the ones in the regular Georgia set. Alternatively, try the same but with Palatino Linotype, Palatino, URW Palladio L used instead of Book Antiqua and the Bookman faces.

For sans-serif font sets, start a new one with Lucida Grande, Lucida Sans, then complete it with the Verdana set. For something a little more individual, make another like this one but use Century Gothic, URW Gothic L instead

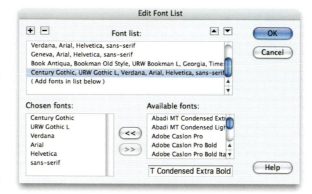

of the Lucida fonts. If you want something more adventurous for display setting, try a custom font set made of Copperplate, Copperplate Gothic Bold, Gill Sans, Gadget, Arial Black, Sans-Serif. Set this with the font weight set to bold. This won't work for every visitor, but with those that have the necessary fonts it looks stunning. Just as importantly, when Copperplate, Gill Sans, and Gadget aren't available Arial Black does the job well enough.

With careful selection it is possible to get a little more variety and even begin to match on-screen body type with what's used in print designs a little more, all without compromising accessibility or function. But you always have to accept and design for the possibility that your text may not appear to others quite the way you see it yourself.

Using CSS

An individual CSS style, or rule, can contain all these settings and much more, including instructions that control practically every parameter of every object in the page. These rules can be stored in a separate style sheet document or inserted as a <style> block in the page code itself. There's no single right way of doing this; external style sheets make mass changes easy, while page-level styles allow more specific page-by-page control over elements and can 'trump' external styles that target the same items.

When it comes to applying CSS styles there are many ways to do this, from directly to selections of text through to creating rules that automatically affect certain structural tags already in the HTML, target specific named containers, and so on. CSS rules allow far more and far finer typographic control of HTML text than the older font tag method, although there's absolutely no getting around the issue of having to use fonts that are likely to be on the end user's computer already.

Smart Objects

Looking up in the Media block atrium at the London College of Communication

Introduction

Adobe's Smart Objects feature is something that could significantly change the way you use Photoshop. It isn't a new feature as such, but it has been enhanced tremendously in Photoshop CS3, making it more flexible and more powerful than before.

Smart Objects are self-contained graphics that live within the regular Photoshop document as individual layers. These can be ordinary Photoshop layers that have been converted to Smart Objects or they can be content from Illustrator or InDesign that has been pasted in as Smart Objects. When a Smart Object contains vector graphics the objects remain resolution independent and scalable. Even Smart Objects created from native Photoshop text can be given effects yet remain editable. This provides the savvy user with a true resolution independent, non-destructive creative workflow, right there in Photoshop CS3.

129

Illustrator into Photoshop

Bringing Illustrator artwork into Photoshop as a Smart Object is simple; choose *File > Place* or just copy and paste from Illustrator directly. Placing creates a Smart Object automatically, but when copying and pasting artwork from Illustrator into Photoshop you're given the choice of pasting the data as a Smart Object, as pixels, as paths, or as Shape Layers. There are times when one of the other options may be better, but for retaining Illustrator's editing abilities the Smart Objects choice can't be beaten. (Choosing Shape Layers or Paths converts the parts of the illustration to native Photoshop vector elements. This preserves scalability but loses any special Illustrator features, not least the ability to edit again in Illustrator, in the process.) The item appears as a new layer in the Layers panel, with a small Smart Objects badge in one corner of the thumbnail image.

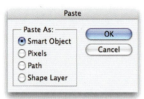

These Vector Smart Object layers in Photoshop are extremely flexible. Because they contain all of the original Illustrator vector graphics, they render to the resolution of your document. This image can also be rescaled up and down without any loss of quality. With the layer selected, choose *Edit > Free Transform* and drag the item's handles. You can scale the layer to any size you like, or resize the whole document for that matter, and the Smart Objects will render cleanly and crisply every time.

There are some limits to what you can do with Smart Object layers in Photoshop, all revolving around the fact that they're not pixel-based graphics. For example, brushes, erasers, and similar tools can't be used without rendering the layer as regular pixels first. If you really want to use these features it can be worth duplicating the Smart Object layer first in case you need to return to the editable shapes version later. Choose *Layer > Duplicate Layer* or *Layer > Smart Objects > New Smart Object* via Copy to do this, then

hide one of the layers and convert the other to pixels with *Layer > Smart Objects > Rasterize*. But Smart Object layers can be treated with blend effects and opacity settings in the Layers panel, given layer styles, layer masks and vector masks, and adjustment layers from the Layer menu. One point to note, however, is that layer masks aren't linked to the layer's movement. If you set a layer mask and then move the layer itself about in the image, the mask will stay put. You'll have to move the layer mask independently to get it into the same relative position.

Smart Filters

Using the new Smart Filters feature, Smart Objects can now also have filters applied, a Creative Suite 3 trick that takes these things to an entirely new level. In fact, for many people the Smart Filters feature is the most important new development for Smart Objects. But don't get confused; despite the name these things aren't different filters, they are the normal range of Photoshop filters applied to regular Smart Objects. By working in this way, filters can be applied, adjusted, and removed without any problem. This is a very different matter to applying filters to regular bitmap layers; those manipulate the pixel data itself, causing permanent changes to the image. Sure, with the History and History Brush you can do a lot to alleviate this, but it is liberating to be able to paste an Illustrator object into a Photoshop image, then apply filters and rearrange them at will at any point.

When a filter is applied to a Smart Object, look in the Layers panel to see how things are organized. A new Smart Filters sub-layer is added to the Smart Object layer, and the filter is nested as another sub-layer within that. The filter layer itself can be shown or hidden, as can the Smart Filter layer. Where this starts to get particularly exciting is when more filters are applied to the Smart Object layer. These are all added as new filter layer items within the Smart Filter layer, each with its own visibility control, and stacked on top of the previous filter. What you should try now is reordering the filters in the stack. Grab one and drag it above or below one of the other filters in the collection. The filters are calculated sequentially, so having a blur filter before or after a pointillize filter will make a big different to the final result. And once you've done this, try dragging a filter from one Smart Object to another in the Layers panel. This is just as easy and effective. About the only trick missing here is alt-dragging to duplicate the filter rather than move it.

Extracting the Original Graphics

As Photoshop doesn't create links to source files, the Smart Object layer contains all your Illustrator drawing data. You can't edit the paths right there in Photoshop, but you can still make all the changes you want. When you choose *Layers > Smart Objects > Edit Contents* or simply double-click the Vector Smart Object layer in Photoshop, a temporary file containing the Illustrator graphic will be made and opened in Illustrator. When you've made your changes a simple save – not 'Save As' – will automatically update the Photoshop document's Vector Smart Object layer. Although you didn't import from a source document in the first place, Photoshop sets this up for you temporarily. This file will be removed automatically after you've saved and closed it, so you never have extra document management issues to deal with.

It is worth considering the implications of this process quite carefully, as it could prove very useful to you at some point. While you're editing the Vector Smart Object in Illustrator you're dealing with a regular Illustrator document, just one that exists only while you make your changes. At this point, choosing Save As from Illustrator's File menu will save a brand new non-temporary copy of the artwork with no link to your Photoshop file and no update made to its layers. Normally this isn't what you'd want to do, but it means you can generate a complete new Illustrator file directly from the Vector Smart Object layer in the Photoshop document – very useful if you've lost the original.

Further Tricks

There are other powerful Smart Object features to know about. The Export Contents command, found in *Layer > Smart Objects*, generates a Portable Document Format (PDF) containing the data from the selected Smart Object layer. This can be opened by Acrobat or any other PDF reader, and Illustrator can also open it as a regular editable file with all of its original attributes intact. Consider this as another way to extract a complete version of a Smart Object layer from a Photoshop document.

Replace Contents, found in the same *Layers > Smart Objects* set of commands, is a fairly heavy-handed way to change a Smart Object layer in a Photoshop document. Of course, if the layer has some carefully tuned transparency, blending, and Layer Style settings, it is more efficient to do this than to import a fresh layer and start all that from scratch. Choose this command; select a new Illustrator document to use instead of the current one, and you're done.

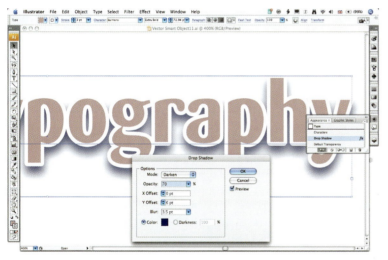

InDesign into Photoshop

You aren't restricted to doing this to content that originates in Illustrator either. As I mentioned a moment ago, Smart Objects can be made from content pasted in from InDesign as well, although you'll find that black from the standard InDesign swatch is a single-color, single-ink black, and it turns into either a single-color black when pasted into a CMYK Photoshop document or a slightly weak version of RGB black when pasted into an RGB Photoshop document. The way around this is to make yourself a rich black in the InDesign Swatches panel, one that matches the CMYK mix of the regular Photoshop black. Set Photoshop's Foreground/Background colors in the Tools panel to black and white, then click the black swatch to see the actual ink mix in the Color Picker window. Matching this in InDesign is the simplest way to ensure a solid, perfect black matching when pasting content into Photoshop.

The fact that InDesign is a relative newcomer to the Smart Object game is given away by what happens when a Smart Object layer is double-clicked in Photoshop. Rather than opening up as a temporary InDesign document, the data is passed over to Illustrator to edit. This can lead to occasional oddities, for example strokes on text are converted to separate drawn paths, but it works very well on the whole.

If placed images are copied from InDesign or Illustrator the original resolution data is embedded. This way, high-resolution photos originally placed in a page layout can be imported to a Photoshop document and retain their full scalable resolution, even if they are used in a small, low-resolution image.

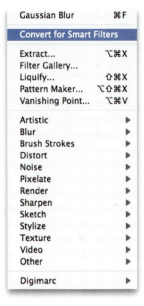

Photoshop into Photoshop

Native Photoshop layers can be turned into Smart Object layers as well. This can be done in two ways; the slightly more traditional one of choosing *Layer > Smart Objects > Convert to Smart Object*, and the new filter-focused route of choosing *Filter > Convert for Smart Filters*. Both do exactly the same job, but the Convert for Smart Filters command does pop open a window that informs the user that the layer will be converted into a Smart Object 're-editable smart filter' feature . There's obviously less call for this as the layer already exists in the Photoshop document – but being able to take advantage of Smart Filters with native Photoshop layers – applying filters without actually altering pixels in the image – is enough to win many fans. And, of course, double-clicking the layer will open it up as a separate document – inside Photoshop, as that's the data type's natural editor. Save changes and return to the original document to see those appear automatically.

Photoshop's text layers can't be edited by filters without being rasterized first, or at least that's what most people think. Fortunately, you don't have to give up text editability to use filters on your graphic headlines. Just convert the text layer into a Smart Object and apply the filters to that. When you want to edit the text just double-click its Layers panel, edit the regular text layer in the new temporary document, then save and close. Simple.

Grouping Smart Object Layers

You can group multiple Smart Object layers into one by choosing *Layers > Smart Objects > Convert to Smart Object*. If you want to apply settings such as Layer Styles or transform Smart Objects together this is invaluable. But although it looks like it just merges the contents of the different Smart Object layers together, it actually embeds the selected layers whole and intact into a new multiple-layered Photoshop file within a single layer in the first document.

Admittedly, this can make life a little confusing, not least because the only indication that a layer isn't a regular pixel one is the standard Smart Object badge in the corner of its thumbnail preview in the Layers palette. But it can also make things very flexible. Double-click a Smart Object layer which is actually a group and it opens the layered contents in a new temporary Photoshop document, ready for you to get creative with filters, masks, new layers, and so on. Save, and the results appear in your original file without you having to close the one you're editing. Yes, this is the same behavior as with

an Illustrator-based Smart Object. Any guesses as to what happens when you double-click a layer in this new temporary document? If it is a Smart Object layer – well, you get the picture.

In yet another interesting twist on Smart Objects in Photoshop, you can turn two or more layers of any type, not just current Smart Objects, into grouped Smart Object layers by using the same *Layers > Smart Objects > Convert to Smart Object* command. You are effectively embedding the selected layers as nested documents within the main file. The downside of this is that you can't use pixel-editing tools or features on the new Smart Object even if it is made of nothing but pixel-based layers; Smart Object layers have to be opened up to be edited like that.

Smart Objects End

So why didn't Adobe build Smart Object import support in InDesign or Illustrator? Well, as professional desktop publishing and drawing applications these have always had fairly rich features for handling artwork placed in layouts, complete with automatic updating when changes to the source files are made and saved. Smart Objects are how Adobe has managed to bring this kind of feature into Photoshop, a program that was never originally designed to do this sort of thing. This is why you bring Illustrator artwork into Photoshop as Smart Objects but simply place Photoshop images into Illustrator.

As the Creative Suite applications continue to mature, one day Smart Objects may be the term we use to describe any artwork placed, linked, or imported from one source into any different destination in the Creative Suite. We will almost certainly see it make its way into some of the other programs, including Dreamweaver, although that's not going to happen overnight. For now, remember that although you use traditional placed graphics in Illustrator and InDesign and Smart Objects in Photoshop, at the basic level the practical difference is just the terminology.

Although it took a step back in one respect with the loss of GoLive, the Smart Object feature is one of the major integration secrets of Creative Suite 3. It helps make the content you create in Illustrator or InDesign be available – and ready to be manipulated in many ways – in Photoshop, without losing the fundamental advantages of the object-oriented vector format. Smart Objects are, in effect, a way to embed one kind of file into another in such a way that you retain important characteristics of the original. This goes far beyond the basic abilities of copying and pasting or even, in certain ways, traditional placing and importing of graphics into layouts.

PDF

Close up view of one of the fountains in London's Trafalgar Square

The Adobe Acrobat PDF format is something that almost everyone has heard of. Despite this, few people realize the format's true scope. PDF stands for Portable Document Format. It is essentially a subset of the PostScript page description language itself, but designed to be self-contained and, of course, highly portable. It can be used for an amazingly wide range of tasks; as a 'soft proof' for design layouts, the basis for a paperless office, a web and email-friendly compact document format, press-ready artwork prepared to exacting standards, professional-quality presentations, media-rich multimedia productions, interactive digital forms, secure documents for legal use, ebooks… the list goes on. From its humble beginnings as a way to exchange documents without printing to paper, the PDF format has grown to become arguably the world's most flexible file format. Despite all these abilities it isn't particularly complex to generate and use, although to get the best from the PDF format it is important to know how to select the right options and versions.

PDFs can be exported directly from Illustrator, InDesign, and Photoshop. Fireworks and Flash only export in web-oriented bitmap or web-specific Flash (SWF) formats and Dreamweaver exports only web pages. However, work exported from both Fireworks and Flash can be placed into InDesign

layouts and exported as dynamic media in multimedia PDFs. If you need to produce PDFs of Dreamweaver web page designs, perhaps for archiving, to allow comments to be added to pages, or to document the visual appearance in different browsers, view the layouts in a browser and choose *File > Print*. Pick the Adobe PDF 8.0 virtual printer driver, click the Print button and then save the PDF. See Printing to PDF on page 143 for details of how to control this process.

Producing PDFs for different printing needs from documents created in Illustrator, InDesign, or Photoshop is simple. Choose *File > Save As* or *File > Export* in InDesign and select the PDF format to get to the Save Adobe PDF or Export Adobe PDF window. Pick an Adobe PDF preset and click Save, and the job is done. Of course it isn't quite that simple; the Adobe PDF Preset menu contains a number of different settings, each suited to different requirements. The real trick lies in knowing which preset to use and also when and how to customize these settings further.

Illustrator and PDFs

Illustrator's PDF production is an option in the file-saving process rather than an export. This is because Illustrator's file format is very close to the regular PDF structure itself. When saving a regular Illustrator document one of the options in the process is called Create PDF Compatible File, a checkbox that is on by default. The Illustrator file wraps the native editable object data in a PDF structure, and the resulting file can be opened in Acrobat or imported by any program that can handle PDFs.

Illustrator's close relationship with the PDF file format also means it can open and edit existing PDFs with virtually no trouble whatsoever. Every element in the PDF page is handled as a regular Illustrator object, although paragraphs of text are turned into individual, unconnected single text lines, some words may be split into multiple text objects, and if typefaces used in the PDF aren't available the relevant text will be turned to outlines. If the PDF needs text editing it is generally better to do this in Acrobat 8 Professional instead, where the Touch Up Text tool can select text across multiple lines even though there's still no basic linewrapping ability. But for graphics adjustments and especially additions, Illustrator is the best tool for the job.

Of course, Illustrator is a single-page graphics program. With multiple-page PDFs, Illustrator will show a small window with a page preview. Scan through the document and pick the right page to edit.

Once editing is done in Illustrator you can just save the document to make the updated PDF. The file this creates will probably be larger than the original, and if there are high-resolution images in the document the size difference can be dramatic. Keeping this under control requires picking the right PDF generation options rather than just saving the file; choose *File > Save As* or Save A Copy and save this as a new document to get to the Save Adobe PDF window. There are two options that make the most difference; Preserve Illustrator Editing Capabilities, found in the General section, and the image downsampling controls, found in Compression. Illustrator will use the Illustrator Default preset unless you say otherwise, and this includes preserving Illustrator-specific document data to make future editing much more flexible and having all image downsampling disabled. Turn off the option to preserve extra Illustrator editing abilities if this isn't a requirement, and pick one of the other Adobe PDF Preset options or adjust the compression options directly to store embedded images more efficiently. JPEG compression will be the most efficient, but be aware that this will apply a new lossy compression process to the data. This can lead to progressive loss of image quality; set the image quality to maximum or pick Zip compression if this is a concern.

If the page that has been edited is from a multiple-page PDF, choosing Save will put the updated page back into the original PDF. The Save As option creates a new single-page PDF instead. This can be inserted into the original PDF and the old page removed using Acrobat's Replace Pages command.

Open PDF

OK

Cancel

☑ Preview

1 of 2

Select a page from the PDF to open.

To save this page back to the original mutiple-page PDF, use the "Save" command. To create a single-page PDF, use the "Save As" command.

InDesign and PDFs

InDesign's PDF production abilities are well known. The PDF format is one of its main methods of producing final press-ready artwork, and the process of creating a PDF using a particular preset is made very efficient by the use of the Adobe PDF Presets item in the File menu. Picking one of these bypasses the Export Adobe PDF window entirely using the selected preset without further interference.

InDesign can import movies and Flash documents as well as ordinary static artwork files. This isn't of any practical use for any final output format other than PDF, but when handled correctly InDesign can serve as a very effective interactive multimedia production tool.

Movies placed into frames shouldn't normally be cropped or scaled; the media still has to play at its full uncropped size when it is activated in the final PDF. And this brings up an important point: never produce multimedia content with InDesign without testing the output very carefully. Using InDesign is a perfectly professional way to create this kind of content, but because you won't see certain aspects of the layout's behavior until it is in a PDF you'll need test and test again to make sure everything works as you want.

Photoshop and PDFs

Photoshop can generate PDFs too, although there's less for the format to have to deal with in terms of layout structure than there is with Illustrator and InDesign documents. The Output and Security sections are no different, but the General section reveals a key option: the ability to preserve Photoshop editing capabilities. With this option checked, Photoshop PDFs will contain the full layer information,

including masks, Smart Objects, vector and text layers, adjustment layers, and so on. Images can be treated as PDFs but retain all editing abilities, at least as long as Photoshop CS3 is used. As with Illustrator-native PDFs, this is where the security settings found in all Adobe PDF export settings can be useful. Passwords can be required before printing and editing is allowed. Use this to distribute a master Photoshop document in PDF format without the worry of it being edited without authorization.

Adobe PDF Presets

When creating PDFs from Illustrator, InDesign, or Photoshop, the Adobe PDF window is used to control the many different output settings. This is presented in a number of different sections within the main window, each focusing on a different aspect of the generation and optimizing process. The scope of all these options can be daunting, but they generally don't have to be dealt with in complete detail. Below is an explanation of every standard Adobe PDF Preset option that is found in Creative Suite 3. Check through this and use the list of different Adobe PDF presets at the top of the window to pick the settings that are most applicable to your needs. Consult with your printer or prepress specialist to see if they recommend particular presets or have their own list of settings.

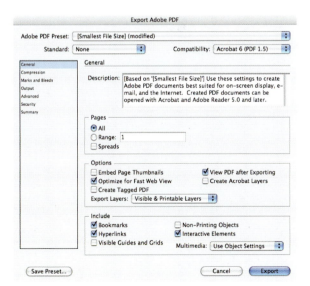

High-Quality Print	Use this preset when making PDFs intended for printing on desktop inkjets, color laser printers, and proofers. There is no color conversion applied, and all tagged source profiles in placed images are included. This is a good general-purpose preset, but it isn't ideal for preparing work for commercial print reproduction.
PDF/X-1a:2001	The PDF/X-1a:2001 preset produces PDFs that conform to that particular variation of the PDF/X 'graphic content exchange' ISO standards. All color is converted to CMYK using the destination profile, and transparency is flattened at high resolution. The result is a standards-based PDF that will be handled with confidence by most prepress operators. This doesn't guarantee that everything will work smoothly, but it can certainly help.
PDF/X-3:2002	Like the PDF/X-1 standard, PDF/X-3:2002 produces PDFs that conform to a particular ISO standard. With this preset, the output intent profile is set to the one defined in the Color Settings controls, but document colors aren't converted at all. This allows for color-managed workflows and color spaces other than CMYK, including spot colors, while still conforming to PDF/X standards. Transparency is flattened at high resolution.
PDF/X-4:2007	The PDF/X-4:2007 preset adds the latest version of the ISO prepress standards to the list. As well as the more flexible approach to color offered by PDF/X-3, it includes support for transparency and layers in the PDF document, so the Transparency Flattener is disabled.
Press Quality	The Press Quality preset generates output tailored for standard high-quality prepress work. Transparency is not flattened, and colors are converted to the destination profile if they differ, with numeric values preserved to help maintain appearance. Any profiles in placed images are removed, as all content is converted to the document's destination profile.
Smallest File Size	When creating PDFs meant for use only on screen and that are to be sent by email or downloaded quickly from web pages, use the Smallest File Size preset. This downsamples color images to 100ppi (pixels per inch), grayscale images to 150ppi, and monochrome graphics to 300ppi. The JPEG quality settings for color and grayscale are set to Low, delivering compact but possibly poor-quality results.
Illustrator Default	This is a preset that doesn't appear outside of Illustrator. Saving an Illustrator document as a PDF uses these settings by default. Full Illustrator editing ability is preserved and the quality of images is left untouched. This option is useful when you may need to edit the page in Illustrator again or if you plan to use it in InDesign. It is also a good option if you don't know the final destination of the PDF, as it makes very few assumptions and applies no lossy compression or downsampling to placed images.

When saving or exporting work as PDF there are a number of different compatibility settings that are applied as part of your selected preset or that can be set manually. These range from the relatively old PDF 1.3 through to PDF 1.7, with the newest versions requiring more recent versions of Acrobat Reader to open. These are controlled in the Export Adobe PDF window, either directly or as part of one of the Adobe PDF Preset choices. For details, see PDF Version Compatibility on page 148.

Multimedia Preset

There's no PDF export preset available for creating multimedia PDFs, so if you plan to do this much it is worth creating one with all the options as you want. Choose *File > Adobe PDF Presets > Define*, select Smallest File Size as the starting point, then click New. The New PDF Export Preset window appears with the settings for Smallest File Size already in place.

First of all, change the PDF compatibility from Acrobat 5 to Acrobat 6 (PDF 1.5) in order to include multimedia content in the PDF file. If you plan to use 3D content as well, pick Acrobat 7 (PDF 1.6) or, for the latest in this field, Acrobat 8 (PDF 1.7). In the General section, pick the options for bookmarks, hyperlinks, and interactive elements. If you want to force all multimedia to be embedded, pick that option here. The alternatives are to link to all multimedia content (good for CD-ROM delivery where there are many different movies), embed it in the PDF (so it can't go astray) or to leave this up to the individual multimedia object's settings.

Image compression is already tuned for compact screen delivery, although setting the image quality for color and grayscale images to medium or high rather than low will improve on-screen appearance. For the Output section, change the Color Conversion option to Convert to Destination (Preserve Numbers). For general distribution, leave the destination set to sRGB. For delivery in controlled environments consider using Adobe RGB (1998) instead to work with a slightly larger and richer RGB color gamut.

Finally, go back to the General section and add a useful description to explain the settings that are used, for example 'PDF output settings tuned for on-screen multimedia delivery, with support for basic 3D objects. Image quality is set to high and the destination is sRGB for general distribution. These documents will work in Acrobat and Adobe Reader 7.0 and later.' Name the preset and click OK.

This new multimedia-specific PDF preset will appear in *File > Adobe PDF Presets* and in the preset list in the standard Export Adobe PDF window. It will also appear as a preset in Illustrator's Save Adobe PDF window, although the multimedia aspects of this preset are ignored in this environment.

Printing to PDF

As well as exporting PDFs from Illustrator, InDesign, and Photoshop, an Adobe PDF 8.0 virtual printer is added to the list of devices available when printing from any program at all, whether it is part of the Creative Suite 3 team or not. It isn't quite as flexible as exporting or saving directly to PDF, but this provides a single universal way to generate a PDF

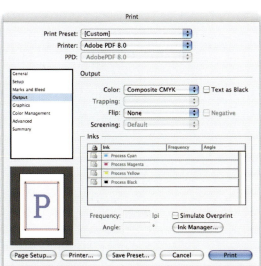

using anything from Microsoft Office programs through to email clients, browsers, text editors – basically, anything that can print. Open the Print window and then, with Adobe PDF 8.0 selected as the target printer, click Print. Save the output to disk with an appropriate name, and the job is done.

PDFs as Importable Artwork Documents

PDF documents can be placed into Illustrator and InDesign layouts as original graphic files, and they behave in the page just as EPS, TIFF, and other more traditional original graphics formats do. In fact, PDFs can even be a more flexible option for original artwork files than other formats. Empty parts of the page and object transparency are handled correctly, and when managing folders of documents the files can be viewed easily using Adobe Reader or Acrobat.

Photoshop is also able to open PDFs, rendering their layout structure into bitmaps at a user-defined resolution and color mode. The mode will default to whatever working space the document itself is, but this can be set to open as 8-bit or 16-bit grayscale, RGB, CMYK or Lab color regardless of the original PDF's mode. Photoshop will only open a single page, so multiple pages are shown side-by-side in the Import PDF preview box. Alternatively, to extract the bitmap images from a PDF, the Images selection mode shows just those items, with the page options and image size controls disabled. Opening an image from a PDF extracts it at its stored resolution and color mode, whether that's its original settings or the ones applied during the original PDF production process.

Transparency in the original PDF, whether from simple 'empty page' areas or actual object opacity settings and soft shadows, translate cleanly to the new Photoshop image, making it simple to take PDF originals created in InDesign or Illustrator, or any other program for that matter, and use them as content in multi-layered Photoshop composite graphics.

PDF Reviewing and Commenting

PDF documents can be more than just packaged-up documents for someone to read and print. Using Acrobat, the pages of a PDF can have text highlighted and comments added and then be sent back. This makes the format a valuable part of an ongoing workflow process.

To get started with marking up and commenting in a PDF, choose *View > Toolbars > Comment & Markup*. The toolbar this opens contains all the features you need. Click the Highlight Text tool and select some text to mark it, just as if you were using a highlighter pen. Double-click the highlighted text and a 'highlight comment' window opens, with your computer login user name and date and time stamps at the top. Although these are always movable it is a good idea to drag this so that it doesn't sit in front of what you're talking about; where you leave it is where it will appear when someone reviews your comments.

The Sticky Note tool creates a note on the page without having to mark up some text first; click or click and drag to place one on the page. The little comment balloon can be dragged around the page to reposition the sticky note. Other additions to the page are predefined stamps, some with dynamic content to include your name and the date and time, a simple text box and a callout text box tool, and cloud, arrows and plain box graphics.

For more direct intervention without actually revising the text in the PDF page directly, the Comment & Markup toolbar's Text Edits tool comes into play. This provides ways to indicate edits to text, from replacing and deleting to inserting. First choose Text Edits Tool from the tool's menu, then select some text and choose what you want to do to it. For example, drag across some text in the page and then choose Replace Selected Text. This marks it with a strikethrough line and an 'insert' caret and opens a window where you can type the text that's

to replace it. Hit the Backspace or Forward Delete key to mark text as to be deleted instead, or just click and start typing to create an Insert Text marker and add your words to a floating window.

Once all your edits, comments, and other markups have been completed, just save the document and send it back for your edits to be reviewed.

Comment Management

If you want to get a PDF reviewed by others there are a variety of ways to do this, apart from simply informally passing around the file. In the Comments menu, Attach for Email Review sends a PDF file to people by email, along with instructions to help them perform the review and comment process and send the result back. When returned, you have the option to merge all the different comments into your original copy of the PDF as they are received. Anyone with Acrobat 6.0 or Adobe Reader 7.0 and later can join in the review process.

The Send for Shared Review option in the Comments menu is a little more sophisticated, letting all the reviewers see and reply to each other's comments as they are made. This is a much more dynamic approach, but it does require a shared network folder or WebDAV server folder to store the shared comments,

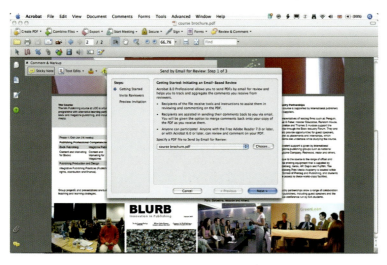

not to mention Acrobat 8.0 or Adobe Reader 8.0. Alternatively, Upload for Browser Review stored the PDF on a web server and provides the invited reviewers with the tools they need, provided they have Acrobat 6.0 or later, to make comments and have them stored online.

Finally, to make a PDF ready for regular commenting using Adobe Reader rather than just the full version of Acrobat, choose Enable for Commenting in Adobe Reader. This changes the PDF document permanently and limits some of the functions that can be done in the full Acrobat program, so always do this with a copy of your PDF.

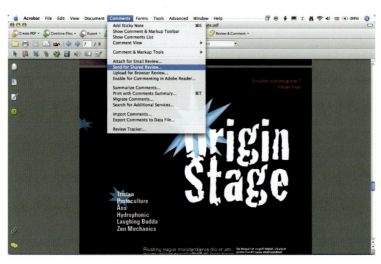

When a number of comments need to be checked through, options in the Comments menu help this process as well. Summarize Comments will create a new PDF with all the comments, arranged

and marked up in a variety of ways, while Print with Comments Summary does the same thing but direct to your printer. Migrate Comments and Import Comments manage the comments found across multiple files, and comments can also be exported to FDF files, which are PDF document with form fields and the ability to capture data.

With a little planning the PDF format can be used as a robust and flexible way to share data between Creative Suite 3 programs, have multiple people proof and review your work, and finally serve as the final artwork format or even as the end result itself.

PDF/X Standards

The PDF/X settings are ISO standards for graphic content exchange. The PDF/X standard was first established as PDF/X-1 in 1998, but it took a number of years before the standard became widely accepted. From 2001 there have been enhancements to the PDF-X standard, but all versions use relatively early versions of the PDF file format. Even the PDF/X-4:2007 uses the PDF 1.4 format.

PDF/X isn't a new form of PDF document. Instead, it sets out an important series of benchmark settings that allow documents to be transferred without requiring further information. PDF/X provides a prepress-oriented set of standards for PDF documents to meet, including full embedding of fonts and high-resolution image data, inclusion of bleed, trim and art-box definitions, embedded information on trapping, and more. The PDF/X-1 standards convert colors to the destination color space, set as the CMYK working space as defined in the Color Settings in the origination program (see Color Management, page 99), whereas the newer PDF-X specifications perform no color conversion at all, but set the declared output intent to the CMYK working space.

If a printer or prepress company asks for a particular PDF-X standard, this is to ensure that the PDF artwork they receive will be prepared to a known, output-ready set of standards. This doesn't guarantee absolutely no problems during production and it is not the same thing as preflighting a document before preparing the PDF, but it does eliminate most of the things that can cause difficulties and inconsistent output.

PDF Version Compatibility

The Acrobat compatibility setting in the PDF presets is important to understand. As the PDF format has been developed, new abilities have been added. Spot color support was improved early on in PDF 1.3, object transparency was added in PDF 1.4, and the world of multimedia was embraced in PDF 1.5. For reliable prepress output it is generally safer to stick to earlier versions simply to ensure broad compatibility with output devices. But check with whoever will be handling the artwork files to see what PDF version they prefer; you may be able to use later versions with their various advantages.

If you are preparing PDFs for distribution rather than prepress, it is generally wise to prepare your documents so that they can be read by the Acrobat or Adobe Reader versions that most of your audience will have. As a quick compatibility guide, add together the numbers in a particular PDF version to find the earliest Acrobat version that supports it. For example, PDF 1.5 can be read by Acrobat 6 or later. Although the latest Adobe Reader can be downloaded free, not everyone will be willing or able to do this in every circumstance. On the other hand, if your document requires certain supported features then recipients will simply have to use an appropriate Acrobat version. Make sure any such requirements are explained, if necessary.

PDF version	Supported by	Significant features
PDF 1.3	Acrobat 4	Includes improved support for spot colors and smooth shading, allows annotations, supports double-byte fonts
PDF 1.4	Acrobat 5	Supports transparency and 16-bit color, adds security settings including limiting output quality and control of copying text, images and other content
PDF 1.5	Acrobat 6	Offers improved compression techniques and support for layers, includes structural metadata, embeds multimedia content
PDF 1.6	Acrobat 7	Handles custom color spaces, preserves OpenType's glyph substitution abilities, embeds 3D artwork
PDF 1.7	Acrobat 8	Embeds default print characteristics, offers enhanced 3D support, includes document constraints to ensure correct display or output, handles PDF multiple-file packages

Printing

Suction feed board for single sheet stream-fed Heidelberg offset litho press

Printing is the ultimate goal for a huge amount of the content that is produced using the Creative Suite. Even web page designs are sometimes printed, and of course InDesign is one of the most flexible desktop publishing programs in use today. Not surprisingly given the different kinds of content that the various programs can product, the printing options available in the different parts of the Creative Suite vary tremendously. The print-based Illustrator and InDesign powerhouse and the all-rounder that is Photoshop have an almost exhaustive range of options. Although you shouldn't expect too much from the more web-focused tools when it comes to printing, there are more options than you might expect when it comes to outputting their final content.

Dreamweaver Printing

Dreamweaver CS3's print options are pretty basic compared with the rest of the Creative Suite programs. Rather than printing out the design view layout, the File menu contains a Print Code command instead. This prints the code in a monospaced font, linewrapped to fit the page width and with line numbers on the left. None of the options in the *View > Code View Options* list are used for this; even syntax coloring is ignored. If this is important, consider printing

```
1   <!DOCTYPE html PUBLIC "-//W3C//DTD XHTML 1.0 Transitional//EN" "http://www.w3.org/TR/
    xhtml1/DTD/xhtml1-transitional.dtd">
2   <html  xmlns="http://www.w3.org/1999/xhtml">
3   <head>
4   <meta http-equiv="Content-Type" content="text/html; charset=UTF-8" />
5   <title>Untitled  Document</title>
6   <link href="main.css" rel="stylesheet" type="text/css" />
7   <!--[if  IE]>
8   <style type="text/css">
9   /* place css fixes for all versions of IE in this conditional comment */
10  .twoColLiqLtHdr #sidebar1 { padding-top: 30px; }
11  .twoColLiqLtHdr #mainContent { zoom: 1; padding-top: 15px; }
12  /* the above proprietary zoom property gives IE the hasLayout it needs to avoid several
    bugs */
13  </style>
14  <![endif]-->
15  <script src="SpryAssets/SpryCollapsiblePanel.js" type="text/javascript"></script>
16  <script type="text/javascript">
17  function  MM_CheckFlashVersion(reqVerStr,msg){
18      with(navigator){
19        var isIE  = (appVersion.indexOf("MSIE") != -1 && userAgent.indexOf("Opera") == -1);
20        var isWin = (appVersion.toLowerCase().indexOf("win") != -1);
21        if (!isIE || !isWin){
22          var flashVer = -1;
23          if (plugins && plugins.length > 0){
24            var desc = plugins["Shockwave Flash"] ? plugins["Shockwave Flash"].description :
    " ";
25            desc = plugins["Shockwave Flash 2.0"] ? plugins["Shockwave Flash
    2.0"].description : desc;
26            if (desc == "") flashVer = -1;
27            else{
28              var descArr = desc.split(" ");
29              var tempArrMajor = descArr[2].split(".");
30              var verMajor = tempArrMajor[0];
31              var tempArrMinor = (descArr[3] != "") ? descArr[3].split("r") : descArr
    [4].split("r");
32              var verMinor = (tempArrMinor[1] > 0) ? tempArrMinor[1] : 0;
33              flashVer =  parseFloat(verMajor + "." + verMinor);
34            }
35          }
36          // WebTV has Flash Player 4 or lower -- too low for video
37          else if (userAgent.toLowerCase().indexOf("webtv") != -1) flashVer = 4.0;
38
39          var verArr = reqVerStr.split(",");
40          var reqVer = parseFloat(verArr[0] + "." + verArr[2]);
41
42          if (flashVer < reqVer){
```

the page code from a web browser such as Firefox or Opera, or from a high-end text editor such as BBEdit instead. Other than the line numbering, there's nothing Dreamweaver does in print terms that the most basic text editor can't do at least as well.

Contribute CS3 is a different matter. Although there's no control to speak of, not even a Page Setup option (it uses your system's default page setup), you're free to print whatever page you're currently browsing using the standard Print window. This hassle-free approach to printing work is well pitched for Contribute's main audience; people who want to manage a site without fuss or learning too much about the intricacies of web production.

When it comes to preparing web pages for others to print there are all sorts of things that can be done. At the basic level, simply making sure a page uses an appropriate width that will work well with the average visitor's Letter or A4 paper size is a start. But rather than go down the road of tailoring your designs to suit the print format or making alternative pages specifically for printing, explore the options provided by using a Cascading Style Sheet (CSS) document just for printing.

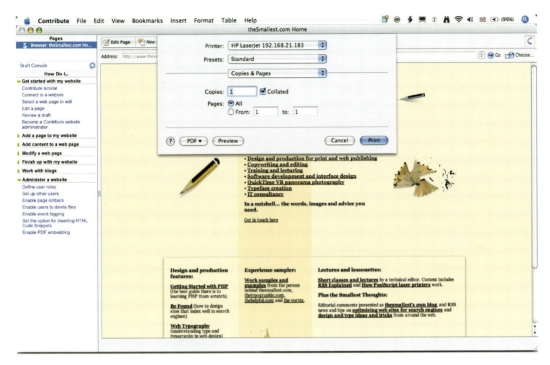

Simply by putting a 'link' style referencing the appropriate CSS style sheet and with the media type declared as print, for example <link rel="stylesheet" type="text/css" href="print.css" media="print">, this will be the style sheet used when printing occurs. Another approach is to import the style sheet using the @import statement, for example @import url(print.css) print, which will do exactly the same thing. Finally, there's the @media rule, used within a standard <style> definition either in the page or in a separate CSS file. The following structure produces white text on black for screen use and black text on a white background (the default colors for both text and backgrounds) for print:

<style type="text/css">

@media print {

 body {font-size: 10pt; line-height: 120%;}

}

@media screen {

 body {font-size: medium; line-height: 1.1em; color: white; background: black;}

}

</style>

Using CSS controls, the elements in a page can be formatted to suit the printed medium better; black text, probably slightly smaller and on white backgrounds, a more appropriate layout arrangement, even using display controls to hide elements that aren't relevant for print, such as navigation

controls. With the appropriate CSS styles set and referenced using the media="print" reference, the printed output will be adjusted automatically. Because the print-specific style uses the same actual page there's no chance of ending up with content going out of sync.

Flash Printing

The Flash CS3 print window is a standard one with no special Flash-specific options. However, the controls in the Print Margins window act as a custom form of Page Setup, helping choose options for controlling what the Print

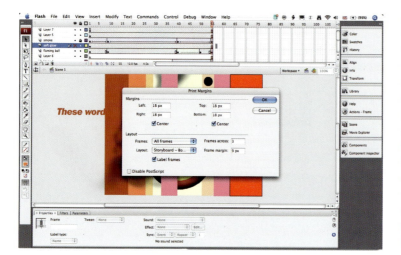

window does. The options default to printing just the first frame at full size, but this can be set to print all frames instead, producing a storyboard in a few different formats from the result. There's no option for selecting a specific series of frames, printing the current frame or for skipping a certain number at a time, so this feature isn't as useful as it could be. Still, on the right occasion it can be very handy.

Of course, this doesn't scratch the surface of

what's possible with printing in Flash if you take control of everything yourself. It is possible to design Flash movies that are designed for print as well as screen display, using off-screen movie clips and ActionScript instructions such as attachMovie() to assemble a print layout dynamically at the moment the print is requested. The basic concept is similar to using print-specific CSS styles for printing regular web pages, but the actual construction process is rather different. The printed results can be exceptional. This is partly because native Flash content is vector based, so those items will always print at the best resolution of the output device.

This is a rather complex and heavy-handed process to go through if you just want to print a set of reference frames, but for building specialized printing features into a Flash movie to benefit the end users there are all sorts of possibilities.

Fireworks Printing

Fireworks CS3 has just the regular print controls to deal with. What you get when you print depends on what layers are visible or hidden at the time; use the Layers panel to set up the graphic and then print its current state. The same doesn't work for frames, however. When Fireworks prints it always uses the first frame in the document, regardless of which frame is currently showing.

Fireworks CS3 documents can contain more than one page, effectively storing multiple complete graphic layouts, even ones of different sizes, within one file. But although these are called 'pages', they don't operate as pages when being printed. Each print from Fireworks prints the current page as if it was the only one. This is hardly a serious problem, but if you do take advantage of the new Pages feature in Fireworks CS3 remember that printing is a manual page-by-page process.

Print

The other three programs in Creative Suite 3 are all designed very much with print production rather than web production in mind, so it isn't surprising that these all have rather more to offer when it comes to printing your work. The main Print windows in Illustrator and InDesign are different in some details, but they share many of the same fundamental controls.

InDesign Printing

With an InDesign document open, choose *File > Print* to show the Print window. You'd be forgiven for thinking that this looks a little like the Export Adobe PDF window, as it covers much of the same ground. The job it does is essentially the same thing, but you're producing real-world printed pages rather than 'virtual print' PDF documents.

Begin by picking the right printer from the section at the top. The options in many of the following settings are dependent on this choice, so it is important to do this first. The Page Setup and Printer buttons at the bottom of the window can be of some use with some low-end printers, but for most work these are irrelevant. Well, almost. There are actually a few settings that aren't duplicated (and hence overridden) by those in the main Print window. For example, when printing to the Acrobat PDF 8.0 printer driver, the PDF Options controls, found by clicking the Printer button, can set the new document to be opened by Acrobat automatically when it is finished.

In the General section you choose basics such as the number of copies, page range, and whether to print the standard 'visible and printable' layers or to take more control over what is and isn't included in the output. Printing all pages is simple; make sure the All button is selected. But to print a smaller range of pages from a document you can type the page numbers into the Range field. For a set of consecutive pages type the first and last numbers separated by a dash, for example 12–15. To pick out individual pages, just separate them with commas. You can mix and match with these options; jump about so you produce output with pages in any order you like, and even repeat the same page if you need to. Take a 16-page document and try printing pages 1, 3–5, 1, 16. It won't be very often at all that you'll need to do this, but the flexibility is there. Master pages can be printed, although you'll probably only want to do this to document the master pages for some reason rather than using them as final artwork.

The Setup section controls page-specific details; the output dimensions and how the document page fits onto this. One feature that shouldn't be overlooked is the option to print thumbnails at various sizes and, going the other way, to tile a large page across multiple output pages, with a user-defined overlap.

Marks and Bleed – well, this is self-explanatory. Control all the different printer's marks here, from registration and crops to page details, and set up a custom bleed if it hasn't been built into the document already. It is generally better to set up bleed in the document in the first place to ensure that objects meant to bleed are extended far enough past the page edge to be safe.

Output is important, obviously. Do you want to print composite color proofs? If you're using a budget inkjet printer you may find that you get better results (comparatively speaking of course) if you print composite RGB and let the printer's own driver perform its own budget-but-tailored conversion to its printing inks. Test to see. If you print separations you'll need to consider your trapping options and halftone screen settings. If you have spot colors in the document and

the final output needs to be straight CMYK click the Ink Manager button. In this new window the All Spots to Process checkbox will take care of this. With this checked, the inks list will show just the cyan, yellow, magenta, and process black inks.

The Graphics section should normally be left alone. If you're dealing with an old output device that doesn't like PostScript level 3 data this can be set to level 2 instead, but the majority of users won't have call to adjust these options.

Color Management is specifically about the output end of this process. Depending on the printer that's selected in the head of the Print window some options may not be available in the Print and Options sections below. Normal output will have Print set to Document, and it will show the document's designated color profile. The Proof option emulates the output characteristics of a different device, and can be useful, with a calibrated proofer, in simulating the results of commercial printing press output.

With both of these options, if Color Handling below is set to Let InDesign Determine Colors it is important that the appropriate profile is selected in the Printer Profile menu. This identifies the printer and type of paper that will be used, and it completes the chain in the color management workflow. Try to get a custom device profile from your printing company if you can, otherwise ask which standard one they recommend – or pick the most appropriate one from the generic set. Note that the items below the dividing line are legacy profiles; Euroscale is not generally recommended by prepress experts today, and the others are there merely to provide legacy support; see Color Management on page 99 for more details on this subject.

The Advanced section handles OPI (Open Prepress Interface), where low-resolution placement images are substituted by the high-resolution originals. If you're using an OPI link to a prepress server system that manages your images this is essential, otherwise this should be left unchecked. The Transparency Flattener is more generally useful, but leave

this at Medium Resolution unless you find a specific reason to choose the low- or high-resolution settings.

With all these options it is a very good job that a complex set of choices can be saved as print presets. Once you've fine-tuned a collection of settings these can all be saved – well, everything apart from the options in the General panel anyway – and used again by picking the new named preset from the Print Preset menu in the Print window or by going straight to it in *File > Print Presets*. Click the Save Preset button and give it a useful name. There isn't any option for adding a description, so give it a name that will be meaningful to whoever needs to use it.

Illustrator Printing

Illustrator's Print window doesn't have every option found in InDesign's, as its documents contain just one page. Although it is possible to make multiple 'crop areas' in a page by alt-dragging with the Crop tool, only one can be focused and hence printed (or exported in other formats) at a time. The General section of Illustrator's Print window does have an option for printing page ranges, but this only comes into play when using the options in the Setup section to tile a design across multiple output sheets at once.

Unlike InDesign's page preview which shows just basic scale, placement and orientation of the layout on the output media using a generic 'P' character, Illustrator's preview shows the actual content that will be printed, including printer's marks. Drag this around to change where on the page the graphics print and what portion of a larger design will be produced. This is extremely helpful when working with tiled output, as the image area of the output media and the overlap regions are also shown in the preview.

The Output section is very slightly simpler than InDesign's, but it has essentially the same functions. The Graphics panel, on the other hand, contains one feature that's peculiar to Illustrator; the Paths flatness control. The process of turning the PostScript descriptions of paths into the high-resolution raster image of the final RIP-processed artwork involves translating the mathematical curves into tiny flat parts, normally far too small to make out. The finer the individual segments are, the smoother the path will be in the final output – but the more work is it to process, especially with very high resolution RIPs. The

setting that defines this is usually left on automatic, but this can be turned off and the flatness level slider moved across from Quality toward Speed. The precise value this produces in terms of segment length is irrelevant at a practical level, and it is relative to the output resolution anyway. Leave this on auto unless you have a complex graphic that's taking too long to process or causing memory problems at some point.

Elsewhere in this section the document raster effects resolution is reported. This is the quality level that is used when converting complex effects to more easily printable content during the output process. Screen resolution is the fastest, but it is also the crudest. For higher-quality resolutions, turn to the controls in *Effects > Document* Raster Effects Settings and select Medium (150ppi) or High (300ppi). Unless you plan to scale the page up dramatically after the final output in some way you won't need a higher value than this.

In Color Management, the options follow the lead of Illustrator's Color Settings controls, which itself should really be set across the whole Creative Suite 3 using Bridge CS3; see Color Management on page 99 for details. If you choose to, the color handling can be changed from being under Illustrator's management to letting the PostScript printer take over the handling of the numeric color data. However, this is generally not done as this introduces another variable into the color management equation. The printer profile should be set to the closest match for the actual output device and paper stock. Finally, see Rendering Intent on page 158 for details of how the document's color will be translated to the output device's color.

The Advanced section in Illustrator's Print window tackles how overprint content is to be handled, and what resolution to use for generating this. For flattening transparent content for

reproduction, the relative balance of using raster (bitmap) and vector shapes to produce the final effects, the resolution to use for different kinds of content, and how to handle text and strokes are all dealt with in the Preset settings here. This is real fine-tuning stuff, so leave the settings at their default unless you have a significant reason to change anything.

As with InDesign, almost all of these options can be captured as a print preset. Illustrator's print presets aren't shared by other programs, but they can be picked from within the program's Print window.

Rendering Intent

In the Print window's Color Management section in both Photoshop and Illustrator there's an option that is particularly useful to note, if not necessarily to change. This is Rendering Intent, a setting that dictates how the colors in a document will be prepared and passed along to the output device. Picking the wrong setting here can have a noticeably detrimental effect on the output, so choose carefully. But before you start to worry too much, I should add that Illustrator's default, Relative Colorimetric, is a good choice for general-purpose professional reproduction. Each different option has its own uses, its own strengths, but keep in mind what these are and don't apply them in different situations. The following descriptions should help explain what each one is for.

Perceptual	The Perceptual rendering intent is designed to preserve the perceived relationship between all the colors in an image. The results will generally look fairly natural, although the actual colors may change. Use this method when the content is photographic and contains colors that are outside the gamut of the destination color space. For more general work where actual color values should be preserved as much as possible, use Relative Colorimetric instead.
Saturation	The Saturation intent makes sure colors are reproduced vividly rather than accurately. This is best kept for business presentation-style content, where impact is more important than precise color fidelity. Don't use when color matching is required or when reproducing photographic content, as colors will shift.
Relative Colorimetric	Compares the white point of the color space of the image to the destination color space and shifts all colors as necessary to adjust the overall balance to fit. Any colors that are outside of the destination profile's gamut, which can be a fair amount if going from an RGB source to a CMYK destination, are shifted to the closest equivalent that the destination can reproduce. This is the best choice for general-purpose work, and preserves more of an image's original color than the Perceptual intent manages.
Absolute Colorimetric	Unlike Relative Colorimetric, the Absolute Colorimetric rendering intent does no white point shifting. Colors that lie within the gamut of the destination color space are untouched, but colors that are out of gamut are shifted to the closest reproducible color. Color relationships between in-gamut and out-of-gamut colors will be affected by this, but the in-gamut reproduction will be accurate. This makes it suitable for simulating the characteristics of an output device for proofing needs, although the shifting of out-of-gamut colors should be remembered.

InDesign Imposition

InDesign CS3 has another trick up its sleeve when it comes to printing. The InBooklet SE plugin that was part of InDesign CS2 has been replaced by a built-in Print Booklet feature, found in the File menu immediately below the Print command. This is used to perform page imposition, producing what are commonly called printers pairs, where the pages are arranged in the correct order for printing and final assembling. Curiously, Print Booklet doesn't have a built-in option for printing InDesign multi-file 'book' documents, but it does a good job with individual documents.

This isn't something you'd use for a very large project; the options are for 2-up Saddle Stitch, Perfect Bound or Consecutive, 3-up Consecutive, and 4-up Consecutive. You won't find this useful for dealing with a 200-page magazine with multiple sections, but it is perfect for slightly shorter documents. This does also have a few fairly sophisticated options, such as creep control, compensating for the problem where the width of pages on the inside of a booklet or signature is fractionally narrower than those on the outside. Graphics and other content that is arranged across spreads is handled perfectly well, being split logically without further intervention.

You can choose the range of pages to handle (which in fact does make working with larger projects more feasible), the booklet type and, depending on the kind of booklet imposition requested, control both space and bleed between pages as well as creep, based on the signature size (group of pages) that you set. Margins can be adjusted automatically as well. If you're used to specialist imposition systems this may feel a little on the simple side, but it presents all the control that most people actually need. Even handling different kinds of paper stock in one section can be done, although the further down this road you go the closer you will need to work with whoever will handle the final production.

Further control is available by clicking the Print Settings button, which opens the standard InDesign Print window. This is where all the regular controls such as the target printer and output media size, printer's marks, bleed settings, and all the rest are found. In the Print Booklet window the Preview section shows thumbnails of the imposition results that the current settings will produce, with the actual page number for each page layered on top.

As the feature's name implies, the actual imposition process is applied during printing rather than changing the existing document or creating a new one. Mind you, if a separate page-imposed document is needed then all you have to do is print using the Adobe PDF 8.0 driver and you'll get a PDF document of the output. This can be used to check the behavior of the imposition settings choices without going all the way through to print, as well as preparing imposed artwork for actual final output. The process uses Distiller to do all the work; it sends it the PostScript data for the page and leaves it to produce the PDF result. This does mean that your final document won't contain transparency, layering, or any other features that can't be produced in standard PostScript. On the other hand, because the Print Booklet process uses all the same controls as standard InDesign print production does, you'll have all the same separations, trapping and color management in both print and PDF output that you'd expect if you were printing normally.

Print Booklet can be an invaluable tool whether you're printing your own documents or preparing something for reproduction elsewhere. However, do ask your printer how they would like the job supplied before assuming control over this part of the process, as you may not always make the right choices.

Photoshop Printing

Photoshop's Print window has a fair range of features. Some are new to Photoshop CS3, but it looks very little like those in InDesign and Illustrator. The large page preview is particularly helpful, and the contents can be scaled and positioned within the printable area. Use Page Setup in the standard way to select the output page size once the printer is selected. The print resolution is a function of the image's scale on the page, another core option in this window.

On the right, the Output mode (see the popup menu near the top of the window) controls the printer's marks, background color behind the image, border, bleed – and on a more practical although distinctly esoteric level, screen frequencies and angles for the color channels and 'transfer functions' that provide curve controls over the individual channels as well. Switch the mode from Output to Color Management for some options that will be more generally useful.

At the top, the Document button, when combined with Photoshop Manages Colors in the Color Handling section, will print the document using Photoshop to handle converting the document color to the output device's capabilities. (The Printer Manages Colors option leaves that responsibility to the printer itself.) Alternatively, use Proof to emulate how the image will reproduce on a different device, specified using the Printer Profile menu.

Best used when the source and output gamuts are similar but blacks are different, Black Point Compensation adjusts for differences in black points when the image color is converted, making sure the full range of the original color space is mapped to the destination's color space. This is only available when the Document option is selected. When using the Proof choice instead, the Simulate Paper Color choice button will adjust colors to match their appearance on the chosen stock, and the Simulate Black Ink option mimics the brightness of dark colors in the selected output device. Both these options are only available when using the Proof option, and they both work to produce more accurate proof simulations of the target output results.

Unlike the Print windows in Illustrator and InDesign there's no provision for saving print presets in Photoshop. However, click Done rather than Print and your settings will be remembered without being put into practice. Then, when you're ready, Photoshop's Print One Copy command can take the remembered print settings and run with them. There's no interaction, not even an OK

button to click, other than confirming the request if the image is larger than the output device's printable area.

The color management proofing features in particular are very useful when printing directly from Photoshop. Of course, that's not something that everyone will want to do; some people will find Photoshop's own printing features useful, others will prefer to leave most printing tasks to the page layout part of Creative Suite 3 instead. There's no single right answer here; print from whichever program makes the most sense with your workflow. As long as you set up your color management options properly, use the right ways to share files between programs and take advantage of the software's print features when you need to produce pages you'll get good results from all of these tools.

Poster

Crowd cheering after Fairport Convention's final encore, Summer 2006

The poster produced in this chapter uses one large photographic image along with a number of secondary ones, optimized and prepared in Photoshop and then imported into an Illustrator layout using Bridge. Illustrator effects are applied to objects and type, and transparency features help to make the various elements work together in the page.

Photoshop Image Preparation

One of the first things to do is to consider the final output format of your Photoshop work. The original Encore Crowd photo is a standard RGB image taken with a digital camera. For commercial print use we'll need to convert this to CMYK rather than RGB color. This should normally be done at the end of the workflow process, as the CMYK color space is more restricted than RGB – not to mention many of Photoshop's features not being available in CMYK mode.

163

One obvious problem with this image is the band of gray that's apparent across the sky. This is where part of the composite image that made up this photograph was exposed incorrectly, and it needs to be reduced back to black. We'll do this now in RGB, using a pure RGB-based black and leaving the CMYK conversion to produce the right color output later in the process.

Now show the Info panel; click its icon in the panel dock, choose *Window > Info*, or type **F8**. When you point at part of the image the RGB percentages that are used to produce that color are shown in the Info panel. This also shows the CMYK values that you will get with the current color conversion settings, something that we'll deal with later on.

You'll see that the black part of the sky just above the horizon is made up of pure RGB black; each channel registers a value of 0. (There's no noise evident here as the image was treated for noise reduction as part of its original assembly process.) Just above the black area there's a band of dark gray, where light contamination from nearby spotlights affected the photograph. This needs to be dealt with before the top section is cropped off to make sure none of this ends up appearing in the final image.

Type **D** to set Photoshop's foreground and background colors to the default

black and white. In RGB documents the black is a pure RGB-zero black, perfect for this job.

Before treating the off-black parts of the sky it is wise to mask off the other parts of the image to protect them from accidental editing. Click the Quick Mask icon near the bottom of the tool panel (Q), then select the Brush tool (B), set the brush size to 200 pixels using the drop-down list in the Options bar, and paint over the parts of the image you want to protect. When you're done, step out of the Quick Mask mode. The unmasked areas will be selected, and the soft boundary from the large brush will make sure that there are no obvious edges to be seen in the final result.

Using the 200 pixel brush, paint the sky black. The selection you created earlier will prevent the rest of the image from being affected. Alternatively, you can simply fill the selection with black by going to *Edit > Fill* and choosing to fill with the foreground color or with the black that's listed in this menu. (If you ever do this in a CMYK image, don't select Black from this list of options. That's a black that is made from 100% coverage in all four colors, and the result will be difficult for most printers to handle.)

Choose *Image > Mode > CMYK Color*. The photo is now converted to CMYK colors using the CMYK workspace settings currently active in the Color Settings dialog. Photoshop's default color conversion settings are acceptable for this project, but you should consider setting up the color settings across the whole of the Creative Suite 3 first. To do this, turn to Color Management starting on page 99.

In Photoshop, show the Info panel *Window > Info* or **F8** and then point at a part of the black sky. The upper-right section of this panel shows the CMYK channel mix of the color under the pointer. Make a note of the color values for the cyan, magenta, yellow and black channels. If you use Photoshop's default CMYK working space, US Web Coated (SWOP), these will be Cyan 75%, Magenta 68%, Yellow 67%, and K (black) 90%. You will use these values in the next stage of this project. Alternatively, you can export the Photoshop color swatches and import them into Illustrator. This isn't really a timesaver when dealing with a single color, but when dealing with multiple swatches (see Sharing Swatches on page 113 for the secrets).

Your image is now prepared for use in the Illustrator layout. When you step into Illustrator you can make your new custom black to match the formula that was used to mix your rich black in Photoshop. (So why not use a regular black from just 100% black and 0% everything else? Because a single-color black prints visibly thinner and weaker than a rich black, and also because it simply wouldn't match the CMYK black created by Photoshop's RGB conversion.)

Illustrator Graphics and Layout

Switch to Illustrator and make a new document. The page for this poster should be A3 or Tabloid size and in CMYK color mode. The Raster Effects setting isn't important right now, although if you use certain Illustrator effects it is for the final artwork production. Choose 300 ppi for now, but if your machine runs slowly when you start exploiting raster effects you may prefer to turn it down for this document until the end of the project. To do this go to *Effect > Document* Effect Raster Settings.

Choose *File > Browse* or just type the standard ⌘ alt O ctrl alt O shortcut to open Bridge. Find your newly saved image and drag it into the Illustrator document window. (You'll probably find this hard with Bridge in its full-size mode. Switch to the Compact mode by clicking the icon in its top-right corner.) Move it down to the bottom of the page and use the Transform palette *Window > Transform* or Shift F8 to scale it to 6 mm wider than the page. Make sure the width and height values are linked (click the chain icon) to prevent the image from distorting. This gives enough for 3 mm bleed off the edges of the page on both sides. Now click the bottom-left corner of the Reference Point part of the Transform palette, so the X and Y locations are relative to the image's lower-left corner, and set it to -3 mm for both fields.

Select the Rectangle tool (M) and draw out a rectangle. Use the Transform palette again to set it to be at least 6 mm wider than the page dimensions (allowing for 3 mm bleed on all sides) and to place it centrally on the page. (Alternatively, rather than reaching for the Transform palette you can just click

with the Rectangle tool and enter the width and height for the object directly. If you prefer, the Control panel above the document window can be used to scale it and also move it into the precise position.) Send it to the back ⌘ *Shift* **[** *ctrl* *Shift* **[** so that it doesn't obscure the photo.

The shape still needs to be filled with the correct rich black to complement the image. Don't just mix this up using the Colors panel; you should create a new swatch for this so that it can be used easily throughout this project. Click the Swatches icon in the panel dock or choose *Window >* *Swatches*, then open its popup menu and choose New Color Group. This will help you organize the colors for this project rather than getting them lost in the standard selection of ready-made swatches. Once you've named this color group, go back to the popup menu and choose New Swatch. Make sure the Color Type is Process Color and the Color Mode is CMYK, then type in the CMYK values you

used earlier in Photoshop. Give the swatch a useful name, for example 'Extra Black', and save it. (If you ever need to edit this swatch just select it and choose Swatch Options from the popup menu.) Now you can apply this custom black color as the fill for your page-filling rectangle.

This custom black is a form of 'rich black', a more solid black than you will

get with a single ink. Rich blacks can be given a cooler or warmer feel by changing the proportions of the non-black inks they use. The most common form of rich black, produced by mixing 100% black with around 80% cyan and no magenta and yellow, will give a strong but subtly cool, blueish accented black, while using 70% or more of magenta and yellow and no cyan in the mix gives a solid black with a redder hint and a warmer feel. Rich blacks shouldn't be used for small type, however, as the slightest misregistration will produce colored halos around the letters.

Making the Sunburst Shape Image Effect

Start by making a new layer; click the Layers icon in the panel dock or type **F7**. In this panel, click the New Layer icon or choose that from the panel's popup menu. New items are made on the selected layer, and existing items can be dragged from the list in one layer to another layer within this panel. Name this layer as 'Sunburst' – double-click its name in the Layers

panel if necessary. Using layers is one of the keys to handling complex layouts, so if you're not particularly familiar with how they behave it is worth practising with them for a while.

The sunburst images effect is made from a number of simple Illustrator shapes, drawn with the Pen tool **P** as a series of simple triangles radiating out past the page edges from a central point a little above the main image. Don't worry too much about precise placement, just make each one come from roughly the same place on the page, and draw straight-sided triangles.

Choose *File > Browse* to open Bridge and browse for your images. Switch the Bridge interface from Full to Compact mode if necessary and drag your chosen images into the Illustrator layout. Position the first image over the first shape and send it to the back, then select both objects and choose *Object > Clipping Mask > Make* **⌘ 7** **ctrl 7**. The image will be clipped by the shape so that it only shows within the triangular boundaries. Repeat this with the rest of the images, clipping each with the appropriate shape.

The next step is to distort the shapes to give them the wave effect. Choose the Selection tool **V** then **Shift**-click each object until they are all selected. Now choose *Effect > Distort & Transform > Twist* to open the Twist dialog. This applies a radial twisting effect to selected Illustrator objects - including type, as we'll see shortly - but not to imported images. Type 25 into the Angle text field and click the Preview checkbox to see what this does to the selected shapes.

If you want to apply a similar twirl effect to the images themselves you'll need to do this in Photoshop rather than Illustrator. Open the image and choose *Filter > Distort > Twirl*, then type in the same value as you used in Illustrator's Twirl effect. You can't use Illustrator's Live Trace to convert the image to vectors and apply the Twirl effect to the result, as the individual shapes will shift and leave gaps as a result of the distortion process.

Once you've settled on the perfect amount of twist, click OK. You can come back and apply Twist again, but it will produce a cumulative effect. The process of warping the objects isn't absolutely perfect either, so if you apply a negative amount of twist to the distorted shapes to try and put them back to normal you'll see the edges won't be precisely as they were originally. If you want to edit the effect that you applied, open the Appearance panel *Shift* *F6* and double-click the Effect entry shown there. To remove an effect just go to the Appearance panel, select the effect, and click the trash icon.

Shape edges that ran along the upper-left and lower-right edges of the page will have been distorted so they don't go to the page edge any more. To fix that you'll need to edit the underlying shapes so they fall far enough outside the page (plus enough extra to account for bleed in the final artwork). Click a problematic object to see its undistorted shape as well as the warped result, and use the Direct Selection tool (A) to adjust it. If you have trouble finding the path to edit choose *View > Outline* and you'll see everything in an effect-free skeleton display. You won't be able to see the warped shape like this, so switch back *View > Preview* once you've selected the right points.

To make the twirled shapes fade into black toward the top of the poster – essential for the legibility of the smaller text – draw a rectangle that's the full page width (plus the bleed) and runs from the top of the page down to near the bottom of the shapes, a little above the main photograph. Open the Gradient panel ⌘ F9 ctrl F9 and click the gradient to apply that as the object's fill. Choose Show Options from the panel's popup menu and set the angle to 90° so it runs from black at the top down to white at the bottom.

Finally, use the Transparency palette and set the compound shape's Blending Mode to Darken. The black area will stay opaque, but it will get progressively transparent in the lighter parts. The effect will be to make the image fade into black as if airbrushed across the top.

The bottom of the shapes need to blend into the black background just above the main image. There are a number of ways to do this, including drawing a basic black shape and applying a large blur to it. But in order to get a little more control over this we'll create a custom blend shape and use Illustrator's transparency overlay effects.

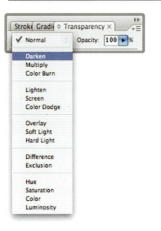

Switch to the Pen tool **P** and draw the outer shape. This will define the beginning of the shading that will mask the images. Fill it with white, then draw the inner shape and fill that with black. Change to the Blend tool **W** and click one object and then the other to make the black to white shape blend. You may need to set the stroke to none to show this properly. Then use the Transparency palette to set this object's Blending Mode to Darken as well. If the mask you've just made doesn't fit perfectly use the Direct Selection tool **A** to adjust the inner and outer shapes; the blend will follow automatically. Make sure there's enough room for the headline - this will be created next.

Setting Graphic-Type Banner

The poster headline is made using a number of Illustrator's built-in effects at once. It is easy to go overboard with these, so feel free to adjust the settings and effects that are shown here. Before you begin, make another layer in the Layers panel and call it 'banner'.

Set your text font, size and color, using something that's bold and not condensed, then apply a slight 3D extrusion. To do this, choose *Effect > 3D > Extrude & Bevel*, and set the rotation values to 10º, 0º, and 0º.

This produces an extrusion that's dropped down slightly but not offset in any other direction. Click the More Options button to expand this window, then drag the light point spot to the center of the small globe icon to have the lighting come directly from the front. This will preserve the type color rather than making it be a shaded tint instead. Finally, set the Perspective value to 20º and click OK.

Now choose *Effect > Warp > Arc Upper* and set the Bend level to 20%. If you click the Preview checkbox you'll be able to see the effect without closing the window. When you're happy with this, click OK and then choose *Effect > Warp > Arc* (click Apply New Effect when asked) and set the Bend level of this effect to 10% or less.

Now that the general structure has been set, it is time to fine-tune things. Use either selection tool and try out a few different typefaces to see how they work with this 3D arc effect. You may find that your preferred typeface looks stretched too tall by the Arc Upper effect. This can be countered by stretching the type box out horizontally using the Selection tool **V**. With effects like this it isn't worth getting too precious about typographic traditions, but even so don't stretch too far or it will feel distinctly wrong.

Illustrator's effects work on the overall results of
previous effects, so the order in which they're applied
can make a difference to the final outcome. The halo
is a good example of this; it is made by applying the
Inner Glow effect after the Drop Shadow so that
the glow works on the larger boundaries made by the
shadow rather than just the borders of the letters
themselves.

Choose *Effect > Stylize > Drop Shadow* and set the
X and Y offsets to zero and the color to white. The
Blend Mode defaults to Multiply, which makes
the shadow color invisible, but this produces a
larger overall area for the next effect to work with.
Now go to *Effect > Stylize > Inner Glow* and try
setting the opacity to 50% and the blur to 10 mm.
The effect is applied within the outermost edge of
the composite shape created by the other effects.
If you get the effects in the wrong order you can
simply drag them to different positions in the
Appearance panel.

All these effects are calculated and drawn on the fly,
leaving you free to alter them as you go by turning
to the Appearance panel and double-clicking the
right effect name. This also means that the more
effects you add, the more processing it will take to
display the graphic. Turning off this item's layer can
help temporarily, but if this is a serious problem
then, once you've finalized the type effect, you can
convert it to a regular graphic instead. Select the
object and choose *Object > Expand Appearance*.
The graphic won't require such intensive processing
to be drawn, but the effects and type won't be
editable any more – except as drawn blends and
shapes of course. It is wise to keep a copy of the
original effect-laden object in a separate document
or as a duplicate hidden layer in case you need to
go back and alter something.

Setting the Other Text

The regular text is set in various weights and styles of a strong sans-serif font.
This is set in a face called Cracked, but Univers 67 Bold Condensed, Helvetica
Bold Condensed, or even Arial Bold will do. Make another layer in the Layers
panel for this part of the artwork, click and drag with the Type tool **T** to
make text boxes at specific sizes, and set your text. If you simply click and type

rather than clicking and dragging out a text box, resizing the resulting text area will distort the type itself rather than just changing the size of the box.

Finally, you may find that the text is simply not quite legible enough on the image parts of the background. Adjusting the blend settings of the large gradient covering the top half of the page may help a little, but if you use *Effect > Stylize > Drop Shadow* to apply a small amount of drop shadow to the text it will stand out very effectively. Adjust the shadow settings carefully; very small amounts with low opacity and no offsets will make individual letters stand out very slightly. Increasing the Blur takes some of the focus off the letter shapes and gives the words some soft background shading, but reduces the strength of the standout a little as well. Using the X and Y offset controls can make the lettering appear to float off the page, but both believability and effective clarity drop as the offset amounts increase.

Book

Sucker bar for a single-sheet offset litho printing press

InDesign's Book panel is the key to managing the production of longer documents. It really comes into its own when handling many dozens or hundreds of pages, but even for this short book project it can prove very helpful.

By linking documents together as a book you can share different attributes between them easily. Type and object styles, swatches, master pages, and a few more esoteric settings can be made available to all the documents within one book. Page and section numbering can also be rationalized so that adding, removing, or reordering pages at any time won't cause pagination headaches across the array of documents. This also makes cross-document table of contents and index generation relatively easy to produce, and allows different parts of a single project to be worked on by different people at the same time.

In InDesign, choose *File > New > Book* or click the Book button in the Welcome Screen window. This doesn't create a new layout document; it creates a 'book' document that's used to link multiple layout documents together.

Start by planning the document structure. As the document we'll be making is relatively straightforward it will be divided up into just three documents; the 4-page front matter (including table of contents), the 16-page main section, and the 4-page index.

Grids

Before we can set up the book we need to make the documents themselves and set up their page structures. In the New Document window, the page dimensions for this project are A5, and the margins should be set to 15 mm on the left and bottom, 18 mm for the top, and 12 mm for the inside. Choose two columns with a 5 mm gutter. The Facing Pages checkbox should be checked, and you can shortcut the process of adding pages to the document by specifying the number you want right here. This is the 'main section' document, so choose 16-pages, then click OK.

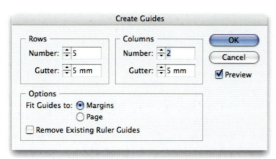

To set up a grid structure beyond the basic margins, first open the Pages panel, choose *Window > Pages* or type ⌘ F12 ctrl F12 and double-click the page icons labeled A-Master. Choose *Layout > Create Guides* and give this document five rows and two columns, with 5 mm gutters. Fit the guides to the margins rather than the page, and click OK when you're done. Double-click one of the regular page icons in the Pages palette to stop editing the master pages.

Do this for all the three documents and save each one to disk, then use the Book panel's Add Documents button to add them to its list. Drag them into the right order if necessary.

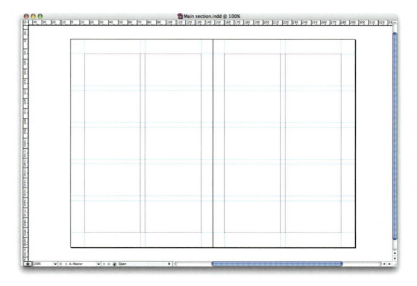

Page Numbers

Once the documents are in the Book panel list you can use InDesign's automatic page numbering to keep pagination on track across all the files. This is a very easy trick, even when dealing with complex multi-part numbering systems. Turn to the Book panel again and pick Book Page Numbering Options from the popup menu. The 'continue from previous document' choice should be selected for most uses, and the option to keep page and section numbers updated automatically should be checked.

Now that that's been checked, select the first document in the list, the 'front matter' one that will contain the table of contents. Open the Book panel's popup menu and choose Document Numbering Options. This is where you can choose what numbering style to use, what number to start at, set section markers, and other related options.

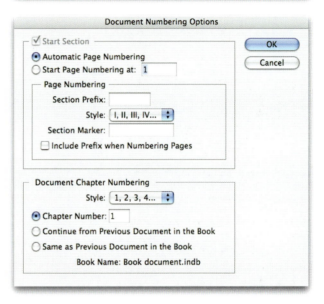

Choose 'I, II, III, IV' from Style in the Page Numbering section to set the numbering style of this first section to Roman numerals. Click OK and then select the second document and open the Document Numbering Options window again. This is where the regular numbering process should begin, so se t the page numbering to start at 1 rather than using automatic numbering, and make sure the chosen style is the traditional '1, 2, 3, 4' format. The rest of the documents in this project will continue the page numbering from this one, so there's nothing more to do. We haven't yet inserted any actual page numbers, but we'll do that in a moment.

Text Import

Up to this point everything can be done using basic template documents without any of the actual content. At this point, however, it becomes useful to have some text content, preferably the final approved version, in place in your layout.

Double-click the entry in the book palette for the main text document to open it. Choose *File > Place* and choose the 'chapter 1' text document. You'll find this on the media CD that comes with this book. Before clicking to place the text on the page, hold down the **Shift** key. With this pressed, clicking the Place Text

cursor will flow the text from one page to the next, creating linked text boxes automatically and making new pages as required. Click in the first column below the second row in the first page, leaving enough room for the chapter title elements. The text will be flowed into new text frames, one in each column. The first column will start in the row where you clicked, but the one in the second column will be the full height of the page margins. Drag this one down to match the first column's height.

Text Styles

Open the Paragraph Styles panel by clicking its icon in the panel dock, choosing *Window > Type & Tables > Paragraph Styles*, or by typing ⌘ F11 ctrl F11. Open the popup menu and choose New Paragraph Style. This will be used to format all the body text, so call it 'Body'.

Use the Basic Character Formats section to set the typeface and size to Palatino, 9 pt on 11.5 pt leading. Select the Indents and Spacing and apply a 2.5 mm first-line indent, then in the Keep Options section click the Keep Lines Together checkbox and choose At Start/End of Paragraph. This makes sure there are never any widows or orphans; single stray lines from a paragraph left behind or spilling over into the next column or page. The All Lines in Paragraph alternative here prevents paragraphs from being split up at all, taking the entire paragraph over to the next column or page instead. This can be good for certain kinds of work-through style textbooks where it is important to keep individual paragraphs entirely intact, but it is a rather heavy-handed approach for most requirements. Click OK when you're done.

Next, make a style for the chapter titles in this document. Call this style 'Chapter', pick Body from the 'Based On' option in the General section, then use Basic Character Formats to change the font to Gill Sans Bold (or Helvetica Bold if necessary) and the size to 15 pt. Step to the Indents and Spacing section and set the First-Line Indent to 0 mm and Space After to 10.75 pt. (Type 'pt' and the value will be converted when you're done.) Once this is finished, make another for the crosshead titles that appear within each chapter text. Call this 'Crosshead', base it on Body as well, and make it Gill Sans Italic with no first-line indent.

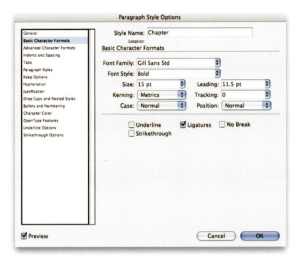

With the styles made, go through the pages and apply them to the appropriate parts of the text, starting by applying the Body style to everything first. Because these are paragraph styles you just need to click within each portion of text before selecting the style from the Paragraph Styles panel. The style will affect the entire run of text up to the first hard return character. If you need styles to apply to portions of text within paragraphs, set these up as character styles instead and select all the text you want to format when you use them.

No matter how experienced you are at producing page layouts, if you don't use style sheets for almost all of your type formatting control you're missing a big trick. It may seem like a hassle to set these up, but once they're made and applied you can just edit the style itself and all your formatted text will change automatically. When faced with a client's request to adjust every crosshead in a set of documents, this turns a long and tedious task into the work of a few moments.

Synchronizing Styles

Styles are stored on a per-document basis, so when you turn to one of the other documents in your book you won't automatically have them available. InDesign's Book panel can set any file it lists as a 'style source' for other documents, but you have to remember to do this manually to bring styles into a document and to update ones brought in previously and then amended in the original document.

There's a small box to the left of each entry in the Book panel. If this has an icon then that's the current style source. Select any item in the list and then click the double arrow icon at the base of the Book panel. (Or choose Synchronize Selected Documents

from the panel's popup menu.) The styles in the nominated source will be copied into the selected document, and existing styles will be updated. You'd normally do this for each document, but there may be some that only need a few styles. You can simply delete unwanted ones from a document's set afterward, and synchronize it again if you change your mind.

Images: Anchored and Free-Floating

Images in a layout can be placed free-floating on the page or anchored within text in a text frame. Most layout work uses free-floating graphics, frequently with text wrap enabled to ensure text flows around the sides of the graphic box. The Text Wrap panel is opened by going to *Window > Text Wrap* or by typing ⌘ ⌥ W ctrl alt W. The panel's top row of icons control the kind of wrap that's applied, and the outset amounts are set in the set of four controls below them. Further sophistication can be set using the Wrap Options choices, but most of the time that's not required.

In-line graphics are a different matter. These flow along with the text, so they always stay connected to the appropriate information even if the text is edited substantially. You can simply copy and paste an existing frame (graphic or otherwise) into some text, but you can create an anchored frame from scratch and give it the correct settings all at once.

Click at the end of the first paragraph of the text that was just imported and formatted, then choose *Object > Anchored Object > Insert*. In this window you

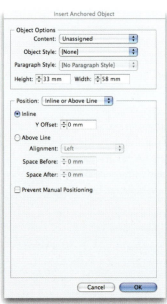

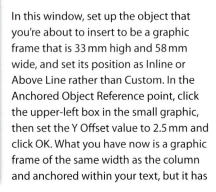

will be able to choose the frame type (text, graphic or unassigned), assign styles and set the dimensions, as with normal frames. The rest of the controls are specific to how anchored objects are positioned.

In this window, set up the object that you're about to insert to be a graphic frame that is 33 mm high and 58 mm wide, and set its position as Inline or Above Line rather than Custom. In the Anchored Object Reference point, click the upper-left box in the small graphic, then set the Y Offset value to 2.5 mm and click OK. What you have now is a graphic frame of the same width as the column and anchored within your text, but it has

no content yet. (If things aren't placed where you expected, choose *Object > Anchored Object > Options* and change the settings there.)

Choose *File > Browse* or type ⌘ ⌥ O ctrl alt O and use Bridge to find the Trees.psd image from the media CD. When you've located it, drag it into the anchored graphic frame. Choose *Object > Fitting > Fill Frame* Proportionately or type ⌘ ⌥ Shift C ctrl alt Shift C to scale the image to the frame without leaving any empty areas. The other frame-fitting option, Fit Content Proportionately, scales the graphic down (or up) to fit the frame, but leaves parts of the frame empty rather than cropping any of the image. When an image's job is to fit a predefined area this is not all that useful.

The next anchored graphic frame will be used as a decorative initial item in a paragraph. Click at the beginning of the first full paragraph of text in the same page, insert a new anchored object, and set the size to 10×10 mm and the position to Custom.

Just as before, when the position controls are set to 'Inline or Above Line' rather than Custom you'll see a few more options. In the Anchored Object reference point, click the tiny upper-left box to change the object's anchor reference point to its top-left corner, and set the Y (that's the vertical positioning) to Relative to Line (Cap Height). The box will now act as a drop-cap element within the text, with its 10 mm height starting at the cap height of the text and hanging down for approximately three lines.

The trouble at the moment is that the type runs underneath the box, so when a graphic is imported or it is given a color fill it obscures some words. To cure that, choose *Window > Text Wrap* or type ⌘ ⌥ W ctrl alt W to open the Text Wrap panel and click the second text wrap icon. The text will now wrap around the object rather than flowing underneath, and if you use the Offset controls just below the text wrap icons you can have the text kept slightly away from the edges of the object rather than sitting snug against it. Click the link icon so that changes in one of these four fields doesn't affect the others, then use the lower-right control to increase the right-hand offset to 2 mm. (If you simply increase all offsets to 2 mm the line below the object will be affected too, leaving an ugly gap in the text.)

At this point you'll notice a problem: the first line of text hasn't been affected by the text wrap setting and still runs underneath the object. This is a known InDesign behavioral quirk that should be addressed in a future version of the software, but for now we have to work around it ourselves. The simplest way is to click into the paragraph, then in the Paragraph panel

Window > Type & Tables > Paragraph, or ⌘ ⌥ T *ctrl* *alt* T set the first-line indent to the width of the anchored box plus the text wrap offset; in this case, this totals 12 mm.

(What may happen now is that the first line of text will appear indented twice as far as it should be. Switch to the Selection tool, click the anchored box, and use the arrow keys to nudge the item up and then down again to make InDesign show things properly.)

Finally, you need to choose what content this object will have. For this book project these boxes are there to hold graphic symbols relating to the text contents. These icons were drawn in Illustrator and can be found in the media CD. Open the Circle.ai graphic in Illustrator to check its dimensions. As long as the graphic will fit into the square frame and will look acceptable at that small size it will be fine, otherwise you'll need to make some adjustments to the shapes.

Select the main brushstroke path, then use the Control bar above the document window to apply the right color. Do this by holding down the shift key and clicking the Path menu. This pops open the alternative color picker panel, showing CMYK ink percentage sliders rather than a list of ready-made swatches. Set the color values to C 30%, M 100%, Y 100%, and K 0%. This gives a slightly maroon red that will match this book section's signature color. Choose *File > Save As* and save this into your book project media folder as a regular Illustrator graphic.

Back in InDesign, choose *File > Browse* to step across to Bridge, then use this to browse to the Illustrator file. Drag this across into the anchored box in the InDesign page to import it. This is much easier to do if you have the Bridge window in Compact rather than Full mode, as this not only makes the Bridge window smaller, but it also floats it above all other windows regardless of what program you're in at the time.

Importing the Illustrator graphic with its custom red stroke color also imports that color to InDesign's Swatches panel; open this panel to see. This should be applied to the crosshead text in this chapter, and this can be done in three different ways.

The basic way to color the crosshead text in this chapter is to select each crosshead in turn, make sure the Swatches panel is set to fill rather than stroke (see the tiny icons in its top-left corner), and click the custom color in the swatches list. Another method is to create a custom crosshead paragraph style for each chapter.

A slightly more sophisticated approach is to set up a custom character style for each chapter and use this to apply the color. Click the Character Styles item on the panel dock or choose *Window > Type & Tables > Character Styles* or type ⌘ Shift F11 ctrl Shift F11, then choose New Character Style from the panel's menu. Pick the custom color in the Character Color section, rename the style 'Chapter 1 Crosshead', and click OK. To set up styles for the colors in other chapters you would simply use this same contextual menu to duplicate and edit the style.

Footnotes

Footnote are meant for explanatory notes or citations referring to specific parts of the main text in a book. These are normally found in research papers and similar publications and aren't at all common in general-interest books, where the preferred style is to include that kind of information into the main body of the text.

Footnote references are inserted into key places in the flow of text, and InDesign's footnote production feature anchors the footnotes themselves in the bottom of the relevant text frame. If the text shifts to a different column, frame, or page the footnotes will follow along automatically. Once the various footnote style and setting options have been set the actual implementation of footnotes is very simple, so we'll concentrate on getting things right here before going ahead and adding in all the footnotes themselves.

You'll find it helpful to have an existing footnote already in place before you start trying to make final formatting choices for this content, so click in your text and choose *Type > Insert Footnote*. A small superscripted footnote reference number will appear in the text, and a corresponding footnote item is created, locked to the bottom of the text frame. Type some text in there to help you through the next step.

Styles are used to format both sets of items, a character style for the footnote reference in the main text and a paragraph style for the footnote text at the bottom of the page. Create these now, using the test footnote items to test out your formatting choices. When you've made these two new style sheet entries, choose *Type > Document Footnote Options* to get at the footnote controls. Choose your numbering and prefix/suffix options, apply your character style and paragraph style in the Formatting section, and then click the Preview checkbox to see how it looks. Change the Separator in the Footnote Formatting section to an En Space (shown as ^>) rather than the standard tab character. You can of course adjust the tab space in the footnote style sheet entry to whatever space you prefer, but the en space – with a width of half the point size of the text – is perfect for this project.

Click the Layout tab and customize the options that control how the footnotes are laid out on the page. Change the minimum space before the first footnote to 2 mm to prevent the main text from coming too close to the footnote rule, and as some footnotes in this document will be a few lines long rather than just a brief snippet, set a 1 mm space between footnotes. The rule above should be 30 mm long – just a short stroke – with all other options at their standard settings; 1 pt weight, black, and so on. Sometimes you'll make these decisions based on careful typographic analysis, sometimes you will just do it so it fits well. Experiment so you know precisely how all these options affect the page and its contents.

Table of Contents

Building a table of contents, or 'TOC', for a document is generally seen as a mysterious and complex process, but all it involves is a careful use of styles – an important part of professional layout production. First you apply a specific style to your chapter headings, then use that to extract the table of contents titles and related page numbers automatically. Use the chapter and crosshead styles created earlier.

Once your styles have been applied, choose *Layout > Table of Contents*. This is where you nominate your particular chapter and crosshead styles for InDesign to use to create your table of contents automatically. First select the Chapter style in the list on the right and click Add to put it into the list on the left. Do the same with the Crosshead style, and it will be added below the Chapter style. (Only paragraph styles show up here, which is why we used a paragraph one for the basic crosshead formatting.) Make sure that the Include Book Documents option is checked, or you'll only be using the contents from the current front-most document.

Once this is done, click OK. If you have overmatter – more text in a story than is shown in its text frame – you'll be able to choose whether or not to include this in the table of contents listing. Now you'll have a 'loaded cursor'; the pointer will show a text frame icon and the first few words of the table of contents text. Click in an existing text frame or click and drag out a new one, and your TOC list will be generated for you.

The titles are taken from the text that's formatted with your nominated styles. If you've applied that to large portions of text or items that shouldn't be in the table of contents you may be tempted to edit the results yourself, but whenever this list is updated the original text will appear again. It is best to plan ahead and make sure the text that wears the styles used for this table of contents process is appropriate, and don't use those styles for anything else. Manual editing of the text is simple, but you'll have to do it again if you update things to follow new pagination.

By default, the page numbers are separated from the titles with a single tab. If you edit this manually you face the same problem of having it reset when

you update the table of contents. Instead, make one or more styles for the table of contents, and include tab settings in them. When you're setting up the table of contents generation you can choose what styles to apply to the table of contents, and you can apply this afterward by choosing *Layout > Table of Contents Styles*. Just as with normal page content, the trick to efficient use of the table of contents feature is to set up styles and use them to do all your formatting.

Of course, if you need to experiment with the formatting of the table of contents first you can reverse-engineer the process to an extent. Create your table of contents, then fine-tune its styling, including tabs and all other formatting characteristics. Once done, choose New Paragraph Style from the Paragraph Styles panel's popup menu and name your new style. Then go to *Layout > Table of Contents Styles*, edit the TOC style you're using, and set it to use that paragraph style for the various parts. Finally, with your contents text box selected, choose *Layout > Update Table of Contents*.

Indexing

The first part of the index creation process involves adding index entries to the Index panel list. This is what's used to generate the index itself, so spending time at this stage is important. Go to *Window > Type & Tables > Index* or type **Shift F8** to open the Index panel. Make sure the Reference button is selected, and click the Book checkbox to ensure you're working across the whole book rather than just the current document.

Select a word or phrase in your text, then choose New Page Reference from the Index panel's popup menu. The selection will be used as the primary entry in the Topic Levels list, and when you click Add All every instance of that word or phrase will be logged along with where it occurs. For entries that should

be sorted in a different manner than the way they're shown on the page, for example to sort someone's name by surname rather than first name, type it into the corresponding Sort By field.

More complex index entries can be made by adding related words or phrases into the second, third, and fourth topic level fields. The Type list of options includes cross-referencing features such as See Also and See Herein, and can extend the index reference range using various different options.

Once the index entries have been created, go to the document and page that's going to hold your index and then click the Generate Index button in the panel or choose Generate Index from the popup menu. In the Generate Index window that shows up, change the index title to something appropriate. Clicking the More Options button reveals a large number of controls for fine-tuning the output, including the separators between different elements in the index, and which styles are used for the different index entry levels. Don't forget to select the option to include book documents, or you'll end up with an index of just one document.

These index styles are automatically created as new paragraph styles in your document. If you haven't already created and assigned your own custom ones, edit these styles to control how your index looks on the page. Right-click or

control-click a style and redefine it in the Paragraph Style Options window. Click the Preview checkbox to see your changes before clicking the OK button.

Exporting Bookmarks

If you plan to use the book in PDF form, even for approval stages, it can be very useful to build in some bookmarks to make navigation easier. Bookmarks can be added to PDF documents in Acrobat, but it can be more sensible to make these in InDesign as part of the whole production process.

Adding individual bookmarks is simple. First, open the Bookmarks panel by choosing *Window > Interactive > Bookmarks*. Select the text or graphic that's to be the target of your bookmark, or select the whole page in the Pages panel if you don't want to use a specific item in the layout. (If you do this, first switch to the Selection tool and make sure nothing is selected on the page.)

Finally, click the Create New Bookmark button or choose that from the panel's popup menu. If you selected some text then that will be used as the bookmark's name and will link directly to

that text, otherwise a page-level item called 'Bookmark 1' will be made. Edit the names to make them more logical.

For an even easier life we'll go back to the table of contents section. Choose *Layout > Table of Contents* and then, in the Edit Table of Contents Styles window, click the Create PDF Bookmarks checkbox. Click OK to update your table of contents, and all the contents entries will be added as bookmarks in the Bookmarks panel as well. All you have to do from here is go through to weed out items you don't want as bookmarks and perhaps rename items to suit their use as bookmarks.

To check that this is all working, select one or more documents in the Book panel and choose Export Selected Documents to PDF (or Export Book to PDF if you selected all the documents in the list) from the panel's menu. This creates a single PDF from the multiple documents. Name the PDF and click Save, and you'll get the Export Adobe PDF window where the many PDF production options are found.

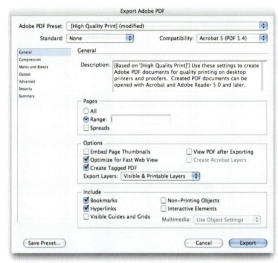

As long as you don't use any of the PDF/X presets or standards choices at the top of this window then the Include section, found in the General panel, will allow Bookmarks to be selected. This creates the bookmarks in the PDF, but they won't be clickable navigation links unless you also select the Hyperlinks option as well. With both those boxes checked, click Export to create your PDF. (Full details on choosing the right PDF output generation options for different kinds of work are shown on page 142.)

Now open the PDF document in Acrobat or Acrobat Reader. The bookmarks will be closed to start with, but click the Bookmarks icon on the left to show the panel and navigate using your bookmarks. If you wish to make simple changes to the bookmark item text labels just click and type; this saves you having to export a new PDF from your InDesign document. However, if you have many changes it is better to do this in the InDesign document instead, in case you need to regenerate the PDF for any other reasons. Changes made to this PDF won't be included in future ones, whereas changes made to the master InDesign layout document will be.

This doesn't mean that setting up bookmarks using Acrobat isn't a good idea. With the Bookmarks pane open in Acrobat, click the Options button and choose New Bookmarks from Structure. Select Chapter and Crosshead from the list and click OK. You'll get a new set of bookmarks created as a nested collection of working hyperlinks, all created from the corresponding elements in the PDF.

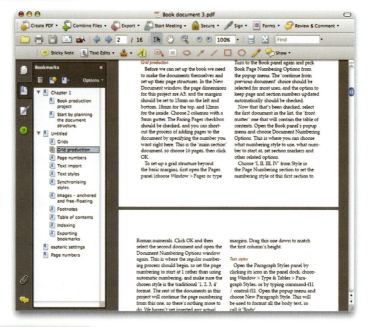

To have this Bookmarks panel show by default in your PDF document, choose *File > Properties* and select the Initial View tab, then pick Bookmarks Panel and Page from the Navigation Tab options. Save your modified PDF, then close and open it again to see this in action.

Magazine Feature

View from inside the Origin stage at Glade festival, Summer 2006

New Document Setup

Whether it is obvious in the final layouts or not, a magazine structure will live and die by its grids. Planning is the key to creating a strong but flexible page grid system. The following steps demonstrate one possible approach, although there are many more ways of tackling this task.

Make a new document, pick A4 from the Page Size options, and make sure the Facing Pages box is checked. Set the margins to 10 mm on the top and sides and 13 mm at the bottom. You'll need to unlink the margin fields to have different values in different ones. Leave the column set to just one; we'll make the columns and rows in this layout by using grids and guides rather than the page margins themselves. Before you click OK, click the More Options button and change the Bleed setting to 3 mm on all sides.

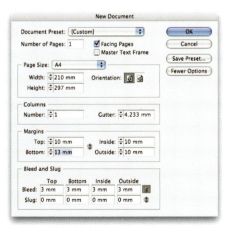

SHORTCUTS
MAC WIN BOTH

191

Page Grid

The grid setup is next. This should be done in the document's master pages otherwise you'll need to repeat the process for every new page you make. Open the Pages panel, *Window > Pages*, press ⌘ F12 ctrl F12, or click the Pages icon in the panel dock and then double-click the left-hand page of the A-Master spread in the top section of this panel.

Choose *Layout > Create Guides* and set up a grid of 23 rows and 16 columns, each with a 2 mm gutter. Make sure the guides are set to fit within the margins rather than the page, and click the Preview checkbox to make sure that your settings will make a result that looks like the grid shown here.

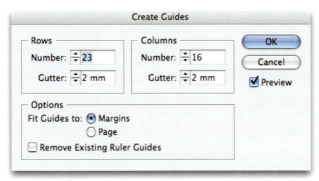

This creates a grid with individual cells that are precisely 10 mm wide and 10 mm tall, spaced apart by 2 mm. Although this grid itself won't be obvious in the final product, all the layout arrangements and objects on every page will fit into this underlying structure. This will make it easy to create interesting and dynamic layouts that avoid the dull 'office newsletter' look while still retaining a sense of control and structure. Other design projects may suit different grid measures, but this particular structure is both simple and versatile. Because the document is set to have facing pages the left and right master pages can have different guides, so you'll need to repeat these steps for the other page in the A-Master spread.

Once the grid is finalized in your master page, choose *View > Grids & Guides > Lock Guides*, or type to lock the guides down. Now the guides can't be accidentally moved or deleted until you unlock them again. Each new page that's made will be created from the pages in this master spread.

If you do need to remake your page grid, first unlock the guides, then go back to *Layout > Create Guides* and make sure the checkbox called Remove Existing Ruler Guides is checked. If you leave your guides locked then this option won't be able to clear your original guides as it makes new ones.

Type Styles

Next comes type styles, the biggest secret to fast, efficient, and repeatable layout production. Double-click the page icon to step from the master pages to the regular document page, then choose the Type tool and make some text boxes in the page, each four grid columns wide. Use one to set some text for general headline use, another for crosshead setting, and a third for setting some regular body text.

The typeface used for this layout is Univers. This has a very clean, strong design and provides a great many different weight and width variations, although in fact only a few variants will be used at this point. (If you don't have Univers available then select another functional Sans-serif instead. Helvetica Neue has a good selection of weights, but even ordinary Helvetica or Arial will do in a pinch.)

Click into one of the text boxes and choose *Type > Fill With Placeholder Text* to get some generic 'lorem ipsum' text to work with. Using the Control bar, format this as Univers 55 Roman scaled to 7.5 pt in size, and set justified rather than aligned left. In the leading field, replace the current contents with '3 mm'. When you hit Enter or just click out, this millimeter value will be converted to the equivalent in points.

The leading needs to be set so that the line heights match up cleanly with the grid. The grid is set using millimeters so, rather than picking point sizes for the leading, we use millimeters here as well. The overall height from the top of one grid 'cell' to the next is 12 mm (10 mm cell height plus 2 mm gutter), so using a leading value that's a clean division of 12 will ensure things line up with the grid automatically all the way down the page.

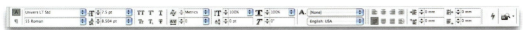

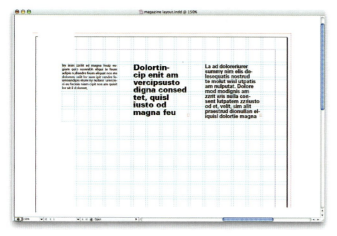

The heading text should be set as Univers 75 Black, 18 pt on 6 mm leading, and the crosshead text should be Univers 65 Bold and 12 pt on 4 mm leading. Although each has a different leading value, because each one's size is a clean division of 12 – which is the distance from one cell top to the next – they all fall at the same relative vertical point on each new row. This can take some careful juggling to achieve in different layout grids, but when it can be managed it will certainly make ongoing fitting of text and boxes a simpler task.

Once the text has been formatted it is time to produce style sheet entries so that you can apply these settings more easily to text in the future. Click into the body text first so that you'll start with the correct styles already configured, then open the Paragraph Styles panel *Window > Type & Tables > Paragraph Styles* or type ⌘ F11 ctrl F11 and choose New Paragraph Style from its popup menu. Name this style 'Body'. Using a keyboard shortcut for high-speed reuse if a style can be very handy, but now that InDesign has so many shortcuts already assigned, finding a free shortcut can be awkward.

Before you click OK there are two more things to do. Go to the General section and click the Apply Style to Selection checkbox. This will make sure that the text you've used to create this new style will also have it applied, so any changes made to the style later will automatically apply to the original text. Then go to the Hyphenation section and uncheck the Hyphenate box. This

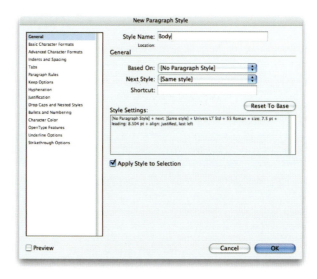

prevents words from being split across lines. Repeat this whole process with the styled text for the headline and the crosshead.

Other styles used in this layout are Boxout Body, set as Univers 57 Condensed, 7.5 pt on 3 mm, and Boxout Crosshead. This should be set as Univers 67 Bold Condensed, 12 pt on 4 mm. This also needs a 1 pt thick paragraph rule below with a 1 mm offset, set in the Paragraph Rules section of the Style Options window, and in the Indents & Spacing section set the Space After to 2 mm.

Library Items

Another major timesaver for busy magazine professionals is having a library of ready-made items that can be added to a page. These can be simple headline boxes with fills or similar attributes applied already, or these can be complex multiple-item structures, for example feature summary boxes with multiple graphics and text frame elements formatted and ready to go.

InDesign libraries are shown in their own Library panel, but as these are created and saved as self-contained documents they aren't initially accessed from the Window menu's list of panels. Choose *File > New > Library* and save this to disk. An empty Library panel will appear, ready to accept new library items. This will now also be available as a new icon in the icon dock and the Window menu while it is open.

Select a set of items and drag them into the Library panel to add them. An added item appears as a new item labeled Untitled; double-click this new

entry in the Library panel to open the Item Information window and give it a more useful name. The object type can also be set, although most of the time InDesign will set this correctly in the first place. Setting the object type incorrectly does no harm, but it won't help when you need to search for specific object types in a large library.

Open the Magazine Library file from the media CD. This contains a number of different library items ready to be dragged into your pages. If you click the search icon at the bottom of this panel you can find all the items that match certain criteria, but for this library just open the panel's popup menu and choose *Sort Items > by Type*. The items will be grouped according to their designated type, helping you find your way to the right items.

Find the Boxout with Illustration item and drag that from the Library panel into your page. A fresh copy will be made, ready to be edited. (Dragging a library item onto the page places it with everything selected ready to be moved. Using the panel's Place Item(s) command places things without selecting them.) The right-hand section contains a picture frame waiting to be filled. Open Bridge, find the Magazine Library.psd image from the media CD, and

drag it into the frame. Use the Direct Selection tool to pick the image and scale it within its frame, then switch to the Text tool and edit the title and body text.

Open the Sample Grid Elements Library from the media CD and try dragging different items into the page. Try mixing and matching different box widths to create a gridded layout structure that has the right kind of balance. The first page here shows different ways that these items can slot together, first using single sizes and then using different ones together. The

next page shows an arrangement of some of these boxes in a single layout, and the final one shows this arrangement used for a simple text-only page with a tint box placed behind one section. Don't try to fill every part of every page, and try to strike a balance of having variety but also a basic structural logic to the page layouts; reuse basic layout themes for similar kinds of content or sections of the publication.

Designing with Spreads and Graphics

The spread that opens the main feature article needs a large illustration that will fill both pages. This is created by taking a Photoshop image and drawing additional elements on top in Illustrator. Before the image was imported to Illustrator the dark outer areas were made a solid RGB black and then it was converted to CMYK. The CMYK conversion was made with Photoshop's default

US Web Coated (SWOP) CMYK settings, so the RGB black was converted to a CMYK black made from Cyan 75%, Magenta 68%, Yellow 67%, and K (black) 90%. As we explained in the poster project on page 165 this ensures a totally solid black with no chance of it appearing a little thin on the page. It also gives us a precise custom black color to mix up in Illustrator so the rest of the page can be filled with a matching black that won't be thinner on the page. (Before you go any further, you should always remember that that Photoshop's default color settings aren't necessarily the best ones for all your work. See Color Management starting on page 99 for details, but make sure you use the same settings across the whole of Creative Suite 3 to make sure everything is produced to the same percentage mixes.)

Make a new A3 landscape Illustrator document, then use Bridge to find the Photoshop image and drop it into the page. Choose the Rectangle tool and draw a rectangle that covers the entire page. Send it to the back, then show the *Swatches panel Window > Swatches*, open its popup menu and choose New Swatch. Set the color mode to CMYK and type in the values that make up the black area of that Photoshop image.

The stars sewn to the top of the canopy in the photo need to be replicated as Illustrator vector objects arranged to match the 3D perspective view angle and extended past the bounds of the photo itself. Make a new layer in the Layers panel and call it Stars. The first step is to make a single star to the right shape and then use that to create the rest of the star field. Click and hold the Rectangle tool in the tool panel to see the popup list of options.

Pick the Star tool from this list, then click – don't drag – on the page. The Star options dialog will appear; set the number of points to 8, then click OK. An eight-sided star will appear. If it isn't rotated so it has a set of points going straight up and down delete it and then click and drag out a new star, turning it to the right orientation before you let go.

Finally, switch to the Direct Selection tool **A** so that individual points can be edited. Start with the top point and nudge it a certain number of arrow key taps further upward, then move the bottom and side points outward as well, matching the nudge values for the opposite sides. Use the *Color panel Window > Color* or **F6** to set the stroke to None and the fill to 80% cyan and 30% magenta.

Use the Selection tool **V** first to scale the star to a more appropriate size, if necessary, and then to duplicate the star by option-dragging it to various places in the page. Avoid putting many in the vertical center of the page as that's where the magazine spread gutter will fall.

Once they're in the approximate position, switch to the Scale tool. Hold the **⌘** **ctrl** key down to switch to the Selection tool

and click one of the stars, then let go – the tool reverts to Scale. Press **Return** to call up the Scale window and scale the selected star to a more appropriate size for its position in the page. The Preview checkbox lets you fine-tune the size before clicking the OK button.

Select one star, then choose *Effect > 3D > Rotate*. Click the Preview checkbox so you can see how your efforts will look and then rotate the cube to tilt the star so that it looks like the ones sewn to the canopy in the photo. If you're having trouble controlling the cube's movements try grabbing and pulling one edge at a time, or just type in coordinates instead. Some rotation settings to get you started are −50°, 30°, and −20°, with perspective set to 30°. Repeat with the rest of the stars to make them fit better with the stars in the photograph.

Now the area on the right needs to be knocked back a little so that text can be reversed out of the dark background without the star shapes interfering with legibility. One simple solution is to darken the fill color of the shapes in that area, but for a more convincing shadow effect a blend shape will be placed on top instead. Pick the Pen tool **P** and draw a box around the right of the page and curving around the illustration on the left. Fill this with white and set the stroke to None, then draw another shape with its curved side much further to the right. Fill this with the rich black.

With the Blend tool **W**, click a point in one shape and then a corresponding point in the other to create a shape blend between the two objects. Finally, use the Transparency panel again to set the blending mode for this object to Darken. The right-hand side of the blend shape is too dark, so switch to the Direct Selection tool **A**, click the black shape in the blend object, and use the Transparency panel *Window > Transparency* or type **⌘ Shift F10** **ctrl Shift F10** to change its opacity to 70%.

Now it is time to pass the graphic along to the magazine layout. If you're working on your own you may prefer to use the standard Save process, but if you work with others then you should use Version Cue instead. It provides simple but robust management of resources, making things available as required while preventing two people from trying to edit the same thing. (If you haven't yet started a Version Cue project you'll need to set it up at this point; see page 49 for details, then carry on with this project.)

Choose *File > Check In* and pick a Version Cue project to use to manage your file. This process is very much like regular saving, but it hands over control to Version Cue to make sure everything is managed safely. If you're working on your own or perhaps with one other person then Version Cue isn't quite such a compelling product, but it can still be very useful for organizing all the various parts of a project together and keeping track of file versions and updates. Save this as a native Illustrator file, but make certain the option for Create PDF Compatible File is checked.

Importing the Spread Illo

In InDesign, choose *File > Browse*, to step over to Bridge. If you saved the file without using Version Cue then just navigate to the Illustrator graphic and select it as normal. Otherwise, select Version Cue on the left. The server used to check in the Illustrator graphic should be visible. Open this, logging in when asked, and locate the project and then the graphic.

Once found, drag and drop the image from Bridge into your layout or choose *File > Place > In InDesign*. Because it was made in an A3 landscape format document this graphic will fill the pair of A4 pages precisely, but it needs to have a 3 mm bleed all around as well. Select the graphic frame, then use the Reference Point control at the left end of the Control bar to set the item's location reference to its top-left corner. All that's needed now is to set the

X and Y coordinates to -3 mm each, and make the width and height 426 and 303 mm so that it projects around the spread by 3 mm on all sides. Select *Object > Fitting > Fill Frame Proportionately* or type ⌘ ⌥ *Shift* *C* *ctrl* *alt* *Shift* *C* to scale the image to fill the box. The enlargement that this causes is minimal, certainly not enough to reduce the resolution of the Photoshop image embedded in this page enough to worry about.

This doesn't account for the problem that the gutter can pose if the magazine is going to be perfect bound (glued edges) rather than saddle stitched (stapled). Because this never opens up completely, you effectively lose a small amount of the layout down there. Rather than just accept this, the answer is to double up the graphic and provide a little duplication in the crease.

Start by choosing the Selection tool and copying the graphic frame. Then drag the right edge of the graphic frame into the gutter so the box only fills the left page of the spread. Choose *Edit > Paste* in Place to put a full-size copy of the graphic frame back in place in the spread. The final step is to nudge this new graphic frame across to the right by 5 mm and then drag its left edge into the spread gutter. It may look a little odd in your on-screen layout, but when the spread is viewed in the magazine the image will appear complete, without any of it being lost to view in the gutter crease. If you find that this amount of graphic duplication is too much then simply reduce the amount that the second item is moved across. But do beware of increasing this value. If it is overdone, this effect is far more noticeable than simply losing some of the illustration.

Locking the graphics using *Object > Lock Position* ⌘ *L* *ctrl* *L* will prevent these from being moved accidentally. They can, however, still be selected. To make these ignore clicks as you go about the rest of the layout

process, put them onto their own layer and then lock the layer itself.

Open the *Layers panel Window > Layers* or type **F7** and use its popup menu to create a new layer. Give this a suitable name, but remember that layers are available throughout an InDesign document rather than just in one spread. Name it appropriately, considering that you may want to use it for similar tasks on other pages too. The other options in this New Layer window are worth noting as they show what can be done with layers, but leave the controls as they are for now.

The graphic is still on the regular Layer 1 layer. With the Selection tool, select both frames and then cut them from the page *Edit > Cut*. Click the new layer in the Layers panel, then choose *Edit > Paste* in Place to put the graphics back into the spread, in the same location but on the new layer. Now the layer can be locked by clicking the area between the visibility icon (the eye) and the layer name. Don't forget to select the other layer before you try to add any elements to the spread.

Now that the graphic is in its final place it is obvious that our version has a star sitting right on the fold. Go back to Illustrator and move the problem star to one side, then save or check the image in again. When you go back to InDesign, show the Links panel; choose *Window > Links* or type **⌘ Shift D** **ctrl Shift D**. If there's a gray pencil icon next to the yellow warning triangle this means that the item in question is in use and needs to be checked back in to the Version Cue project. Select the image's entry in the Links list and then choose Check In Link from the panel's popup menu. Once this icon is cleared, choose Update Link from the panel's popup menu. Repeat for the second copy.

Laying Out the Page

With the background image layer safely locked, the feature title, standfirst and main text can be laid out on the page. Show the page grid if it isn't currently visible, then choose the Type tool **T** and draw out a text frame for the main

title. For this spread, the title text is 'Origin Stage'. It is set here in a font called Cracked, but any bold condensed sans-serif will do. The text frame is nine columns wide and placed starting from the eighth column (counting from the margins, not the page edge); just a little left of the middle. With this font, the type is set as 155 pt on 100 pt leading, tight enough to bring the two lines clashing together as a graphic unit. At this size the type itself fills eight columns. Place it vertically centered in the top half of the page, with three grid rows above the lettering, and use the Swatches panel to make the text white.

The lower half of the page will hold the start of the article itself. Draw out a text frame directly below the title, in the same eight columns, starting in the fourth row below the headline. Make this eight rows high so the frame is a square, click inside and choose *File > Place* and import the Magazine Article. txt file from the media CD. Format this type using the Body paragraph style, then use the Swatched panel to color this white as well.

The standfirst, or kicker, is used to provide an attention-grabbing summary of the article. Draw a new text frame for this, eight columns wide as well but just a couple of rows deep. Place this so it projects halfway into the main text block, then open the Text Wrap panel and click the simple 'Wrap around

bounding box' icon. The final touch here is to unlink the offset fields by clicking the chain icon in the middle and change the right-hand offset to 2 mm. The article text will wrap around the box, leaving it visually clear and ready to hold the standfirst, up to five lines of intriguing summary text. If you use less text so this box isn't filled you can either leave the empty space there as part of the design or bring up the base of this frame so the body text can wrap up around the standfirst.

Master Pages and Page Numbering

InDesign's master pages can be used for far more than just holding grids ready for your new pages. Anything you put on them will appear on every regular page that uses that master. There is a limitation with this feature that makes it somewhat less flexible than it might be, so we'll explain that first of all. Master page content can't be changed on individual pages; frames can't be adjusted and, more importantly, contents can't be edited. This means you can't set up generic text and graphic frames in the master pages and use that to hold different content in different sections of the magazine. However, this is still a useful feature when dealing with standing content such as the magazine name itself and perhaps the web address. And there is a certain type of content that does change itself, entirely automatically, according to the page it is on.

InDesign's automatic page numbering feature is the most widely used example of this ability. Insert its special character into a text frame on a master page, and every regular page will show its current page number in its place. There's a sophisticated Text Variable feature that stems from this; other things that can be used include chapter number, creation and modification date, last page number, and running header.

(The Running Header text variable in particular is a curious option. It replicates the content from the highest-placed non-linked text box on the page, so that it can be placed at the top of the page as a small header and it will show the text from the main title frame. Or, in fact, whichever frame is 'on top', highest in the stacking order on the page; there's no way to apply any further control over it. Use this with care, as a careless 'bring to front' or just pasting a new text frame will change the text that this variable shows.)

Double-click the A-Master page icons in the Pages panel and draw out a text frame fitting into the top row of the grid. Click into this and select *Type > Insert Special Character > Markers > Current Page Number* or type ⌘ ⌥ *Shift* N *ctrl* *alt* *Shift* N. The object inserted looks like a letter A, but it is replaced by the current page number in the regular pages that use this master. Format this as small text; 10 pt Univers 45 Light, or a similar font at that size. Pick a text color that will work across all your pages if possible. If not, you'll have to work around this on individual pages where graphics and filled frames demand different colors – or simply allow the numbers on those pages to be lost in the background surrounding tones in some layouts.

Table Handling

Tabular data is often used in magazines, whether it is schedules, scores, or countless other things. InDesign's tables are easy to use, but there's no separate tool for creating them. Instead, you have to use a text frame and insert the table there, or have a table created from the existing text content. Draw out

a text frame to the left of the main title in the opening spread and import the 'Origin schedule. txt' text file from the media CD. This contains tab-separated text, but you can work with other text delimiter formats if you like. Data exported from Excel or databases in standard tab and return-delimited format is ideal for this kind of use.

Apply the crosshead style, then color the text white so you can see it on the black background. With tabbed text you'd normally have to set up the tab spacing formats, but instead, this will be turned into a table and handled like that. Select all the text – this process only works on selected text, so you can do this within longer runs of copy if necessary – and choose *Table* > *Convert Text to Table*. InDesign assumes the table elements will be separated by tabs and returns, but as well as the tab, comma, and return options you can use any single character to define the column and row separators.

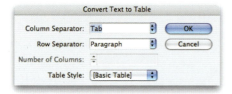

The result is a table with the data held in equal-sized cells. To alter the size of a column or row, click and drag its border. The table will resize to accommodate your changes, but if you'd rather it stayed the same overall dimensions then hold down the Shift key while you drag. This makes the column or row divider move without affecting the overall table size. Adjust the table so that the cell edges fit into the page grid.

Table cells have a default inset value so the contents don't sit against the cell edges. As a result, the text doesn't sit perfectly on the grid. If this is an issue then there are various ways of improving the appearance. The simplest method simply involves dragging the cell borders off the grid so the content sits on it instead. If the border keeps snapping to the grid too much, hold down the Control key as you drag; that toggles the Snap to Guides setting found in *View* > *Grids & Guides*; if snap is on this turns it off, and vice versa.

To control the text inset directly, drag-select through the cells you want to change, then choose *Table* > *Cell Options* > *Text* ⌘ ⌥ *B* *ctrl* *alt* *B*

and change the Cell Inset values. Unlink the four fields and change just the sides that matter, or you may find that you have height differences with other text in the table.

In fact, the solution used for this layout involves showing the columns and rows directly instead of trying to push the text to fit the grid. Choose *Table > Table Options > Table Setup* ⌘ *Shift* ⌥ *B* *ctrl* *Shift* *alt* *B* and click the Fills tab. Open the Alternating Pattern popup menu and choose Every Other Row. In these controls, set the first row to have a black fill with an 80% tint and the next to have no fill. Applying fills to the table rows helps to present the table as a complete unit rather than simply as spaced-out items of text.

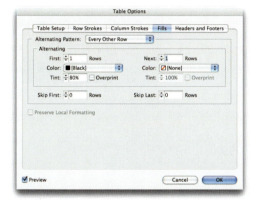

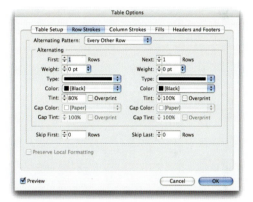

If you hide frame edges *View > Hide Frame Edges* you'll now notice that the divisions between each cell, the column and row dividers, are shown as gaps between the cells. Open the Table Setup window again and click the Column Strokes tab. When the Alternating Patterns popup menu is set to None the rest of the controls are disabled, so pick Every Other Column and then set the weight of both lines to 0 pt. Do this with the Row Strokes tab as well if necessary, and in the Table Border section of the Table Setup options too.

PDF Production

The final layout must be exported as a PDF before it can be sent to be approved and printed. First, however, it should be preflighted to make sure

everything is correctly formed and used. Choose *File > Preflight* ⌘ ⌥ *Shift* *F* *ctrl* *alt* *Shift* *F* to have InDesign create a report on the fonts, images, and colors used in the document. Once done, the Package button can be used to make a complete copy of the layout and all its assets, ready to be delivered or archived. But for most production needs a PDF is better; it contains all fonts and images in a single optimized and transportable file. So, having used this to ensure that there are no lurking problems, click Cancel to close the Preflight window.

Select *File > Export* and choose Adobe PDF from the Format popup menu. Check that the name is appropriate, and click Save. At this point the Export Adobe PDF window is used to pick the many different options that are available. Fortunately, you can pick from a number of presets rather than having to go through every choice in detail. Check with your chosen printer for the format they prefer, but Press Quality is likely to satisfy most commercial printing requirements without amendment. This downsamples very high-resolution images to 300 pixels per inch and converts color profiles to the document's destination profile. By default this will be CMYK US Web Coated (SWOP) v2. This can be changed in the Output panel in this window, but it is a better idea to set this in the layout document itself as a part of your color workflow process.

You may need to amend the Press Quality preset by adding various printers' marks in the Marks and Bleeds section; crops marks, color bars, and page information are options frequently required. Here you must also click the Use Document Bleed Settings checkbox or the PDF won't include this in the final artwork. Once ready, click Export and the PDF will be created. Here, the output is as a spread for proofing. Regular prepress production would generally involve imposition work to produce 'printer's pairs' rather than designer's pairs, so the Spreads option in the General section would normally be unchecked.

Gatefold Brochure

Fisheye view of the sea at Eastbourne, in England's south coast

Making the Gatefold Document Structure

Gatefold design requires a little more work than a simple page or even a standard double-page spread layout. Gatefold layouts are normally made in one of two ways; either by putting multiple regular pages together in a large spread or by dividing a custom page size up into sections, with each section representing a different gatefold panel 'page'. If a simple gatefold brochure is needed then you can use whichever method you prefer, but if the gatefold is part of a larger document you'll need to work with the existing page sizes. Although this project involves creating a self-contained gatefold brochure rather than adding gatefold pages to a magazine we will use the multiple page approach.

Make a new InDesign document and pick A5 (148 × 210 mm) as the page size. Have Facing Pages unchecked and set the margins to 5 mm, then click OK. Now open the Pages panel by clicking its icon in the panel dock, choosing *Window > Pages*, or typing ⌘ F12 ctrl F12. As normal, the first page in a document is placed on the right. But for this project you need to be able to make a spread there instead. To make InDesign let you do this, open this

209

panel's popup menu and uncheck the option called Allow Document Pages to Shuffle. This means that pages will now go where you put them without causing the page and spread order to shuffle around to accommodate the new items. Now you can add more pages to a single spread.

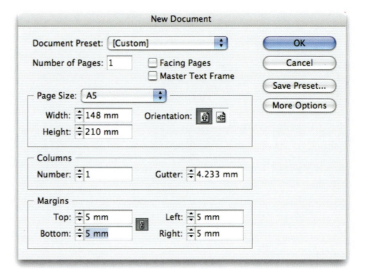

Drag a page from the A-Master set down next to the single page in the main part of this panel. Don't let go until you see the narrow 'square bracket' symbol indicating that this will be placed alongside the existing page rather than as a new spread or replacing the current page. This option is only available if page shuffling is turned off, either for the current spread or for the document as a whole. Drag pages into this spread so that there are four pages in total, one for each of the panels in one side of the double gatefold spread.

Okay, that's made all the pages that are required for one side of the gatefold (the other we'll handle in a little while), but guides are needed before the layout process begins. In the Pages panel, double-click the A-Master page icon and then choose *Layout > Create Guides*. Set the guides to fit to the margins rather than the page, and give this 8 rows with a 3 mm gutter and 5 columns with a 5 mm gutter. These are also applied to all the regular pages already created in this document, as you'll see when you double-click the spread icons again.

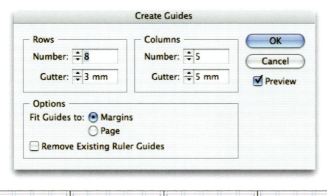

New Version Cue Project

Before going any further a new Version Cue project should be set up to store the files that will be used with this task. Open Bridge, select Version Cue on the left, and double-click the Integration Server icon in the Content pane in the middle. (Assuming that's the name you used when setting up Version Cue – see Version Cue on page 53 for details.) When you are asked to log in, use the 'system' administrator username and password that was set up when you first started Version Cue. This process is discussed in more detail in the main Version Cue section.

Click the New Project icon or choose *Tools > Version Cue > New Project* and name the project Gatefold Layout. Type some descriptive text into the Project Info field, and click the 'Share this project with others' checkbox. Click OK and this will appear as another project icon in the Version Cue server.

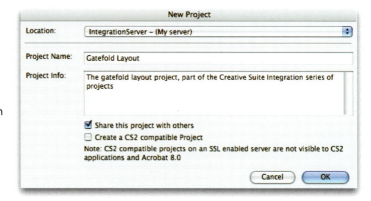

Now step back to InDesign and save your project. Select Version Cue in the dialog window (click

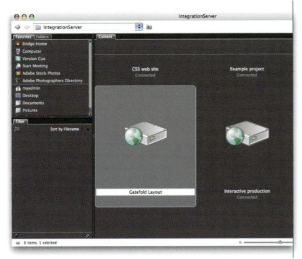

the Use Adobe Dialog button if necessary), go into the server and the gatefold project – sign in when asked, using the regular user name rather than the system administrator details – and save this layout document there. As well as saving a copy to disk, this creates the first Version Cue-tracked version of the layout document, so type an appropriate version description at this point.

All the files that go to make up this gatefold will be kept in this Version Cue project, and the versioning features will be used to help produce different versions of the layout as you progress. As well as general management of ongoing work, this is very useful when managing alternative versions of the layout while waiting for client approval.

Custom Crops

One big stumbling block for gatefold production is the inability to make pages of different sizes in one InDesign document. This is needed in order to make the outer gatefold pages smaller than the regular pages so they fit inside when everything is folded together. As InDesign can't do that on its own we have to fake it by drawing custom crop marks. For this job the custom crops will be set 2.5 mm in from the actual page edge so that the gatefold page is a quarter of a centimeter narrower. This is not a particularly large gap, but it is enough to

ensure that the gatefold panels will stay clear of the center fold. These should be used instead of the regular crop marks when the document is produced.

In order for the hand-drawn crop marks to be printed the document's bleed setting needs to be set to an appropriate size; 3 mm is commonly used for regular bleed requirements, but you'll need rather more than this to show enough of your hand-made crop marks so that the printer can find the right place to trim the pages. Choose *File > Document Setup* and click the More Options button if it is showing. (If this is already open, the button will read Fewer Options instead.) Change the Bleed value to 8 mm. This is an exceptionally large amount of bleed, but it will allow full-size crop marks to show up.

Next, open the Layers panel, make a new layer and call it Crops. Keep this layer above all others,

and draw out the crop marks here. The crop marks themselves must be made from fairly thin lines. InDesign's regular crop marks are 0.25pt in thickness and a fraction over 5 mm long, offset away from the page edge by a little over 2 mm unless you choose otherwise. This is thick enough to be easily visible on the freshly printed page but thin enough to provide a precise point for the trimming process, so make your crop marks the same as this.

Use the Line tool to draw short strokes in roughly the right position and then fine-tune their size and position using the X, Y, width and height fields at the left end of the Control bar above the document window. Remember to inset the vertical ones by 2.5 mm from the page edge to reduce the width of the gatefold page by that amount. It is also worth having a custom guide positioned at the left and the right where the gatefold will be cut to help you plan the design carefully.

Draw marks to indicate the folds as well, as gatefold spreads are a little more complex than standard left/right page pairs. These marks need to be lined up above and below each of the page divisions, where the folds need to go. Use the Stroke panel to change the line type from solid to dashed, and consider putting a small text frame next to it that labels it as 'fold'.

The stroke color of all these lines should be Registration rather than black. The Registration color is used at full strength on every separation of the final product; it appears on the cyan, magenta, yellow and black plate as well as any spot color plates you might have. This is done so that it doesn't matter if you only use some of the color channels in a job rather than the full CMYK set or even if you use spot colors only, you'll still get a full complement of crop marks.

Crops are also normally given a white surround in case they sit over a dark image that's bleeding off the page edge. Once you've made your custom crop marks and put them in position you should set up a similar effect to ensure they remain visible in all situations. Select all the crop marks and copy them, then choose *Edit > Paste* in Place ⌘ *Shift* ⌥ *V* *ctrl* *Shift* *alt* *V* to paste them back into the exact same place on the page. Open the Stroke panel (*Window > Stroke*) and set the weight of all these lines to 2 pt, then choose *Object > Arrange > Send to Back* ⌘ *Shift* *[* *ctrl* *Shift* *[* to put them all behind the slim black strokes. Now anything that sits in the same place in a lower layer won't be able to obscure the crop mark strokes, whatever color it is. Lock this layer so that you won't accidentally move your carefully crafted custom crop and fold marks later on as you work.

Now that you've finished this stage it is the perfect time to duplicate the spread. This gives you the second spread for the back face of the gatefold document, complete with all the crops in position and ready to use. Open the Pages panel *Window > Pages*, or ⌘ *F12* *ctrl* *F12* and shift-click the first and the last page icons to select the whole spread. Choose *Layout > Pages > Duplicate Spread* to produce a copy of the selected spread. In the InDesign numbering scheme these will be pages 5–8, but in your gatefold spread terms this is simply page 2. The right-hand page 'panel' in the second spread will print on the reverse of the left-hand panel in the first spread, and because the custom crop marks are equally inset on both sides of the document everything will line up precisely.

If this layout was for a single gatefold you would need to put the cropped page on the opposite side for the second spread, or the slightly narrower panel wouldn't match up front to back.

Large Illustration

The contents of the outsides of the gatefold pages need to be considered carefully, from the esthetic, creative point of view and from the technical angle too. Should the panels have visual content that works across from one page to another when one or both sides (if it is a double gatefold, as this project requires) are folded in, or should these extra parts be used to show other content? How can you make the most of the fact that the spread has, in effect, multiple states, meaning with the gatefold panels closed and with them open? And don't forget to factor in the slightly narrower size of the gatefold panels themselves when planning the layout contents. Gatefolds offer a great deal of creative scope, but they take a certain amount of technical discipline to handle well.

This gatefold design project uses an image that's run across the whole inside spread, with type arranged in regular column grids within each page panel. The total width that the image needs to be is two times the standard 148 mm width of the inner A5 pages plus two times the 145.5 mm width of the gatefold panels, plus the standard 3 mm printing bleed allowance on each end. At a total width of 593 mm including bleed allowance this image needs to be fairly large.

Launch Bridge and find the Gatefold photo.psd image from the media CD. With it selected, the File Properties section of the Metadata pane shows the image dimensions in pixels and in inches, its resolution, and a lot of other information. If you prefer to see the dimensions in centimeters rather than inches, open Bridge's preferences, select Metadata, and check the Dimensions (in centimeter) item. Click OK and this information will appear.

As with many digital photographs this has a resolution of 72ppi. This is why the physical measured width is so large. Double-click to open this image in Photoshop, then choose *Image > Image Size* or type ⌘ Shift I ctrl Shift I.

In the Image Size window, uncheck the Resample Image checkbox first of all, then change the Width field in the Document Size panel to 59.3 cm. (The height will change automatically.) Because the image won't be resampled to the new size, the pixel grid that makes up this image will be scaled to fit the existing image into the new dimensions. This gives an output resolution of just over 350ppi, which is perfect for high-quality print work. Detailed photographic images should normally not be printed at less than 300ppi at their output scale, and 350ppi is a goal worth aiming for when possible.

This image is still in RGB mode, not in the CMYK format that's required for professional color reproduction in print. You should be sure that your CMYK conversion settings are appropriate for this task; see Color Management on page 99 to read about this topic in detail. For this project we will use Photoshop's current settings, the key one being the CMYK 'working space'. (The selected CMYK working space defines the print characteristics that will be used to reproduce the image on paper, and they have a bearing on how the RGB color is converted to CMYK.) Choose *Image > Mode > CMYK* to convert the image using the current settings.

At this point you should save the image into the Version Cue gatefold project that you set up earlier. Choose *File > Check In*, pick Version Cue on the left and navigate your way to the Gatefold Layout project, and save this as a native Photoshop (.psd) document. Add appropriate information as the version comment when asked, as it can be very useful to have a little extra information about individual files when rooting through long lists of documents later on.

Placing the Image

Draw out a rectangle using the Rectangle Frame tool **F** and make it fill the whole spread, but run from the top to half way down the page. With the rectangle frame still selected, choose *File > Place* **⌘ D** **ctrl D** to import the image. Choose Version Cue from the left of the Place dialog and find the CMYK image you just saved in the Gatefold Layout project.

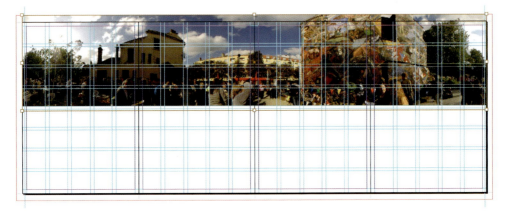

When you click OK, the image will be placed into the selected rectangle. If you didn't select one first you'll have to click on the page to place it, then use the Selection tool to move and crop it to fit – although only the height of this image needs to be cropped; the width was set to precisely what was needed using Photoshop's Image Size controls. If you do need to resize an image, use the Info panel to check that the effective pixel per inch – the output resolution after scaling – is good enough for high-quality printing, or at least the level of printing that is planned.

Typesetting

The gatefold document will contain headline and body copy text plus some tables of information. The headline type will be run across the middle two pages of the inside spread, crossing the center fold line. Select the Type tool and drag out a text frame that sits over the bottom edge of the image, running across pages 2 and 3, as shown here. The frame itself won't sit precisely on the grid lines, but the text content itself will.

In this text box type the headline, 'The Battle of Cable Street'. Here, it is set as 52 pt Frutiger 65 Bold in black. If this isn't available then use Arial Black at 44 pt instead. The type should run across the right-hand four columns of the second page through to the left-hand four columns of the third – in other words right across the center of the spread.

Switch to the Selection tool and use the arrow keys to nudge the text frame down until the bottom of the letters are along the bottom of the image and the type is centered in the layout. The central page division should fall neatly between the words 'of' and 'Cable'. It doesn't matter for this particular instance of type if the fold falls between the words or not, but we'll be using this headline again across the gatefold and it certainly will make a difference there.

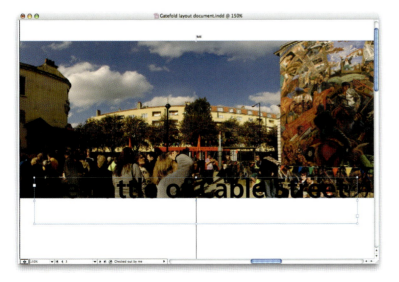

Select the headline text frame and choose *Object > Effects > Drop Shadow* to add a drop shadow effect to this type. Don't accept the default settings, change the angle to 90°, the X and Y offsets to 0 and 1 mm, respectively, and make the size to 2 mm.

The body text frames will run across the center three columns of each panel in the spreads. Choose the Type tool again **T** and draw out a box in one page, starting from the second row down and continuing to the second from last row. Fill it with dummy text by choosing *Type > Fill with Placeholder Text*, then select the text and set it as 10 pt Frutiger 55 Roman, or 10 pt Arial Regular if Frutiger isn't available.

The leading needs to be slightly wider set than the default 120%, partly so that it sets a little less densely on the page and partly so the lines begin at the same location down the page from one row to the next. Five lines between each row is what's wanted, so the leading needs to be the distance between the top of one row and the next divided by five.

Draw out a basic rectangle that covers this vertical distance and make a note of its height and the units of measure. Select and copy the text and put that value plus '/5' into the leading field. With the grids in this example you should have '23.375 mm/5'. Press **Return** or **Enter** and the number will be divided by five and the result shown in the standard unit of measure – which is, in the leading field, points. What you should have, assuming you followed the guides setup directions earlier, is a leading of 14.386 pt and every sixth line of type beginning at the same point in the next grid row down.

This approach to determining leading may seem a little over-picky, but it can help make type and objects in layouts behave much more consistently throughout the page. With some of this text selected, open the Paragraph Styles panel **⌘** **F11** **ctrl** **F11** and choose Redefine Style from the panel's popup menu. Now type will default to these settings without further work.

One popular alternative uses the baseline grid, set in the Grids section of InDesign's Preferences window. Set this to the desired line spacing frequency

and click OK. This grid is shown by choosing *View* > *Grids & Guides* > *Show Baseline Grid*, and type is snapped to the baseline grid by clicking the small Align to Baseline Grid icon at the base of the Paragraph panel *Window* > *Type & Tables* > *Paragraph* or type ⌘ Shift T ctrl Shift T. As long as the paragraph's leading isn't larger than the baseline grid spacing the type will snap to each of the baseline guides, otherwise it will snap to fewer guides and have substantially larger effective leading.

Once the type is set, use the Text tool T to create matching text frames in the other three pages in this spread, then link them together. Switch to the Selection tool V and select the first text frame. Now click the small box in the lower-left of the frame, then click the second frame. Any overmatter – excess text – in the first frame will flow to the next. Repeat with the other frames, then choose *Type* > *Fill with Placeholder Text* again.

Once the body text frames are finished in this spread, select the headline frame and use the Text Wrap panel *Window > Text Wrap*, or ⌘ ⌥ W ctrl alt W to give this a basic text wrap setting. Type in the main body text frames that run over the headline frame will wrap around the boundaries of this box rather than flowing over the large type. Drag the bottom of the headline frame up so that the body text stops and starts again at appropriate distance from the headline characters. The headline's text wrap has been given a top offset of 2 mm to balance the distance between the lines of body text, something that will become obvious in a moment.

The picture now needs to be treated to improve the text legibility. Select it, then choose *Object > Effects > Gradient Feather*. The Effects window will open with this option selected. Change the angle from 0° to −90° and click OK to apply this setting, and the image will have a transparency gradient going from solid at the top down to totally transparent at the bottom. Body type will be clear and legible on top of this knocked-back image, allowing lots of information to be laid out on the gatefold's inside spread.

Placing the Image on the Other Gatefold

Select the image and the headline text frame and copy them, then scroll to the second spread, double-click a page and choose *Edit > Paste* in Place. The items will be placed into the same relative location in the second spread. Drag both items together to the left so that the right-hand edge of the image sits snug against the page division in the middle of the spread. The headline should now be projecting halfway off the left of the spread. Now hold down the ⌥ *alt* and drag everything so that a duplicate starts in the middle of the spread and projects off to the right as well. (Option/alt-dragging duplicates the items being dragged, leaving the original in its place.) Now when the gatefold is printed and the panels folded up, the images and the headline type on the gatefold panels themselves will mimic the image and headline on the inside.

Use the Swatches panel change the color of this headline type to white, then select the frame with the Selection tool, open the Effects panel ⌘ *Shift* *F10* and click the Clear Effects button at its base to remove the drop shadow effect. Do the same to remove the gradient feather effect from the image. The type should now be reversed out of the picture.

At this point you should choose *File > Check In*. This creates a new version in the Version Cue server, complete with your comments.

Importing, Modifying, and Relinking an Image

Part of the mural in the main photograph has been cut out as a separate graphic and saved with a transparent background; this is the image called 'Horse.psd' that you'll find on the media CD. Open the image in Photoshop, choose *File > Check In* and store it in the Gatefold Layout project without making any amendments. Make a new Illustrator document in CMYK mode, choose *File > Place* and import this image from the Version Cue project.

With the image selected in the Illustrator page, choose *Object > Live Trace > Tracing Options* and click the Preview checkbox. The trace will start as a black and white graphic, but this can be changed very simply. In the Adjustments section, change the mode from Black and White to Color and set the Max Colors to just 4. Click the Trace button and the image will be shown as a vector-traced object rather than the actual bitmap image. Check this into the Version Cue project to save it as an Illustrator document and make it ready for use, picking the PDF Compatible File option when choosing the format.

Back in InDesign, choose *File > Place* and import the image. Place it so it sits on the edge of the right-hand gatefold page in the first spread and scale it so that it goes across three columns, as shown here.

Open the Text Wrap panel *Window > Text Wrap* or type ⌘ ⌥ W ctrl alt W and click the third icon (not the second) in this panel's set of options to wrap the text around the object. At this point the rectangular boundaries of the image are used. Choose More Options from the panel's popup menu and then select Detect Edges from the Contour Options Type menu; now the text wraps around the contours of the graphic itself. Send the image to the back *Object > Arrange > Send to Back* so it doesn't obscure any of the text.

What would be ideal for this image is a bit more of the neck in the image so the head could be a little higher on the page. Go back into Photoshop – open the Horse.psd from Bridge again if necessary – and use the Layers panel *Window > Layers* or type F7 to show the second layer in this file. This contains, for your convenience, more of the image, so you don't have to rebuild it yourself. Save the change you just made and step across to Illustrator and the Live Trace vector version of the horse head.

Illustrator may now ask permission to update the image, or it may simply go ahead and apply the image changes. Either way, the traced image will be rebuilt using the extra image data. All you need to do now is save the graphic – but leave it open for the moment.

Step back to the InDesign layout once more and open the Links panel *Window > Links* or type ⌘ Shift D ctrl Shift D. The

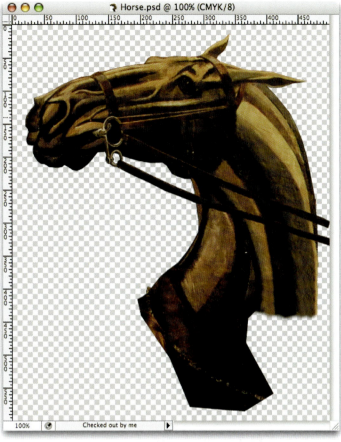

line that lists this image will show two icons next to the file name. The gray circle with the pencil shows that the image is in use, with the latest edition not checked in, and the yellow alert triangle shows that the linked file has been modified.

Select this entry in the Links panel and choose Check In Link from the panel's menu. Add comments to this new version. Now the gray 'in use' icon will disappear and you can choose Update Link from the panel's menu to bring in the latest version of the image into the layout.

There are more cutout Photoshop images supplied on the media CD that are intended to be treated in this way. Use the same process with the Bottle.psd and Man.psd images and add them to the InDesign layout. Check the layout in again and give it an appropriate description, then close it.

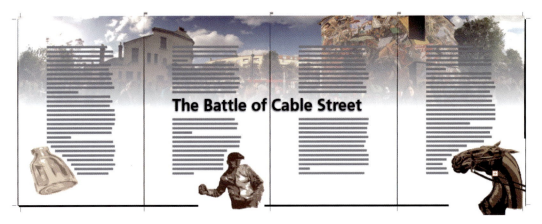

Dealing with Versions

You can return to any version that you've made at any point. To do this, open Bridge and navigate to the Version Cue gatefold project, logging in if requested. You'll now see thumbnail icons for each file in the project. The preview images for the InDesign layouts are taken from the first spread in the document. Click the gatefold layout document icon and then click the small View Versions icon in the top of the main Content pane.

The Bridge view will change to show every version of this document that you saved. Shift-click to select the two most recent versions and then double-click to open them. To see the two documents side by side, choose *Window > Arrange > Tile Vertically*.

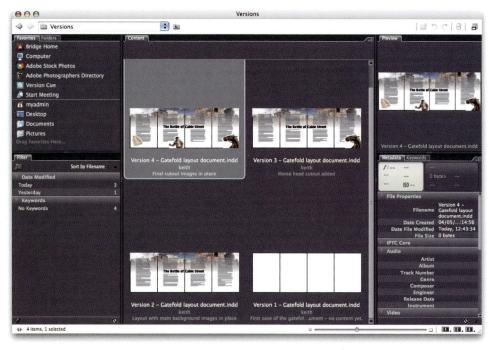

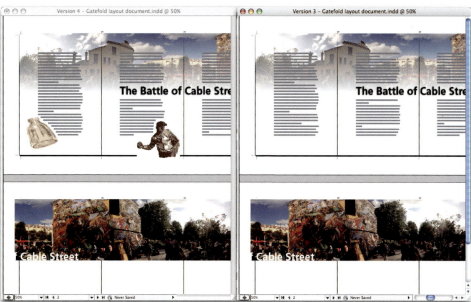

Presenting both versions to the client is best done by making PDFs from the different versions. The best PDF settings to choose depend on a number of factors, but you're unlikely to need to produce press-ready artwork. The perfect predefined settings are either High Quality Print or Smallest File Size.

High Quality Print is suitable for good-quality output on desktop printers such as inkjet devices. No color conversion is performed, but embedded profiles are included. Use this for general-purpose PDF production where the file may need to be sent by email and viewed on screen, but also may be used for desktop proofing – at least where absolute color precision isn't critical.

Smallest File Size is ideal when you need to email PDFs and know the document doesn't need to be printed. All color content is converted to RGB using the sRGB profile, a slightly reduced RGB space that's ideal for general cross-platform viewing. This preset also downsamples high-resolution bitmaps to just 100ppi, only a little higher than base screen resolution. As well as keeping file sizes right down, this ensures that any bitmap images aren't high enough quality for final print, so you remain in control of the print-ready artwork production.

(Of course, if this was the main reason for choosing the low-resolution output the alternative route would be to use the Security options in the Export Adobe PDF dialog to prevent printing entirely or only allow low-resolution output.)

Go to *File > Adobe PDF* Presets and choose Smallest File Size. In the Export Adobe PDF dialog you can customize any of the settings, but these are already set to the ideal combination for this project – apart from one vital option. In the Pages section of the General panel, click the Spreads checkbox. Without this checked, each page would be produced as a separate item.

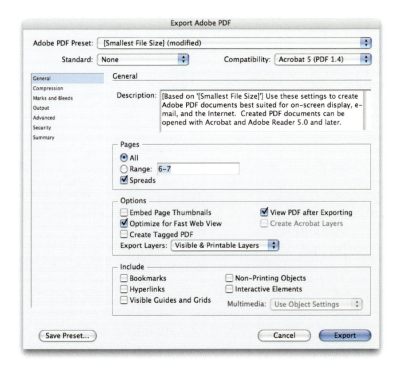

If there are any pages that have overset text, where there's more text than fits into a text frame, you'll be warned and given the option to cancel the export process and attend to the problem. One alert you definitely will see is the warning about mismatched color spaces. This is just to be expected as your document contains CMYK elements and the PDF will be made for sRGB. Just click OK to continue. However, although the PDF will reproduce the color layouts very well, be wary of making any crucial color evaluations from this.

Repeat this for the second spread. Thanks to the optimization methods used the final PDFs this produces will be well under 1 MB each despite having a large image running right across the top half of each spread.

File versions opened using Bridge will be named with their version numbers, so that will be added to the PDF file name too. Keep this to help both you and any clients know which PDF is which by the file name.

If you just want to send PDFs to a client for casual review then use your email software to send them as normal. The recipient can view them and let you know which version is preferred.

But if you want to have comments made directly in the PDF and also merge them together from multiple sources Acrobat itself can help. There are three methods, Email Review, Shared Review, and Browser Review. Use the email option when the recipients don't have direct access to a network folder or WebDAV server to store their comments. Open the PDF in Acrobat and choose *Comments > Attach* for Email Review. In the window that this opens, click Next (the file's already chosen) and add one or more email addresses. If you need responses to be sent to someone else's address click Customize Review Options and enter it here. You can also choose whether or not to allow Acrobat Reader users (version 7.0 and up) to be included or just those with the full Acrobat 6.0 and newer.

Click Next again to see the contents of the message that will be sent out with the PDF. This contains full instructions for someone to carry out a review and comment process and send back the PDF. Once received again, you can merge the comments into your original PDF.

The Shared Review uses a network or WebDAV folder to store the PDF and collect the review data. WebDAV support allows access from across the Internet, but if all the reviewers have access to the same network the Network Folder option is the easier option.

PDF review processes deal with on document at a time so they aren't suitable for comparing two PDFs at once. The only way to achieve this is to combine two or more PDFs into one and send the combined result to be reviewed in one file.

In Acrobat, choose *File > Combine Files* and add your files to the list. The file size and conversion settings are fairly basic: smaller, default, or larger are the three options available. In the next screen the choices allow a single PDF or a PDF Package to be produced. The PDF Package presents multiple files within one PDF wrapper, keeping the two originals a little more separate than if they are merged into one regular document. Do, however, check that this new format works with your reviewers before committing to using this for an important project.

If you decide to go back to a previous version the best way to do that is to 'promote' it in Bridge. Show the different versions of the gatefold layout and select the second from final one. Click the Promote button in the Content pane to create a brand new version from the selected item. Add fresh comments to help identify it and you'll have the chosen version recreated as the newest item in the set.

Designing for PDF Delivery

PDF documents can be considered as virtual printouts, the perfect way to publish precise layouts when paper is too slow and unwieldy. More and more documents are being made for use only in PDF form. But it takes care and thought to create a PDF that works really well on screen, especially if it should also double as a print source when required.

Size and Orientation

The first thing that needs to be considered is the orientation of the pages themselves. Most layouts are produced for portrait-oriented use, but as displays are invariably landscape this doesn't make the best use of the screen medium. For documents that will be the main focus of attention while they are in use, whether for reports or presentations, landscape pages are best. These make the most of the screen area. On the other hand, PDFs meant for use as reference works that are supposed to be used alongside other documents and windows on screen can be better as portrait-oriented documents so that they leave enough room for other windows to be seen.

The page size is another important related point to consider. The standard A4 or Letter size is fine for full-screen use when used in landscape mode, but these will use the majority of the average screen size when shown at 100% scale. For handy reference PDFs a smaller size is more useful; A5 or half-Letter are both fairly compact, but still allow enough room for usable design space. If the target audience is made up of creative professionals the screen is likely to be larger, so even A4 or Letter may do well as a reference document if more page space is needed.

You could simply pick a scale that's tailored precisely to the screen dimensions and intended uses of the PDF. For presentations an 800 × 600 or a 1024 × 768 pt document size will fit standard displays and projectors well in full-screen mode. Similarly, display-only reference works could be much taller than they are wide, for example 650 pt tall by 300 pt wide, leaving plenty of room for other software to use. But this approach precludes the option of being able to make sensible size prints as well.

This document we will produce will be a style guide showing logo, typeface and color usage instructions, and restrictions. The PDF needs to fit along with other work on a screen, giving room for users to produce reports, presentations, and layouts for print and web use while referring to the PDF pages.

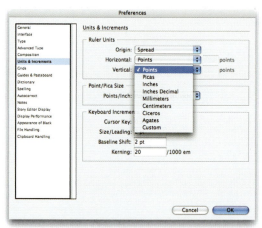

In InDesign, start by opening the program's Preferences window and going to Units & Increments. Because this is to be a screen-oriented design the measurement units best suited to this task are pixels, the smallest units possible in a screen-specific construction. InDesign doesn't offer pixels, but it does have points – and at the modern PostScript standard of 72 pt per inch these are effectively the same thing.

Choose *File > New > Document* and set the page size to A5 and the orientation to landscape. Type 10 into the Number of Pages text field, set the margins to a compact 10 pt, turn off Facing Pages (this isn't useful for screen-based documents) and click OK to create the document. Choose *View > Actual Size* ⌘ 1 ctrl 1 to view the first page at 100% scale rather than zoomed to fit the InDesign document window. The PDF created in this project will be set to open at this size so we can have some control over the layout presentation. This won't stop users from zooming the page magnification if they want, and in fact Acrobat 8 itself will do some scaling unbidden, but the design will be fine-tuned for this size.

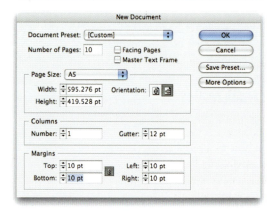

Guides

Open the Pages panel *Window > Pages* or type ⌘ F12 ctrl F12 and double-click the A-Master icon to show the master page. Choose *Layout > Create Guides* and set up a grid on the master page that is made of 8 rows with 0 pt gutters and 6 columns with 10 pt gutters. Fit the guides to the margins rather than the page and click OK.

You now have a grid structure ready for your screen-based layout. Regular type columns will always be at least two grid columns wide, although the type frames won't always be in the same place. The top two rows will be reserved for the logo, titles and navigation elements, and the rest of the vertical space is used for main content, divided up into two sets of three rows.

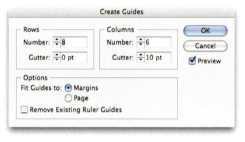

Type

Good screen-oriented design means taking care that your type setting is legible at the final display size. (Without taking charge of the display size of the PDF you can never be sure what scale that will be, but that will be made to default to 100%.) Headings and other display text requirements can be set with whatever suits the creative needs, but the body text typeface and size should be handled much more carefully.

Choice of typeface is critical here, especially with text sizes below 12 pt – and for effective use of type in smaller page sizes you should certainly be considering 10 or 11 pt, nothing larger for body text, and nothing smaller than 9 pt as the results are too cramped and distorted to be read comfortably. Most typefaces don't look particularly good even at 10 or 11 pt; many letterforms

tend to deform and shapes run together. Because of this, the best fonts in terms of pure legibility are the core 'web-safe' fonts, the ones designed to be clear and legible on screens at body text sizes. In terms of good typography these are Verdana, Trebuchet MS, and Georgia, with Arial making an appearance at 10 pt only. (Arial can't hold up at 9 pt, and at 11 pt and larger body sizes it shows slightly clunky letter shapes. Because of zoom control issues with Acrobat 8 it is best to avoid using Arial for small body text.)

Select the Text tool ⓣ and draw out a text frame two columns wide and three rows high in the lower-right section of the page. Choose *Type > Fill with Placeholder Text* to fill up the frame, then select all the type and set it as 11 pt Georgia with 14 pt leading. Open the Paragraph panel ⌘ ⌥ ⓣ ctrl alt ⓣ and uncheck the Hyphenate box.

With the type still selected, open the Swatches panel *Window > Swatches* or type ⒡⑤, choose New Color Swatch from the panel's popup menu and switch the color model to RGB. Set the color to 0 Red, 0 Green, and 127 Blue to produce a fairly dark blue, and click OK. This applies the color to the selected type and also stores it in the Swatches panel for use later as well. (If the type grows in weight the color has been applied to the stroke rather than the fill. Use the Fill/Stroke icons in the Swatches panel to set the stroke to none and the fill to the new blue.)

Open the Paragraph Styles panel *Window > Type & Tables > Paragraph Styles*, or type ⌘ F11 ctrl F11, show the panel's popup menu, and choose Redefine Style. This redefines the default 'Basic Paragraph' style to have the attributes of the selected text, so any further unstyled text will automatically take on this appearance.

Now choose Duplicate Style from the Style panel's popup menu to create a copy of the Basic Paragraph style. Call this Navigation Text, then click Basic Character Formats in the list on the left and set the font family to Verdana and the font style to Bold. Click Indents and Spacing and set the left indent to 20 pt and the first line indent to −20 pt. Click OK. This style will be used for the table of contents text that will be placed on the left.

Draw out a text frame that fits across the first two columns, starting from the second row down. This will be used for the table of contents, so import the Table of contents.txt file from the media CD. This text contains the titles and page numbers for the different pages that are in this document, with a tab between each number and the corresponding title. (As shown in the previous project, you could use the special technique for generating a table of contents from the document later on, but this is a simple project that doesn't need that kind of automation.)

Images

The only graphic used in this document will be the logo, an Illustrator document called AE Logo.ai that can be found on the media CD. First import this into a graphic frame in the first page, scale it up so that it falls off all the sides of the page, then open the Effects panel *Window > Effects* or type ⌘ *Shift* F10 *ctrl* *Shift* F10 and set the opacity of this object to 20%. Send it to the back to act as a visual branding element to this first page. Once it is in place, choose *Object > Lock Position* ⌘ L *ctrl* L to preventing from being moved again by mistake.

Now go to the A-Master master page, draw out a small graphic frame on the upper-left grid box and a little larger, and import the same graphic into this. Choose *Object > Fitting > Fit Content Proportionally* type ⌘ *Shift* ⌥ E *ctrl* *Shift* *alt* E to scale the graphic to fit the box without distorting. Because this is placed on a master page it will appear on every page in the document. It can't be edited or even selected on any of these pages, but it is just used here as a branding element and won't need to change from one page to the next.

While you're here in the master page, draw a rule starting from two rows and two columns in, straight down to the bottom margin. This is a standing structural element that will be used to separate different kinds of content in the individual pages. Go back to the first page to inspect the results.

Now use the Pages panel to move the second page. Page 2 contains a new copy of the logo with two boxes surrounding it, each with a simple 1-pixel stroke. This shows the minimum space that should be allowed around the logo. Draw out a text frame to the left of the vertical bar, two columns wide and starting two rows from the top, and add the following text: 'Regardless of the size that the logo is used, there should be a minimum safety margin of one 'logo stroke' width around the graphic.' To save time, put a simple label on the rest of the pages that don't yet have any content so you know which page you see when using the navigation links.

Hyperlinks (internal and external)

On page 2, draw out a small text frame in the right-hand column at the base of the top row, and make it the width of the column and 14 pt high. Type 'contents' in here, use the Character panel to style it as Verdana bold at 10 pt,

the Swatches panel to give it the custom blue color, and the Paragraph panel to make it centered. Then choose *Object > Text Frame Options* and set the vertical justification alignment to Centered. This will be used to take readers back to the contents page when clicked.

Choose *Window > Interactive > Hyperlinks* to open the Hyperlinks panel, and pick New Hyperlink Destination from the panel's popup menu. Name this destination 'Contents' and make sure the Page text field shows 1, or the destination will be incorrect. The Zoom setting should be either Fixed or Inherit Zoom so that the scale doesn't change when this destination is shown. Click OK.

Make sure the 'contents' text is selected in the frame and then, from the Hyperlink panel's popup menu, choose New Hyperlink. In the dialog window that this opens, almost all of the settings will all be correct already as there's not yet any other hyperlink destination created: it will take the user to the page with the destination link named 'Contents'. Change the appearance type to Invisible Rectangle so there's no rectangle shown around the link, and set the highlight to Invert so the link shows when it is clicked. Other than giving this an appropriate name, for example 'Back to Contents', that's all that needs to be done here, the link is made.

You can check that the link is working without having to create a PDF first. Select the link in the panel and click the right arrow at the bottom of the same panel. This takes you to the link destination, so you can check that you got this right.

In this 'Contents' text frame, put a 'less than' symbol (<) to the left and a 'greater than' symbol (>) to the right, with a couple of spaces between each to pad them out from the word in the middle. These will be used as back and forward links to turn the page. Unfortunately, there's no provision for a true generic 'previous' or 'next' link, so you'll have to make these links as you go, page by page. Copy and paste the text frame through the different pages before applying the right page number links; use *Edit > Paste* in Place to put the frame in the same position on each page.

This creates new instances of the 'Back to Contents' hyperlink; double-click each one to rename them so that it is easier to know which is which.

To make the back and next arrows link, select an arrow character inside one and choose New Hyperlink from the Hyperlinks panel's popup menu. Choose [Unnamed] from the Name popup menu and set the right page number below. Don't forget to give this hyperlink a name (and don't get too confused by all the name references here) so you can make sense of it later on in the Hyperlinks panel. Repeat with all the arrow characters in each page.

In the first page where the basic table of contents is found, select the first item in the table of contents and make it a hyperlink; choose New Hyperlink from the panel's popup menu, then pick the appropriate page number. If you'd rather choose names rather than numbers you'll need to add each one as a hyperlink destination first and then select that from the Name menu in the New Hyperlink dialog. This approach takes longer to set up, but it can be a little less confusing than using plain page numbers.

These hyperlinks can provide external links as well as links to different parts of the document. Go to the last page, draw out a text frame in the middle two columns in the lower three rows, and type 'See the Creative Suite Integration site for more information – click here'. Select the text and apply the Navigation Text style (you may then want to reset the indents to zero using the Paragraph panel), then choose New Hyperlink from the Hyperlinks panel's popup menu. Call this item 'CSI site link', choose URL as the type, and type the URL itself, http://www.creativesuiteintegration. com/, into the appropriate text field. Always include the protocol – in this case http://, although it could be https://, mailto:, ftp://, and so on – so that the link gets passed by Acrobat and the computer's operating system to the correct software.

Finally, remember to set the hyperlink's appearance correctly. As before, the main decision is whether you want a visible rectangle around the link or not, and if not, then whether you want a highlight to show when it is clicked.

(Because you have text rather than a frame selected when you open the panel's popup menu you could also choose New Hyperlink from URL.

This creates an external link without asking for further details, using the text as the URL. If you do this, make sure the URL is correctly formed in the text or double-click the new entry in the Hyperlinks panel to edit it.)

PDF Production

When the document is ready to be published as a PDF and tested, choose *File > Adobe PDF Presets > Smallest File Size* and choose where to save the PDF and what to call it. The Export Adobe PDF dialog will be configured already to match the Smallest File Size settings, ready to produce a compact, email attachment-friendly PDF in RGB format. (In fact, the resolution reduction feature of this setting is irrelevant for EPS graphics, but it is a good option in general anyway.) But don't click Export yet or your hyperlinks won't be included in the final document. In the Include box at the bottom of the General section, click the Hyperlink checkbox – that's all that needs to be done to enable the internal and external links. Click the View PDF after Exporting checkbox to have the document opened in Acrobat for you, saving you a small bit of effort in finding and double-clicking the file yourself.

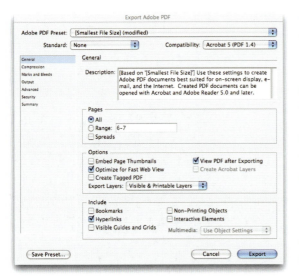

Now when you click Export the PDF will be generated as a compact, low-resolution document with embedded hyperlinks. Test out the links in Acrobat, making sure that they all take the user where they're supposed to.

If you find any problems with the links you should go back to the InDesign document to correct them. You can of course handle this entirely in Acrobat, but doing that means that if you need to make other corrections to the InDesign layout the PDF you generate will still

have those problem hyperlinks to be fixed. Always deal with this sort of thing as close to the source as you can in order to minimise the effort that has to be done later. (Not to mention helping avoid simply forgetting to do them at some point.)

Acrobat Zoom

When you finally get to test your PDF in Acrobat there are a few things that you have to do as part of the finishing process, things that can't be done earlier in the production process in InDesign. The first is to set up the default zoom setting for this document, otherwise the document window will automatically fill the screen and the page will automatically fill the window.

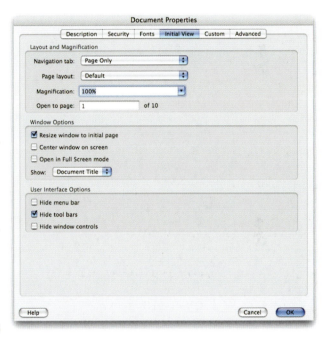

Choose *File* > *Properties* ⌘ D ctrl D to open the Document Properties window. Click the Initial View tab. This section controls how the PDF behaves when it is first shown. Leave the navigation and page layout options to Page Only and Default, but set the magnification to 100%.

Because this document is meant to be used as an on-screen reference it should be shown with its window wrapped tightly around the page rather than filling the screen. Select the Resize Window to Initial Page checkbox in the Window Options section and select the Hide Tool Bars checkbox. In addition, set the Show option to Document Title. Leave the other settings alone, those are aimed at presentation-style use of PDFs instead.

Click the Description tab next and type in the details for title, author, subject, and keywords. The title in particular should be considered carefully as we just told the PDF to use this rather than the file name in the document's titlebar. Type 'AE Official Style Guide' here.

You'll probably notice that Acrobat 8 is showing your PDF larger than it appears in your InDesign. This is intended behavior controlled by the application's built-in pixel

per inch compensation settings, although it makes a bit of a mess of the careful scaling efforts we went through earlier. Fortunately, older versions of Acrobat don't use custom pixel-per-inch settings to scale their '100%' zoom scale, so they will honor the default magnification correctly. The same goes for other non-Acrobat PDF reader utilities. With Acrobat 8, however, this is dealt with in the end user's application's preferences away from your control. You'll have to simply live with it – or perhaps pick a different default zoom if most or all of your readers are using Acrobat 8.

Security

There is one aspect of the PDF production and management that can be done in both programs, but can be best done in Acrobat. PDF security settings can prevent someone from opening the PDF entirely if they don't have a password, or it can simply block certain actions such as editing and printing. The security controls found in Acrobat have a few more options than those in the standard PDF export dialog, so open the PDF in Acrobat, choose *File > Properties*, click Security, and then choose Password Security from the Security Method menu.

The compatibility level dictates what security options are available, with higher versions of Acrobat being able to handle more restrictive controls. The standard option is to encrypt all the document contents, enabled by clicking the option to require a password to open the document. There is a separate option that can function independently of this setting, requiring a password before the user can print or make changes. Leave the first option unchecked so anyone can open the document, but click the checkbox entitled Restrict editing and printing of this document. Type a password into the Change Permissions Password field, set Printing to High Resolution, but leave Changes Allowed set to None. When you save the changes to this PDF everyone will be able to open, read, and even print the document, but only those with the password will be able to edit it. This is precisely the kind of restriction that's needed for an official corporate identity style guide document.

When closing the window you'll be warned that not all PDF readers respect the security settings. You'll also be required to type the password again to make sure you didn't make a typing error.

Web Graphics

The opulent Neptune pool at Hearst Castle, California

C reating graphics for use in web pages is very well catered for, despite the absence of ImageReady from the software suite. The programs to use are the ever-useful Photoshop and Illustrator plus the web-oriented Fireworks (only with the Web version of Creative Suite 3) and Flash, with the results put into practice using Dreamweaver. This project goes through the process of creating original web-ready graphics using Illustrator and Photoshop and also the adaptation of existing graphics and photographs for use online. Web graphics can be made in Illustrator, Photoshop, Fireworks, and even Flash – although Flash is obviously best at making its own Flash format media.

When working with bitmap (raster) images for print, the pixel-per-inch setting of the graphic is vitally important. If an image is used at a low pixel-per-inch level the printed result would look pixelated and soft and lack detail. Web graphics, on the other hand, are entirely independent of any such pixel per inch concerns. What matters is simply the pixels themselves, as the final display medium they appear in, the viewer's screen, is pixel-based itself. Each single pixel in the image is displayed using a single pixel of the end display, at

SHORTCUTS
MAC WIN BOTH

least unless it is specifically scaled differently in the web page. The pixel per inch setting of web-optimized, web-ready graphics is simply irrelevant. What matters is the number of pixels themselves. To fill a 400-pixel-wide space in a web page you need – a 400-pixel-wide image, plain and simple.

Basic Image Preparation

One of the most common processes is preparing photographic images for use online, and this is where Photoshop is the undisputed king. If the whole original image is wanted then all that needs to be done is to resample it to the appropriate pixel size. If it needs to be cropped as well then things can become a little more involved.

Open the SF Bay.psd image from the media CD. First of all, the horizon needs to be straightened. The final result will be scaled to fit a space 450 pixels high, but that won't be done yet. All editing of images should be done before the final resizing while there is as much resolution as possible, otherwise you won't have as much detail to work with and the results won't be as precise.

Go to *View > Screen Mode* and choose Maximized or Full Screen mode. This expands the window borders so the area around the image itself is visible.

To straighten the horizon first show the rulers – choose *View > Rulers* or press ⌘ R ctrl R – then drag a guide out from the top ruler down to the

general horizon area. You could instead show Photoshop's image grid by choosing *View > Show > Grid* ⌘ *'* *ctrl* *'*, but although this gives a grid over the whole image it tends to be too obtrusive, obscuring image detail too much.

Open the Layers panel (*F7*) and double-click the single layer in this image, the one called 'Background'. In the New Layer dialog that this opens, just click OK; you don't need to give this a custom name. This converts the flat background into a regular layer and makes it able to be rotated visually. (You can always rotate the whole canvas by choosing *Image > Rotate Canvas > Arbitrary* and typing specific degrees, but this is far too blind a method for this task.

Instead, now that the image is a floating layer, choose *Edit > Free Transform*. The image will have handles that make it scalable and, more importantly, rotatable. Point to just outside one of the corners and drag to rotate the image. Turn it to the left until the horizon is level, using the guide as an aid.

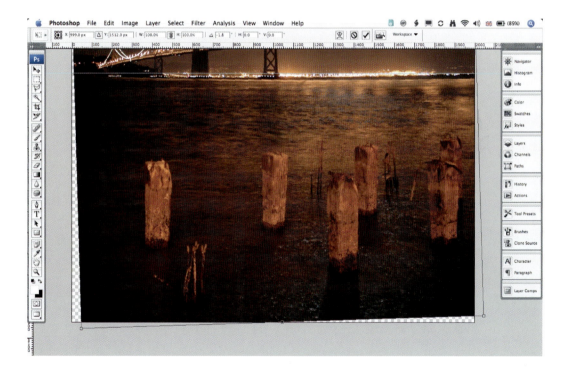

The content will now be level, but the corners need to be dealt with. Drag the handles in the middle of each side to stretch the picture out to fill in the gaps. Hold down *ctrl* as you do so to turn off the snap behavior so the edges don't snap to the image boundaries. When you're done, hit the *Enter* key, click the checkmark button in the Control bar or just double-click in the image to apply the transformation.

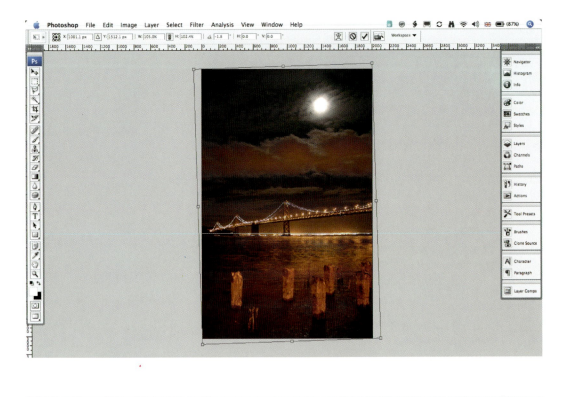

Choose *Image* > *Image Size* to scale the picture to the final dimensions. Make sure that both the Constrain Proportions and the Resample Image boxes are checked, then type 450 into the Pixel Dimensions section's Height field. Make sure 'Bicubic Sharper (best for reduction)' is chosen before clicking OK.

Select *File* > *Save* for Web & Devices to produce the final web-optimized graphic. Pick JPEG as the format and sit a little closer to the screen to pick the best compression level. With Medium selected as the quality preset the file size – reported in the image's lower-left corner – is under 14 KB, but blocky strips in the lower area and other artifacts around the bridge become apparent at this level. Use the Zoom tool **Z** if you can't see these clearly. At the High compression level the file size is nearly 30 KB, but the quality is much better. The

Very High setting gives an even better result, but the file size is over 50 KB – too much for the average web graphic. With the High setting chosen, click Save to save the image with the current settings. Close the original image without saving changes when you're done.

Banner Graphic

A banner graphic is a very common element in a web page. They are used as graphic headline statements, section dividers, and of course advertising links. As with all web graphic production, it is important to know how large, in pixel dimensions, the item needs to be. Banners often refer adverts in web pages, and these generally come in specific sizes to help site designers plan their page designs. The following list shows the pixel measurements for some of these, although there are others that are commonly used as well.

Leaderboard	728 × 90
Full-size banner	468 × 60
Full banner with navigation bar	392 × 72
Half banner	234 × 60
Button 1	120 × 90
Button 2	120 × 60
Micro button	80 × 15
Square button	125 × 125
Micro bar	88 × 31
Wide skyscraper	160 × 600
Skyscraper	120 × 600

Illustrator's web document profile tailors its settings and features to making web-ready graphics. This is extremely useful when highly controlled vector shapes are needed to produce the artwork. There's no direct provision for creating rollovers or animations, but by using different layers and choosing how you generate the final artwork and which other programs are used it is possible to produce both rollover elements and animation sequences.

Fireworks is a great tool for creating web graphics and buttons. Its toolset is tailored for this kind of work, unlike Photoshop's which is made to accommodate high-resolution content for print as well as for screen use. There are features in Photoshop that aren't in Fireworks, of course, so it can be useful to start off in that program first. And, as Fireworks will open Photoshop documents without hassle, this is a perfectly valid route to take.

Fireworks doesn't yet have any further integration with Photoshop or Illustrator, so there's no deeper integration within the Creative Suite beyond the basic pasting of images and use of layered Photoshop files. Having said that, these two methods do allow a lot of creative freedom, so it is often best to use Photoshop for the first part of a project and finish off in Fireworks for the more web-specific specialist requirements.

Controlling how Fireworks imports Photoshop layers is important, especially as Photoshop layers and Fireworks layers aren't handled in the same way. Rather than having a different layer for each separate element in an image, Fireworks

layers behave more like Photoshop's layer groups. Different image elements are 'objects', and a layer can contain many of these items.

In the Fireworks Preferences window, click the Import tab. The Photoshop File Conversion settings will either convert layers to Fireworks objects or to frames. When using Fireworks to create a flipbook-style animation from Photoshop layers, choose Convert to Frames before opening the Photoshop file, otherwise you'll generally find Convert to Fireworks Objects to be better. If you've used effects such as warping type you should choose Maintain Appearance for text, but this means you can't edit the words in Fireworks.

Simple Buttons

Basic button graphics can be made in almost any program in the Creative Suite. To start with, a graphic button will be made using Illustrator, as part of this particular design production suits its strengths best. Make a new document, choosing Web as the document profile and setting the width to 120 pixels and the height to 60 pixels. Click OK, then zoom the display to 100%.

Choose *File > Place* or *File > Browse*, navigate to the media CD, and place the Celebration.psd image on the page. Using the Selection tool **V**, scale it down to be roughly as wide as the button area itself and place it so the top part of the image falls off the button boundaries.

Switch to the Type tool **T** and set a single line of text; 'seemoremusic.com', all in lower case. Choose a strong sans-serif font such as Univers or Helvetica Neue and pick the condensed or extra condensed style. The font shown in this example is called Cracked, a design that's similar to Universe 59 Ultra Condensed but with a broken up, distressed appearance. If you want to simulate this look with a more common typeface then select the type block and choose *Type > Create Outlines*, then try applying one of Illustrator's brushstroke settings to the paths and play with the different characters' vertical positions. But watch out for the legibility of the words when viewed at 100%.

The final element in the button design is the rays of light coming from the right-hand part of the image. Switch to the Rectangle tool **M** and draw a tall thin shape, 16 pixels wide by 250 pixels tall, remove the stroke, and fill it with a pale golden yellow. Use the Color panel **F6** to mix an RGB color that's 255, 255, 220.

With the rectangle selected, choose *Object > Transform > Move* **⌘** **Shift** **M** **ctrl** **Shift** **M**, set Horizontal to 32 pixels and Vertical to 0 pixel, and then click the Copy button to produce a copy of the item in the new position rather than moving the original. Now if you choose *Object > Transform > Transform Again* **⌘** **D** **ctrl** **D** the process is repeated. Keep doing this until you have ten rectangles arranged in a regular pattern.

These need to be rotated in 3D with as much perspective as possible to turn the plain rectangles into beams of light. But first, to make them act as a unit rather than rotating individually, select them all and choose *Object > Group* ⌘ **G** *ctrl* **G** to group them.

Now you can choose *Effect > 3D > Rotate* to open the 3D rotation controls. Click Preview first to see how the changes made here will affect your graphic. You can drag the cube around to tumble the shape or select edges to turn things in a slightly more controlled manner, but the settings needed here are simply 60° in the top field (the X axis), 0° in both the Y and Z axes, and 160° – the maximum allowed – for the perspective. Click OK, then choose *Effect > Apply* Rotate to apply a new instance of the effect settings again; click Apply New Effect when asked. The 3D perspective effect will be quite extreme now, and well suited to our needs.

Choose *Object > Expand Appearance* to convert the live effect to actual paths. This means the 3D rotate settings can't be altered later, but it does make the items a little easier to select and manipulate. Drag the graphic group so that the top is just below the type and the center on the right-hand edge of the button boundary.

Open the Transparency panel ⌘ *Shift* *F10* *ctrl* *Shift* *F10* and set the blending mode to Overlay and the opacity to 50% to let the underlying image merge with the color and make it feel more like rays of light.

The final step is to get the image out of Illustrator. If this is all that's needed, choose *File > Save* for Web & Devices and pick the right format. Choose the 2-Up tab to compare formats side by side. In this case, JPEG at high quality (in the top panel) produces a clean result and a size under 3.8 KB. GIF (in the bottom panel) manages a clean result too, but the size is hard to pull down much lower than 5 KB. Click the JPEG panel and click Save to produce a web-optimized JPEG copy of your Illustrator layout. Don't forget to save the Illustrator document itself in case you need to edit anything in the future.

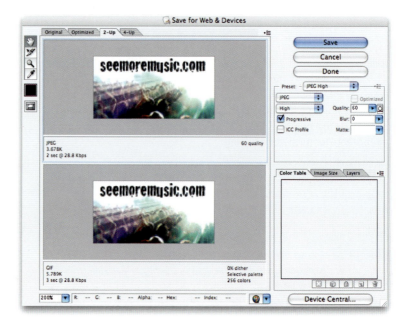

In order to take this graphic layout into Photoshop or Fireworks with the different elements intact rather than as a single flattened bitmap image, don't save for web. Instead, choose *File > Export*, pick Photoshop from the list of formats, and name it 'See More Music button.psd'. Click Export to see the Photoshop Export Options dialog. The resolution should be 72ppi, as you want to produce a pixel-for-pixel version of this layout. Make sure Write Layers is chosen in the Options section, with both the Preserve Text Editability and the Maximum Editability boxes checked. Click OK to create the Photoshop document.

Rollovers

Rollovers are simply different images shown in one place, using JavaScript triggers to swap them around when the cursor passes across a particular area. Fireworks is particularly good at making rollovers and exporting them for use in a number of different programs, so we'll take the button graphic there for further processing.

Step across to Fireworks, but, before you open the button graphic just exported from Illustrator, go to the program's preferences. Click the Import tab and check that the Photoshop File Conversion options are set appropriately, specifically that layers are converted to Fireworks objects. Click OK, then choose *File > Open* and select the Photoshop format button graphic.

The image is now in native Fireworks form, ready to be turned into a rollover. Open the Frames panel, part of the 'Pages and Frames and History' panel group. Press **Shift** **F2** if this isn't immediately obvious. To start with you'll

have just one frame in the document. On this frame, there's a single layer containing three different objects; the sunburst blocks, the type and the background image of the crowd.

In the Frame panel, click the popup menu and choose Duplicate Frame. The default settings are fine, so just click OK. This will duplicate frame 1 and insert it after the current frame. Step across to the Layers panel, part of the same panel group, and use its popup menu to turn off the Share Layer to Frames option and make sure Single Layer Editing has a mark by its name. Without doing this, edits made to any items in one frame will affect all the other frames as well.

Make sure the second frame is selected in the Frames panel, then click the 'see more music.com' text block in the image to select it. In the Properties window at the bottom of the screen – type ⌘ F3 ctrl F3 if it isn't visible – click the Filters button and choose Photoshop Live Effects. This opens a new dialog with a collection of different visual effects to try out. The effects are shown live in your image as you adjust these settings, so drag this window so that it doesn't cover your work.

Select Outer Glow and pick a golden yellow, #ffff33, from the swatches popup. Feel free to experiment with the other settings here, but that's all that is needed for this element. Click OK.

Select the sunburst graphic and take a look at its properties in the Properties window. The settings on the right show exactly the same options as was set back in Illustrator; 50% opacity and Overlay for the blend mode. Leave the blend mode as it is but change the opacity to 75%. Use the Previous Frame and Next Frame buttons at the base of the document window to step back and forth

between the two frames to assess the visual effect of the rollover. If both frames show the same thing for either the text or the sunburst effect, show the Layers panel and make sure that Single Layer Editing is chosen in its popup menu. Correct this and make adjustments to each frame's contents if necessary.

Turning these two frames into a functioning rollover uses Fireworks' slice feature. First of all, make sure that frame 1 is showing so it is used as the 'normal' state in the rollover, then select the Slice tool (K) from the Web section of the Tools panel and draw out a slice that covers the entire image. Switch back to the pointer tool before trying to adjust it. Click the slice overlay and a target icon will appear in the middle of the image. Grab and drag this to any part of the same slice, then pick Frame 2 in the Swap Image dialog and click OK.

The final step is to export the rollover, so select *File > Export*. To produce both the images and the necessary rollover code, make sure Export is set to HTML and Images and the HTML option reads Export HTML File. Be certain that a web-safe filename is used in the Save As field, as this dictates the names of the images as well as the HTML file. Use hyphens or underscores rather than spaces. You may well plan to add the images to a layout and make the rollover code yourself, using Dreamweaver's built-in rollover features. If this is the case, choose to export images only rather than bothering with creating a separate HTML code fragment as well – or just discard the HTML file that Fireworks makes.

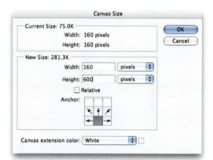

Animated GIFs

Animated GIF images are the simplest form of animation that's possible in web pages. These don't rely on any browser plugins and don't even need JavaScript in order to work. This graphic format works by storing multiple frames within a single GIF document, along with embedded instructions that dictate how long each frame is to be shown before moving to the next and how looping is to be handled.

Although this is something that Fireworks can do well, Photoshop CS3 includes some very useful and surprisingly sophisticated animation controls of its own. One thing you do have to watch out for in Photoshop when creating animations meant for GIF delivery is keeping things simple. It is very easy to get carried away with opacity effects and smooth movements and end up with a single animation that takes more than half a megabyte,

10 or 20 times larger than most recommended maximums. This is because Photoshop's new animation feature is aimed more at digital video production requirements than at the humble needs of animated GIFs. However, with the right approach it can be put to very good use for web animation. The trick is to treat GIF animation projects like flipbooks: use simple movement and turn things on and off rather than creating complex animation 'tweens' that are better suited to video.

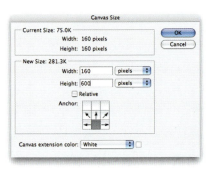

This animation will create a simple 'wide skyscraper' web banner animation. Open the Clayface.psd graphic from the media CD and choose *Image > Canvas Size*. This image is currently 160 × 160 pixels, so anchor the image to the bottom and set the height to 600 pixels, making the size 160 × 600 pixels with the picture at the base. Set the canvas extension color to white.

Use the Eyedropper tool to sample some of the dark blue from the image so the type that's made in the next step will have an appropriate color fill.

Choose the Type tool **T** and click at the top of the image. Type 'animation at', then open the Character panel (select *Window > Character*) and set this text to be 22 pt Arial Black with tracking at -50 to tighten up the letterspacing. Switch to the Selection tool and back to the Type tool to stop working with this text layer, then click below the existing text to make another text layer. Type 'claynation', and set this as 27 pt Arial Black with the same tracking. These should fit neatly within the image width.

Finally, make a third type layer in the same way, but type '.co.uk' and set this size to 47 pt Arial Black. The ascender of the letter k needs to be trimmed to the height of the other characters, so choose *Layer > Rasterize > Type* to convert this type layer to a regular bitmap image layer. Now the ascender can be selected and cropped using Photoshop's regular tools. For the perfect effect use the top of one of the 'u' strokes.

Once the type is arranged, show the Animation panel by choosing *Window >
Animation*. This has two different modes, frame animation and timeline
animation. The frame mode is more useful for this kind of work, as it lets you
set different layer states for different frames in the animation.

To start with there's just one frame. Use the Layer panel
and its opacity settings to turn off the layer visibility for all
the type layers, and turn off the layers called 'mouth 2' and
'mouth 3' as well. Set the frame delay time to 0.5 seconds
by clicking at the base of the frame icon. The first frame of
the animation is done, so pick New Frame from the panel's
popup menu or click the Duplicate Selected Frame button at
the panel's base.

Show the first line of type as well in this frame, and set the delay to 1 second
to allow enough time to read it. Remember, you rarely have people's full
attention for banner animations, so allow enough time for lines of text to sink
in. When this is done, make another frame, show the second line of type, and
make sure this one's delay is 1 second as well.

Make another frame and show the final line of text, the large '.co.uk'. Set this
delay to 0.2 seconds, duplicate it, and in the new frame switch from 'mouth
1' to 'mouth 2'. Set this frame's delay to 0.2 seconds as well, then make yet
another frame. Show the 'wink' layer and switch to 'mouth 3' to show the full
plasticine smile. Set this frame's delay to 0.5 seconds. Finally, make one more
layer, hide the wink again, and set this one's delay to 1 second.

Click the Play button in the Animation panel to see this work brought to life. If it
plays through once and stops, choose Forever from the Looping Options popup
menu in the Animation panel's lower-left corner. (Animated GIFs can play once,
loop forever, or be set to play a specific number of times before they stop.)

To create the animated GIF from this Photoshop document, choose *File* > *Save* for Web & Devices. In this window, when GIF is selected as the output format a set of controls for playback and looping options is enabled. The graphic that this produces will play back in any web browser that can show GIFs at all.

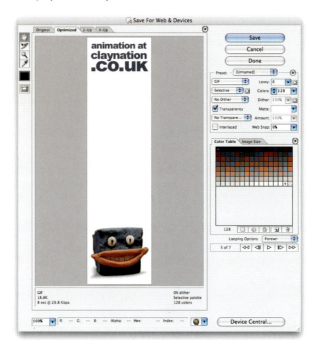

Background Images

Web page background images are normally designed so that they repeat seamlessly horizontally, vertically or both, filling the browser window however large it gets or however far down the page has to scroll. Graphics that fill a browser window in one go are rarely used simply because the file size becomes uncomfortably large and slow for viewers to download.

The process of getting an image to tile in a web page is simple enough, but creating images that repeat in one or both dimensions without a noticeable line can sometimes be a bit of a challenge. If you know that there's a clean pattern repeat, such as with an image of patterned wallpaper, it is largely a matter of finding the precise point where the repeat occurs and cropping the image down to that point on every side. But if manual editing is needed to make the sizes or tops match up, stronger measures are called for.

Photoshop
First, the easy method. Launch Photoshop and open the Flock Wallpaper.psd image from the media CD. This is a repeating pattern, but we need to come up with a single section of it that repeats with no discernible join. Open the Layers panel *F7* and drag the existing layer onto the New Layer

icon to duplicate it. Make sure the
Selection tool **V** is chosen, then
drag the new layer across to the
right, a little more than halfway
over. You should soon notice
where the pattern that goes off
the left side of this layer coincides
with the pattern in the underlying
image. Make sure you've zoomed
in to at least 100% and nudge the
upper layer into alignment with
the pattern underneath. The layer
shouldn't be moved up or down,
just across to the right.

When you're satisfied that it is
in place do it all again, but this
time drag the new duplicate layer downward to find the vertical repeat point
instead. All that's left now is to crop the image to the boundaries defined by
the two new displaced layers.

Choose *Edit > Select All* to select he entire image, then down ⌘ ⌥
ctrl **alt** together and click the icon of the second layer in the Layers panel.
This subtracts the image area of the second layer, as a selection, from the
current selection. Now repeat using the third layer. What's left of the selection
is the precise size of the pattern repeat for this image. Choose *Image > Crop*
to trim the image to this selection. The graphic is ready to be saved as a web-
optimized image, so choose *File > Save* for Web & Devices and create a GIF
image – the format best suited to these crisp edges and flat colors.

Making a repeat pattern from an image that isn't designed to repeat takes a little more work. The main challenge here is normally producing something that doesn't look repeated, so avoid particularly small tiles, especially if there's any detail at all in the original. Start by making a new image that's 300 pixels square. Set the foreground and background color chips in the Tools panel to a pale sky blue and to white, then choose *Filter > Render > Clouds* to produce a random cloud effect using the foreground and background colors.

Open the Layers panel **F7** and duplicate the current layer by dragging it onto the New Layer button at the bottom. With the Selection tool **V**, shift-drag the new layer halfway up the image. As long as Snap is checked in the View menu this should snap into position when it is precisely halfway. Choose *Edit > Select All*, and flip it over by selecting *Edit > Transform > Flip Vertical*. Drag the image back up again. The image now repeats vertically, although there's probably an obvious mirror effect along the center line. Use the Clone Stamp tool **S** and a large brush size to obscure this by painting different parts of the cloud effect across the central division. Once finished, choose *Layer > Flatten Image*.

Duplicate the layer again and repeat the process, but this time dragging the layers across horizontally and flipping the second new layer horizontally. Flatten the image to finish.

To test the repeat, make sure nothing is selected (or select the whole image) and choose *Edit > Define Pattern*. Click OK. Now make an image at least twice the size of your repeat pattern image – try 1000 pixels square – and choose *Edit > Fill*. Set this to use Pattern for the contents and select your new pattern from the Custom Pattern list. This will flood the image with your new pattern, showing exactly how it will behave as a repeating web page background.

If you're happy, go back to your original pattern image and choose *File > Save* for Web & Devices. Save this as a GIF or JPEG and use it in your web page designs as a background image. If not, go back and try again. It can take a little while to come up with a result that tiles unobtrusively, but the best thing to do is simply keep trying.

Fireworks

Fireworks has a large number of repeat patterns built in ready to apply as object fills. The only trouble here is that it doesn't show where the edge of its repeating image tiles are, but rather than spending time working out where the repeat occurs you can simply open the source images Fireworks uses for these tile fills. Macintosh users will find these by going into the Fireworks application folder, opening the Configuration and then the Patterns folder. Windows users will find these in: \Program Files\Adobe\Adobe Fireworks CS3\Configuration\Patterns.

These are used by Fireworks itself so don't edit them directly; make copies into your images folder before making any changes. Watch out for alterations that affect the edges of images differently from the inner areas; blurs and similar effects produce slightly different results along the sides of an image or selection. To work around this problem, start by filling a larger image with a tiled version of the pattern, using the technique described earlier. Apply the blur or other effect to the entire image, then crop to a selection the precise pixel size of the original tile from anywhere within the full image.

Slicing

Image slicing is used to turn a large image into a series of smaller ones, held together using an invisible table structure in the HTML code. This can help present a graphic in a more user-friendly way in web pages, especially for those with slower connections, as the various parts will load in parallel. The total load time is not reduced (and in fact, technically, this actually increases it fractionally), but the user won't be left waiting for one large image to draw itself before seeing what the gist of the layout is.

Another very practical use of image slicing is where a graphic has some areas with smooth, soft photographic imagery and other areas with crisp, flat colors. One section is better suited to JPEG compression and the other to GIF. Slicing an image up allows the different parts to be compressed using the most appropriate method. Fireworks offers a way around this problem with its Selective Quality option for JPEGs, but the trick is still worth learning.

And finally, slicing allows a portion of an image to act as part of a rollover effect. Because rollovers are simply done by swapping one image for another in the page, each rollover in a large image needs to be made from a different sliced section. Slicing can be done in both Photoshop and Fireworks, so we'll look at how this works in both programs.

Go to Photoshop and open the Boat.psd image from the media CD. The top part of the sky is perfect for the title text, so click up there with the Type tool **T** and type 'Welcome to the Fisherman's Wharf photo gallery' in three lines. Set this in Arial Black, 36 pt, centered, and with a white fill.

Choose the Slice tool **K** and drag a rectangle out to that it surrounds the type. You'll see immediately how the slicing will be done to the image; the dotted lines show how the parts will be produced and what number each one will be. Grab the slice object's side handles and make it fill the complete width of the picture to keep the output as simple as possible. The Control bar's slice tools help handle multiple slices, shuffling slice objects back and forth, and splitting items into parts.

Double-click the slice object to see how it will be named and what options there are here. Change the name to 'fishermans-wharf-title', keeping the name web-safe; no spaces or exotic characters. Give this a URL so the slice area will take the visitor somewhere when they click, and add a descriptive alt tag for this with problems seeing images.

Next, choose *File > Save* for Web & Devices. With the slices made visible it is easy to see which section is being worked on. With the text section active, set the format to GIF, the colors to 32, and pick No Dither. Click the top section and set this to JPEG with quality set to 30. This will apply to the bottom section too, as they're both 'auto slices' generated as a result of the hand-made one placed over the type. Try setting the type slice as a JPEG and zooming in to see the effect this has.

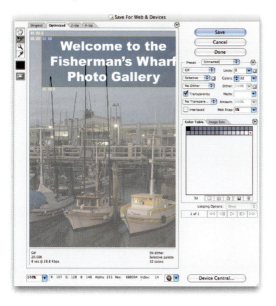

Fireworks operates in a very similar way, but the output settings for each slice can be configured directly from the Optimize panel as you work, and the Preview mode is better integrated than Photoshop's Save for Web dialog. Mind you, there's no integrated way to add links or alt text code to the table structure that holds it all together afterward, so regardless of where you make your graphics this is done later in the web page assembly stage in Dreamweaver.

Pixel-Level Editing

Unlike high-resolution print content, web graphics are entirely pixel-driven items; every pixel in an image is shown using a corresponding pixel on screen. This means that there will be times when you'll want to resort to pixel-level adjustments of your graphics to achieve the very best final results.

In both Photoshop and Fireworks, the pencil tool gives single-pixel precision while the brush tool gives an antialiased, soft edge even at its smallest size. Hold down the option key while using these tools to switch to the Eyedropper tool temporarily in order to sample a new color, and use the shift key to constrain lines to horizontal or vertical as you draw.

But in both programs, it is seeing what you're doing that's the most important trick. In Photoshop, choose *Window* > *Arrange* > *New Window* for the document in current use, while in Fireworks choose *Window* > *Duplicate Window*. These commands create a new window showing the same image; set the zoom level of one to 100%, or 'actual pixels', and in the other zoom to at least a few hundred percent. This gives you a clear overview of how the image will look while also allowing pixel-precise editing.

With Smart Objects, live type and other similar items, these would have to be rendered to pixels or overlaid with a regular layer and the hand-drawn pixels placed there instead.

Website

A tight row of village houses in Glynade, East Sussex

Dreamweaver CS3 is an incredibly powerful website authoring program. It is used to create and manage anything from the simplest home page to seriously complex database-driven and interactive mammoths. If you're not particularly experienced with Dreamweaver it can seem a daunting thing to pick up. But if you tackle things correctly from the start you'll find it isn't all that bad. Its roots are based in direct HTML code editing and you'll have to dive into that side of things from time to time, but it doesn't take that long to understand.

One of the keys to working with Dreamweaver effectively is setting up the 'site root' for any site you work on. This is the local analog of what is or will be stored on the remote web server, and you need to make sure that all media – images, movies, Flash documents, PDFs, sound files, and so on – are copied to the appropriate place within the site root structure before they're used in the site page layouts. Although it isn't a requirement, you'll find parts of this project easier to complete if you are able to upload files to a working website.

The best way to set up a site root is to define your site right from the start. This also connects it to the remote web server and helps manage keeping files in sync. Once defined, your site contents are accessed, uploaded and downloaded with the Files panel.

SHORTCUTS
MAC WIN BOTH

265

Setting up a Site

Start a new site by choosing Dreamweaver Site from the Welcome Screen window or by selecting *Site > New Site* from the menus. You'll need to name the site at this point, so call it 'Creative Suite Integration project', and add the web address of your site below.

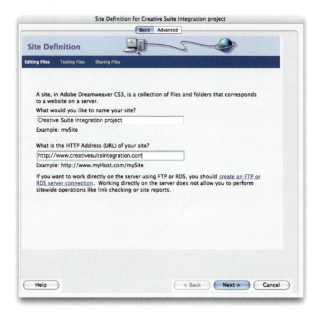

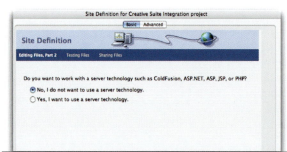

In the next screen, don't worry about choosing a 'server technology'. This essentially means that Dreamweaver wants to know if you'll be using any special 'server-side' scripting languages such as PHP or Cold Fusion. If you will you'll know this already. If you're not, don't worry about it; just click Next.

In the following screen you define how you will work on files during development. Choose to edit files locally and then upload to the remote server separately when ready. Click the folder icon and choose where your site root folder should be stored on your computer.

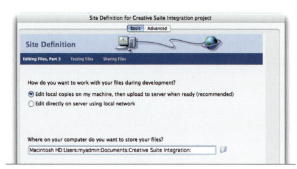

The options provided for connecting to the remote web server for transferring files are FTP, Local/Network, WebDAV, or RDS – or None, of course, if you don't want to set up a connection at this time. Pick FTP – still the most common method for transferring website files – and type

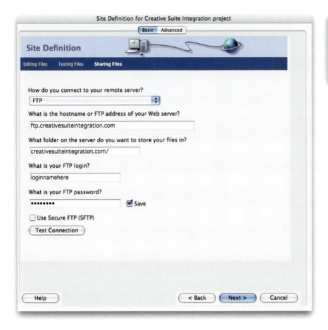

in your access details here. It is wise to set up a separate folder (directory) within the site on the server so that your project files remain separate from any existing files the site may contain. Click the Test Connection button to confirm that the details you've typed are correct.

If you don't have access to an FTP server just pick None from the popup menu instead. You won't be able to upload files to a working web server using Dreamweaver, but you can still test everything using your web browser and the local files instead.

Next comes the check in, check out question. Dreamweaver can lock files on the remote server that you've opened yourself in order to make them unavailable for others to edit. This is very handy when more than one person needs to edit the site, but it is arguably overkill when working on a site on your own. For simplicity we won't use this feature here, so make sure No is chosen. However, do click the Yes button to see the options that Dreamweaver offers so you understand how things can work. Click No again before clicking Next.

The final panel shows a summary of the settings. Click Done to finalize the process. When the New Site window is closed it probably looks like nothing's happened – but if you look over to the right you'll see that your site is now listed in the Files panel. From here, adding pages is the next step.

Templates, DIVs and CSS

When no document is open the Dreamweaver Welcome Screen should appear. (If it doesn't, open Dreamweaver's preferences and enable the Show Welcome Screen option in the General section.) In the Create New column, click the More item at the bottom of the list. This opens the full New Document window with all the template options available. (Of course, you can just choose *File > New* to get to the same place.)

A number of ready-made templates with content already set up is found in the Page from Sample section, but this site will use some more bare-bones templates than these. Select Blank Page, then click HTML and choose '2 column liquid, left sidebar, header and footer'.

In the right-hand section the DocType specifies what variation of standards will be used for the page code. XHTML 1.0 Transitional is Dreamweaver's default and is generally considered to be a good, future-oriented standard. HTML 4.01 can be a little more compatible across different browsers in certain situations,

but we'll stick to XHTML 1.0 Transitional for this project.

More importantly, make sure that the Layout CSS option is set to Create New File for this first page. This means that the CSS (Cascading Style Sheet) styling instructions that control the page's appearance will be stored in an external document, available for use with other pages as well.

Click Create. The next thing you'll be asked to do is save the external

CSS document; call this main.css rather than the 'twoColLiqLtHdr' name that's suggested and save it into the site folder. Once this is done you'll be able to see your first page.

This page is created using divs, CSS-positioned elements, rather than old-fashioned, less flexible table structures. It is almost painfully dull right now, so we'll change this to suit the site a little better. We won't try to do this directly to the items in the page, however. Instead, we'll edit the CSS instructions that give them their current appearance.

The first thing to do is expand the CSS panel so more of its contents can be seen. Use the disclosure triangles (the twisty arrows) in the other visible panels to collapse them down or just pick their names in the Window menu. Click the All tab to see the All Rules portion of the CSS panel, then click the disclosure arrow to show the list of the different CSS style definitions. Now grab and drag down the division between the All Rules and the Properties sections of the CSS panel so you can see all the rules.

The CSS rule names start with what may look like incomprehensible text. These are 'class names', group-like identifiers that are applied to the various div containers. Using this means that custom CSS style rules can be made for the same core content types in different sections of a page. This is certainly useful with more complex layouts, but it is overkill for this page so we'll delete these parts from each rule name. (This simplification does have an impact in terms of absolute flexibility, but it also makes things easier to manage and understand.)

You can select a rule in this panel, click the name again, and delete the part that reads .twoColElsLt (including the trailing space) from the name. The only trouble is that one of these rules contains two sets of names, and you'll have trouble editing it properly in this way.

Instead, double-click the main.css item itself to open the CSS document in Dreamweaver. Select and copy one example of the .twoColLiqLtHdr text (including the leading dot), then go to *Edit > Find and Replace* and paste into the Find field. Click Replace All and the class name will be removed entirely from the CSS code, wherever it appears. Save and close the CSS document.

Now take a look at the layout itself. Click on the border of one of the boxes and it will show its selection rectangle. In addition, its name appears at the bottom of the window. This is a quick way to see which div element is which in the page. Each named rule in the CSS 'All Rules' section corresponds to a named div in the page layout. Select the CSS rule called #header (not #header h1) and then click the pencil icon at the bottom of the CSS panel to open the CSS Rule definition dialog for the #header rule.

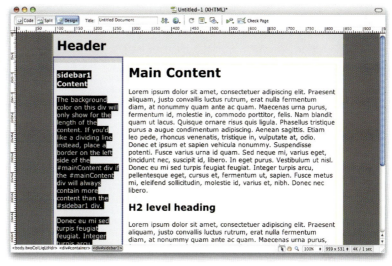

In the Background section, click Browse to select a background image. Find the Background Dark.psd Photoshop document from the media CD and click Choose. At this point you'll be required to generate a web-optimized copy of the Photoshop document. Change the format to GIF before you click OK.

Make sure you're looking into the site's root, then make a new folder called 'images' and save the graphic there. Click Apply to see the change.

Before you close this window, take a look at the background color control. The image obscures this div's background color, but if a site visitor had a problem loading the graphic they'd be left with an ugly pale gray header block. Click the Background Color color chip to open the colors panel, then use

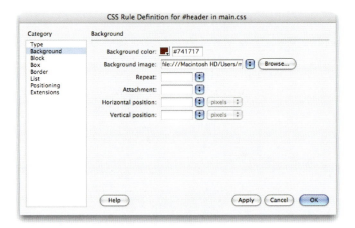

the eyedropper tool to sample the lighter of the two reds in the background image that's now showing in the header section. Click OK to close the window.

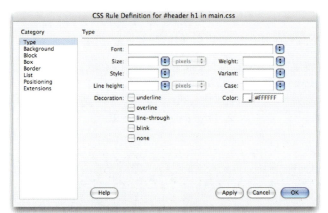

The headline text that's in this 'header' div is black, so it is all but invisible now that the dark image is tiled into the element's background. In the CSS panel, select the rule called '#header h1' – the rule that defines h1-styled text in the header element – and click the pencil icon to open the CSS Rule definition window.

Select Type in the list on the left and use the Color popup panel to pick white for the default text color in this div. Click Apply and the H1-formatted text in this part of the page will turn white.

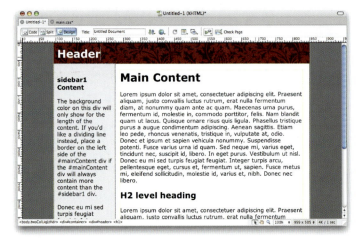

Page Background

The page itself behind the main content blocks needs a better background than the current gloomy gray one. The traditional way of doing this is to use the Properties panel floating below the document window. With nothing selected, this shows a Page Properties button. Clicking this shows a window with the Background Color and Background Image controls.

But instead, as this is a rather old-fashioned method, we'll use the CSS controls to sort this out. Select the CSS rule called body and open its CSS Rule definitions by clicking that pencil icon once more. Use this to set a background image, using the 'Background Light.psd' image from the media CD. Leave the format as JPEG, set the compression level to 60%, and save the optimized graphic into the site's images folder.

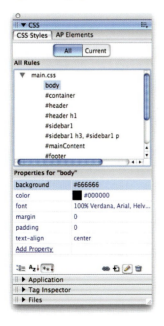

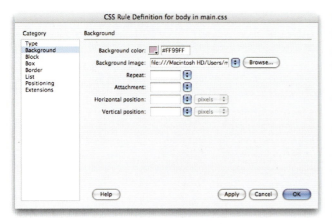

Set the background color to something more appropriate in case a visitor has problems with the image content, and click Apply to see the changes. What this does is customize the CSS rule that defines certain properties for the page's <body> tag, the HTML element that sets up the visible part of the web page.

At this point save the page as 'index.html' and type **alt F12** or go to *File > Preview in Browser* to preview the page in a browser window, clicking Yes to save changes to the style sheet as well.

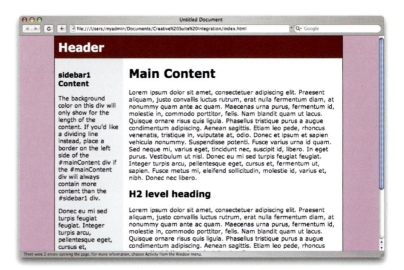

If your images don't show in the browser, step back to Dreamweaver and open the relevant CSS rule, for example #header. In the Background section, look at the path shown for the background image. In some situations an absolute path that is specific to your computer will be used, but editing this here fixes the problem.

Trim the file path so it contains just the 'images' folder name and the file name, as in 'images/background-dark.jpg'. Save the main.css document and try previewing the document again; the images should now appear as intended.

Layout Structure Editing

Now the main div item, the one that contains all the other items, needs to be given an inset so that it sits clear of the top and bottom of the browser window edges rather than slamming up against them. To do this you'll need to edit the #container item's CSS rule. (Click on the outer edge of the main content box so that the whole thing is selected and you'll see that the bottom of the document window reports the overall containing div as being named 'container'.)

Select the #container CSS rule and open its CSS Rule definition window. In the Box section, go to the Margin controls and set the top and bottom margin values to 20 pixels each. Select Pixels from the menus next to these fields. This offsets the div that follows this rule by 20 pixels from its containing element, which in this case is the page body tag. The effect is to make a small margin of space above and below the div, floating it in the body space.

Adjusting Widths

Select the #sidebar1 rule in the CSS Rules panel. This defines the properties for the sidebar1 div in the page, just to the left of the main content section. In the Box section, the setting that we'll be editing is the width, currently set as 24%. The container div that contains this (and the other content areas) scales its width relative to the browser window, so the percentage setting here means the sidebar will flex along with it. Instead, this should be set to a specific width so it stays the same width and leaves the flexing to the other elements.

Click on the 24% value in the Properties part of the CSS Rules panel. Change the 24 to 190 and pick Pixels from the popup menu to the right. The sidebar1 div will now be fixed to a specific pixel width.

Now click on the edge of the main content box (called, logically enough, mainContent). The content area itself shows a blue rectangle highlight, but on either side there's also a shaded area showing its CSS-defined margin offsets. Just like the sidebar1 div, this div's positioning and dimensions are relative to the container div that encloses it.

The margin settings, which define its dimensions, are set using a mixture of percentage and pixel values; select the #mainContent CSS rule to see the specific values. The left edge is 26% of the distance from the left edge of its 'parent' div, and the right is pinned at 20 pixels from the right.

Rather than try to edit it directly in the Properties panel, click the pencil icon to open the CSS Rule definition window. In the Box section, you can see the margin settings; change the left value from 26% to 210 pixels. Save the changes and type **alt** **F12** to preview the page in a browser window. Change the width of the window to see how the shapes behave.

{AQ}

Now that the CSS formatting is established, we can create new pages and link them to this CSS file. Any div items in the new pages that have the same names as the CSS rules will take on those style settings automatically.

Choose *File > New* and pick any of the two-column pages with sidebars. It doesn't actually matter which of those you pick, as absolutely all settings are controlled by the rules in the external CSS file. Rather than the elements in the template doing as the template title suggests, they'll all work exactly as you defined in the main.css file. (Even the templates with right-hand sidebars will behave as left-hand ones because our CSS rule for the item called 'sidebar' places it on the left.) It is important, however, that you set the Layout CSS menu to Link to Existing File and then choose the 'main.css' file; click the small chain button below this popup menu and browse to the CSS document in your site folder. Once made, save this page into the site folder and call it news.html.

Open the text file called 'web content news.txt' from the media CD and copy and paste the first paragraph into the sidebar1 div and the rest into the mainContent div. If you replace all the existing text then the new text will take on the 'None' paragraph formatting. First in the sidebar1 div and then in the mainContent div, select all the text and see what format it has by looking in the Properties panel. If necessary, format it as 'Paragraph' by using the Format popup menu or choosing *Text > Paragraph Format > Paragraph* ⌘ Shift P ctrl Shift P.

Click at the beginning of the sidebar1 text, type 'In Brief' and a return, then click in this new first line and choose Heading 3 as the format. In the mainContent div, type 'Claynation Declares Independence' as the headline and format it using the Heading 1 style. Finally, type 'News' in the header and then save the page.

Make another new page and pick a template that doesn't have a sidebar. Make this link to the existing main.css style sheet and see what you get. There's no sidebar1 div, but the mainContent div still sits over to the right because that's what the #mainContent CSS rule tells it to do.

Click the New CSS Rule button at the bottom of the CSS Styles panel, the small page icon with the plus symbol. Set the selector type to Advanced and type #mainContentWide in the Selector field. (Don't forget the hash symbol at the beginning of the name; this marks the CSS rule as applying to an object that identifies itself with that name.) Choose to define this in the main.css document so that it will be available to all pages that link to this style sheet, and click OK.

In the CSS Rule Definition window that opens next, click Box, go to the Margin section and set both Left and Right to 20 pixels. Click OK. Nothing will change yet because the box in question still has the old mainContent ID.

Make sure the box is still selected, then go to the Properties panel and use the Div ID popup menu to change the ID to mainContentWide. Now the box jumps to show the new

settings, filling the container div's width in a much more balanced form. Save this page as history.html.

Now the only trouble comes when you want to have a layout that doesn't follow this model so precisely. Fortunately, this isn't so hard to work around; make new CSS rules to go with custom ID names and then apply the new IDs to the items.

To flesh out our CSS file start with a page with the elements you want to adjust, so make a new page using the 'three-column liquid, header and footer' template. Make sure it links to the existing main.css file when you are picking the right template.

This page design has a second sidebar div, called sidebar2. Right now it appears unstyled, stretched across the width of the container div that holds it. Click the New CSS Rule button in the CSS Styles panel again and name the selector '#sidebar2'. Make sure it will be defined in main.css and click OK.

Start off in the Box section of the CSS Rule Definition window. To make the div box be aligned to the right of the container choose 'right' from the Float menu. In the Padding set of controls, uncheck the Same for all box, then set the top and bottom both to 15 pixels. Set the width to 190 pixels – this matches the sidebar1 settings precisely, with

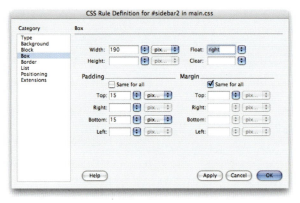

the one difference being Float set to the right. Then switch to the Background section and set the background color to the same as the sidebar1 gray.

Okay, there's just one more difference. The type inside the sidebar2 box needs a 10 pixels indent from the sides, but this is done using a different rule. Make one more CSS rule, call this '#sidebar2 h1, #sidebar2 p' – yes, effectively two selectors in one in order to apply the settings to both the h3-styled text and the regular paragraph text that is found in the sidebar2 div. This saves you from having to define the settings for each text format in a separate CSS rule. In the Box section of the CSS Rule Definition window set the right and left margin to 10 pixels each and click OK.

Images…

Tracing Image

Page mockups created in graphics programs can be used as a tracing image in Dreamweaver to help you recreate the design using proper HTML structures and elements. With nothing in your page selected, click the Page Properties button in the Properties panel ⌘ J ctrl J, then click the Tracing Image item in the Page Properties window. The image must be in JPEG or GIF format to be shown in Dreamweaver, although a native Photoshop PSD file can be used as it will be turned into a more web-friendly format as part of the process. If you create your layouts in InDesign – which is, after all, a far more capable page layout program than Photoshop – then you can export as a PDF (which will then need to be turned into a JPEG or GIF) or as a JPEG directly.

Using the Tracing Image control in the Page Properties window, pick the Sample Background.psd graphic from the media CD, choose a compression setting and save the web version somewhere inside your site folder.

Reduce the transparency to make the image behave more like something behind tracing paper. This helps to make sure you can tell what's real and what's actually in the tracing image as you go about recreating the layout using Dreamweaver elements. Dreamweaver renders the colors rather oddly, turning the visible areas more yellow the lower the transparency level, but it is still perfectly usable.

This image shows up in Dreamweaver as a handy layout guide, but it won't show in any browser. Even so, the code reference remains in the page so it is tidier to remove this when you're done. Just delete the path to the image in the Page Properties window to remove the code from the page.

Inserting Images

Images in a published web page should always be the final web-optimized graphics that browsers understand. But this doesn't mean you can't pick native Photoshop or Fireworks images to use in your pages. Dreamweaver can generate optimized, web-ready graphics from these files as you work. This also means that you can jump to the original in Fireworks or Photoshop, edit it and have your changes shown immediately in the Dreamweaver page.

Using Photoshop Images in Dreamweaver

When placing a Photoshop image in a page, Dreamweaver can see that it is in a non-web format and asks your assistance in creating the right web-format version from this image. It isn't quite the same with native Fireworks images; Fireworks uses the PNG file format (pronounced 'ping') for its own documents. PNG files can be ready by most modern browsers, although the extra data used for layers, editable text and object, and Fireworks' many other tricks means its PNG files are not meant for web use without export. But you can switch the output to a different format and set up an image source link to tell Dreamweaver to link the image in the page to a master source file on disk.

First we'll import the Photoshop file for the record image and have that converted into the appropriate output format. Open the index.html page,

then click into the sidebar box in the page structure below the headline, type a return and choose *Insert > Image*. Pick the Vinyl Record.psd image from the media CD. The Image Preview window opens to let you pick an output format for the version that will be used in the page. Choose JPEG from the Format popup menu.

The problem with this image is that it needs to sit on a non-white background, but the area behind the record and its shadow, although transparent in the Photoshop document, is white in the output preview. If the GIF format with its 1-bit transparency option is used you'll just get a harsh cutout, no good with the soft shadow, and the file size for this particular image will be larger as well.

Instead, drag this whole window a little to one side so that you can see the section of the page with the background color, then click the Matte color chip and use the dropper tool to sample that color from the page. The graphic's white background will be replaced with what's been sampled, and the shadow will blend seamlessly. (This can be done with GIF images as well. This simply tells the software to matte the transparent areas to the selected color.)

Save the optimized graphic into the appropriate place in the site folder and it will appear in the web page with its background matching the div's background perfectly. The size will be wrong, so click the Optimize button in the Properties panel to get this window open once more, switch to the File tab, and change the pixel dimensions. This needs to be 170 pixels wide.

To edit the original graphic, select it in the Dreamweaver page and look at the Properties panel. The Edit section has a string of small icons, and first in line is

the one for the original image's parent program; Photoshop. Click this and you'll find yourself back in Photoshop and ready to make changes. Show the hidden layer (the 'record' layer has a blend effect to merge with this image), save and click back into Dreamweaver and – well, the image won't update automatically, but all you have to do now is click the Optimize icon, the tiny C-clamp graphic, and the Image Preview window opens up. It will still have the settings you put in place, but it will now show the latest version of the master Photoshop document.

You may need to redo the matte color; in some circumstances it can shift slightly and leave the image box area visible. Normally, however, it is perfectly fine.

You don't have to save a Photoshop graphic before importing it to Dreamweaver. If you copy and paste from Photoshop straight into Dreamweaver you'll be asked to choose the image compression format and settings and where the graphic should be saved. The only problem with this is that you won't have a source file to go to should you wish to adjust something in the graphic later, so bear this in mind as you work.

Using Fireworks Images in Dreamweaver

Importing a Fireworks document isn't quite as straight forward, simply because Dreamweaver accepts it as a web-ready image format from the start rather than a master document that needs to be optimized – although a native Fireworks file is far from optimized. The workaround isn't hard, fortunately. Choose *Insert > Image* and select the Music Logo.png graphic from the media CD. When you're asked if you want to copy the file into the site folder go ahead and do so – although it would be wise to make a new folder in there to store this 'master' content.

The image that's placed into the Dreamweaver page is the PNG file rather than a GIF or JPEG. When the page is finalized this will have to be altered, but it can be left as this for the moment. To edit the image in Fireworks you can click the tiny Fireworks icon in the Properties panel or you can choose *Modify > Image > Adobe Fireworks CS3*.

(Dreamweaver automatically sets up Fireworks as the editing tool of choice for PNG files, so the program button in the Edit section of the Properties panel should show the Fireworks icon. If it doesn't, double-click the image and reselect the source file, this time choosing the copy that you put into the website folder.)

When you want to convert the image to JPEG or GIF click the Optimize button in the Properties panel and choose the right format. In this case the graphic is actually best handled as a JPEG even though it is a non-photographic image with crisp, sharp edges.

From this point, to edit this using the master image you'll need to double-click it and reselect the master graphic file, choosing the one that was copied into the site folder. Then simply use the Fireworks 'edit' button in the Properties panel or choose *Modify > Image > Adobe Fireworks CS3*. When you've finished editing, save and close the document or just click the Done button that's shown and it will be saved and closed for you. The image in the Dreamweaver page will reference the PNG file once more, so remember to optimize and generate a new JPEG (or GIF) before you finish.

Resizing an image directly in the Dreamweaver page isn't generally recommended, as this just uses the same image pixel data in a different sized area. If you scale down you're squashing an image into a smaller space, using bigger files than is necessary, and if you scale up you simply get ugly enlarged pixels. But it can be done and appropriate results obtained if you have a corresponding source image to resample from.

In Dreamweaver, select the music logo image in the banner section. We need this to be a little larger than the 125 × 125 pixels of the original document. If the Fireworks icon shows as the 'edit' button just click that, otherwise double-click the image and reselect the PNG file first, then click the edit button. In Fireworks, choose *Modify > Canvas > Image Size* and enter the new pixel dimensions. Click the image's Done button when you've resized the graphic.

Your graphic will be resized for you in the page. It will also be converted to a GIF automatically at this point, so you'll need to relink the image to the master PNG file (again) and click the Optimize button to select the final format once more. This little dance needs to be done every time you resize Fireworks graphics, but it doesn't take all that long.

Adding Flash Media

Of course, adding Flash media is also easy, and it helps make a site more dynamic and interactive than a standard text and graphics production. Weaving Flash content into a layout to get the best of both worlds is generally a better idea than making a Flash-only site, although that can still be perfect for some requirements. Flash content can be as simple as sets of dynamic buttons or an animated text banner set in a custom typeface, and it can be as complex as the Flash developer has the time to make it.

Flash Text

Flash text is an excellent way to preserve typographic precision and custom fonts, and it allows rollover effects without using extra elements. Click before the first text in the sidebar1 box and choose *Insert > Media > Flash Text*. Type the word 'Specials' into the text box, pick Curlz MT (or any casual script font you have) from the Font menu, and set the size to 42. Set the name in the Save As field to 'specials.swf', then click the Apply button to generate the item without closing this window.

Use the Color popups to sample the lighter color from the header background and set the Rollover color to a shade sampled from the orange graphic. Down in the Link field, type 'special.html' to link to a page of that name, something that would need to be made later. (Or use the Browse button to find an existing page.) Finally, set the Bg color, the Flash graphic's background, to the same as the sidebar's background by opening the color popup and using the sample dropper.

Click OK and the Flash text is placed in the page. If it isn't the right size simply drag its lower-right corner to resize. The Flash text size will change, although if you double-click the item to open up the Insert Flash Text window again you'll see that the size is still shown the same. Click Reset Size in the Properties panel to make it the original scale again.

Flash Video

Flash video is now incredibly popular for delivering movie clips online. This is the format used by YouTube and the other video-sharing sites, and the Creative Suite now makes it simple to make your own and use them in your web pages.

To convert movies to the .flv (Flash video) format yourself using your own settings, launch the Flash Video Encoder application, one of the items provided by the Creative Suite 3 installer. Click Add and select the Flipbook.mov movie file from the media CD.

Click Settings. The Profiles tab is where you choose the quality and compatibility of the Flash video; pick Flash 7 – Medium Quality (400 kbps) from the encoding profile choices. Flash 8 is very widespread, but for greater compatibility, at the slight expense of quality, choose the Flash 7 output format.

Possibly the most interesting options here aren't the encoding controls, they're the cropping, resizing, and trimming controls. Click the Crop and Resize tab, then set the output size to 400 × 300 pixels. You can even click and drag the Crop sliders (or type into the fields) to trim off the sides of a movie, but that's not required for this item. Click OK when you're done, then click Start Queue. The .flv file will be made in the same place as the original movie, ready for use.

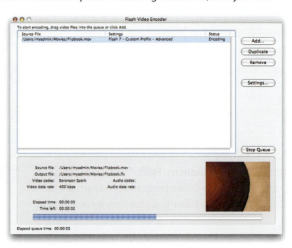

First, though, we need to make the page that this will go into. Step back to Dreamweaver and make a new page; use one of the two-column templates. Make sure the Layout CSS option is still set to link to the existing main.css file before you click OK.

Open the text file called 'video page content.txt', found on the media CD, and copy and paste the text into the sidebar1 div. Select the first paragraph and

format it as Header 3, then format the rest as Paragraph. Either use the Format popup menu or choose the options in *Text > Paragraph Format*. Save the page and call it video-sampler.html.

Click before the first word in the mainContent div's text and choose *Insert > Media > Flash Video*. In the Insert Flash Video window, click Browse and select the Flash video file we just made. Choose to copy the file to the site, then make a new folder called 'movies' and save the file in there. The Clear Skin 1 controller option is the smallest and simplest, so leave that chosen.

Click Detect Size and enable the Auto Play and Auto Rewind options, then click OK. The movie will appear at the beginning of the block of text, but with the text running from its bottom edge. It shows as a gray block with the Flash video icon in the middle. To see the video itself you have to save the page and preview in a browser. Unlike regular Flash content there's no way to preview it in the Dreamweaver page itself.

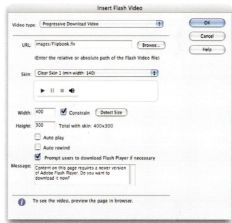

Click between the movie object and the first word. Add a return, delete the header text, then drag-select across the movie to select it as if it was text. Click the Align Center button in the Properties panel or choose *Text > Align > Center*. If you want to adjust any of the Flash video parameters you'll have to do that down in the Properties panel as you can't reopen the Insert Flash Video window with its controls.

(Other forms of Flash media that Dreamweaver helps create are Flash Buttons and FlashPaper. Flash Buttons are self-contained rollover buttons with ready-made states and appearances and an easy way to add links to different destinations. FlashPaper is a Flash-based export feature in Office programs that turn printable documents into Flash media for easy web delivery.)

Navigation

The one thing that's lacking so far in this site is navigation, a way for users to move from one page to another to find the information and entertainment that they expect from this site. This will be provided by using one of Dreamweaver's new Spry code components and a ready-made Dreamweaver 'snippet'. Adobe's Spry is a new JavaScript library framework that provides ways to add cutting-edge features to websites with very little work, and snippets are simply drop-in bits of code that save us from having to make everything the long way.

We'll use a Spry Collapsible Panel to contain our navigation links. This needs to be inserted in the main container div, between the header div and all other divs (in other words the mainContent div and any sidebar divs). To do this we'll work in the code view for a minute, so begin by clicking the Split button at the top of the document window. The display will now show the page code in the top section and the visual layout underneath.

In the visual design view, click the edge of the header div. The corresponding code will be selected in the top section. Click at the end of this selection, after the closing '</div>' text, and type a return to get a new line.

Choose *Insert > Spry > Spry Collapsible Panel* to put the Spry code into the page. This generates a small amount of code in the page itself – two lines in the head section and four lines in the body itself – but it also creates a new CSS file and JavaScript file that need to be stored within your site. (When the site is finished make sure you upload these, in their current folder, along with everything else, to make sure the panel works.)

Leave the split view active for now. In the design view (or the code view if you prefer), select the word 'Tab' in this new element and change it to 'Navigation' instead. In the bar just below, select and delete the word 'Content'. This is where the navigation item will be stored so that it can be opened and closed as the reader pleases.

Choose *Window > Snippets* or open the Files panel and click the Snippets tab. Scroll down to the Navigation section, click the disclosure triangle to show its contents, and flip open the folder called Horizontal. Drag the item called Pipe as Separator into the place in the code where the word Content used to be – between <div class="CollapsiblePanelContent"> and the closing </div>.

The type size is rather large for this particular use, so we'll knock it down to a more appropriate size – using CSS, of course. This new Spry structure that contains the navigation bar has its own CSS rules already set up, in the SpryCollapsiblePanel.css document.

Click the disclosure triangle to hide the main.css item in the CSS Styles panel, then open up the SpryCollapsiblePanel.css item. Double-click the .CollapsiblePanelContent item to open it in the CSS Rule Definitions window, then set the type size to 70%. Click Apply to see the effects; the type will now be 70% of the default size, and be far less obtrusive in the page.

Next, the navigation item needs to be pushed in slightly from the container's edge. Go to the Box section in this window, uncheck the Same for all checkbox by the Margin controls and set the left margin to 5 pixels. Leave all the others as they are and click Apply to see how this works. The entire contents of the CollapsiblePanelContent div –

in other words the navigation table structure – will be pushed in from the left edge by 5 pixels, making the text align visually with the contents of the sidebar1 div below it.

Select the first link in the navigation bar, change the text to read 'Home', and use the Properties panel's Link controls to link this to the index.html page in the site folder. Do this by clicking the folder icon to the right of the Link text field and selecting the target file. Change the second link to read 'News' and link it to the news.html document, then change the third link to Video and link it to the 'video-sampler.html' page.

The unused table cells can be deleted, so point at the top of each cell in turn and hit the backspace key. But don't delete the last cell at the end of the row. This is set to 100% width to force the other cells to collapse down as tightly as possible, so delete its contents but leave this one in place.

Now click the Spry Collapsible Panel tab title and use the Properties panel to set the default state to closed. Once the navigation is finished, type **alt** **F12** to preview the page in a browser. You'll need to click the Navigation text to open the links section.

Once this is done you need to make sure all the other pages have the same content. Rather than copy the whole Spry code structure, including the content that's been added elsewhere in the code, just insert new structures by repeating the first steps in the other pages. But first, select the navigation-link structure in the code view, as shown here, and copy it. Once you've inserted the Spry Collapsible Panel code, select the word Content and paste the

navigation structure in its place. Change 'Tab' to 'Navigation', set the default state to Closed, and move on to the next page.

Making a Page Template

Of course, for future pages this is far too unwieldy, so we'll make a template from one of these pages instead. Choose *File > Save as Template*. Save the template into your current site, call it Flexible Wallpaper, and agree to have the links updated. The page will be given the Dreamweaver .dwt filename suffix, and the links to the images updated to keep everything intact.

Close this document now. Dreamweaver will warn you that the template doesn't have any editable regions. Click OK to continue anyway; we're going to use the templates as starting points for new pages that can be edited completely rather than ones that are locked down apart from certain areas.

Choose *File > New* and select Page from Template on the left. Pick the Creative Suite Integration Project site in the middle, then the Flexible Wallpaper template. The preview thumbnail on the right should show you the page that's just been made. Uncheck the option to have the page updated with changes to the template, click Create, and your new page is ready. You can go ahead and make all the new pages you like from this template.

Box/Note

Dreamweaver's editable region features for its page templates can be very useful if you want to set up pages that can only have certain areas edited. This means complex coding work can be protected and the templates handed over to someone else for further work, with no risk at all to any part of the page that hasn't been explicitly defined as an editable region. When you want to use templates in a less controlled manner, as starting points for editable pages, this is controlled at the point of creating the page. Just uncheck the option to have the page updated to follow template changes, and the new HTML document won't have any editing restrictions in place.

Uploading

To upload the entire site to the FTP location you defined at the beginning of the project go to the Files panel select *Window > Files* or type *F8*, select the site folder, and click the upward-pointing Put Files arrow. In future, if you just want to upload certain parts instead of everything, select the items themselves and click the Put Files arrow.

Design Notes

Dreamweaver can associate 'design notes' with individual pages to help you keep track of comments, suggestions, thoughts, and so on as you work. This is particularly helpful when you work in a team, helping to keep each other informed as you work.

To apply a Design Note to the current page, choose *File > Design Notes*. In the window that opens up, pick the appropriate status form the Status menu and type some notes in the Notes field. Click the tiny calendar icon to insert the current date. Click the checkbox below the Notes field to have this window appear whenever this page is opened. That will make sure your comments won't be missed when the page is opened again.

Click the All Info tab to see and make more notes. But keep each one brief; don't try to include more information than can fit on one line in the Design Notes window or you'll have trouble seeing it all afterward.

Interactive Multimedia

Elephant seals basking on a protected beach in the Big Sur area, California

A s well as traditional print documents and websites, the Creative Suite programs can be put to work to create rich, dynamic multimedia documents. This is where most of the programs in the suite can be put to use; Photoshop, Illustrator, and Fireworks for creating graphics, Photoshop for rotoscoping short video clips, Bridge and Version Cue for managing all the different files in the project, and InDesign for laying it all out into the final design. Even Dreamweaver can get in on the act if you want to have online web facets to the overall project. And of course Acrobat is used to fine-tune the final PDF so that it behaves precisely as you want when it is in front of its audience.

This project will produce a PDF with embedded video, audio, and virtual reality panorama content in addition to its static photos, graphics, and text. It will also include embedded links to email addresses and external websites.

Before starting we'll set up a Version Cue project to help keep track of all the different files and document versions as we work. Launch Bridge and select Version Cue in the Favourites pane on the left. If you see your server in this list, open it up now. Otherwise, open the Browse Servers icon and look for your server there. Authenticate using the name of a user that's authorized to make

new projects – or authenticate using the 'system' user created when Version Cue was first set up. Once in, click the New Project icon at the top of the Content pane or choose *Tools > Version Cue > New Project*. Name this project 'Interactive Production'. If you want to share the project with other users then click that checkbox. Click OK to create the new project.

Document Setup

The main multimedia layout will be put together using InDesign, so launch this and make a new document. We'll be making a design that is shown in full-screen mode, but, rather than picking one of the preset print-oriented page sizes, we'll choose one tailored somewhat better to screen sizes and dimensions.

The measurement system should be in points, as that's synonymous with pixels – at least in PostScript terms. If it isn't set up in points already don't worry for the moment; just include the abbreviation for the appropriate measurement system when you type the numbers. In this case, type 'pt' for points.

Set the page width to 1024pt and the height to 768pt, and turn off the Facing Pages option. Set the margins to 25pt (not 25 mm) all around and choose five columns. Leave the gutter at the default – this will be 12pt, regardless of the measurement system it is thinking in right now.

As this won't be printed it won't matter that the document size doesn't really fit any standard paper size. And if you do want to print it anyway, perhaps to

deliver as editorial proofs to the client, you can simply scale the output to fit your printer's page size anyway. Click OK to make your document.

If the measurement system wasn't set to points already then open InDesign's preferences and choose Units & Increments. Pick Points for both the horizontal and vertical rulers and click OK. As points are synonymous with pixels, and as that's the finest element that a screen – not to mention digital movies – can show, there's little reason to work with a finer-grained measurement system when designing screen-based multimedia. Select *View > Show Rulers* ⌘ R ctrl R if they're not already visible.

Now open the Pages panel *Window > Pages* or ⌘ F12 ctrl F12 and double-click one of the A-Master page icons. Choose *Layout > Create Guides* and give this five rows, fitted to the margins rather than the whole page. Don't worry about making spreads or not as you work; the work will be presented as individual screen-based pages in the end, which is all that matters.

Customizing the Master Pages

Regardless of its multimedia capabilities, InDesign is very clearly designed as a print-oriented layout tool. If you want to make your pages anything other than paper white you'll need to draw a box, fill it with the desired color or import a full-page image, and make sure it is sent behind all other items.

First make sure you're still editing the master page, then select the Rectangle tool **M** and draw out a rectangle to fill the first page in the master spread. At this point we need to mix a new color swatch for the background.

Open the Swatches panel (go to *Window > Swatches* or type **F5**) and choose New Color Swatch from its popup menu. Make sure Color Type is set to Process and Color Mode to CMYK. Although this document will be published as a screen-specific RGB document we can still use the CMYK color sliders to pick colors. Set cyan to 0%, magenta to 4%, yellow to 14%, and black to 28%. (If you'd rather do this in RGB the values are 194, 186, and 173, but for this kind of color mixing most people find CMYK easier to follow.) Click OK when you're done.

Next, pick New Gradient Swatch from the Swatches panel's popup menu. Click the left-most marker in the gradient ramp bar, set the Stop Color to CMYK and the color mix to cyan 0%, magenta 1%, yellow 3%, and black 7%. Click the opposite marker in the Gradient Ramp bar, set the Stop Color to Swatches and pick the color swatch we made a minute ago. Call this 'Tan Gradient' and click OK.

Fill the rectangle with the new color, then draw out a new rectangle, fitted within the margins and covering just the top row in one of the pages. Set its fill to the Tan Gradient swatch, then open the Gradient panel (choose *Window > Gradient* or click its icon in the panel dock) and set the angle to 90° so the dark part is at the top and the light below. If these frames have strokes around the outsides then use the Swatches panel to give it the empty color or the Stroke panel to give the line a zero weight.

Use the Pages panel again to step back from the master page spread to the first page in the document and inspect your work. Because the rectangles were placed on the master pages they can't be selected on any 'real' page, so there's no chance of them being moved accidentally as you work your way through the rest of this project.

At this point we should add more pages to this document in preparation for the new content. Go to *Layout > Pages > Insert Pages* and add 10 pages

to the document. Each page will have the same master page-derived background fill and grid structure. But before we go further with this layout we should save it because it is time to customize some video content to work with the planned design. Save it to the Version Cue project, calling it 'Interactive project' and adding a comment when prompted.

Editing Video

Photoshop CS3 Extended, part of every Premium version of Creative Suite 3, can work directly with frames from video sources. This includes movies saved to disk as well as footage stored on DV cameras. We'll prepare a short video clip by importing it into Photoshop, applying some simple treatments and editing, and then exporting as a new QuickTime movie, ready to be placed into your InDesign layout. Of course, this loses the sound, so you'd need to strip that back in again if you want audio with your video.

In Photoshop, choose *File > Import > Video Frames* to Layers, and select the Claynation.mov file from the media CD. You have a few options here; import the whole thing or shift-drag the playhead to choose just a portion of the movie, how many frames to skip between each one that's imported, and whether or not to turn the layers into frames right there at the import stage. Import it 'from beginning to end', but limit it to every second frame. The video contents need a little work, so make sure this option is unchecked before you click OK.

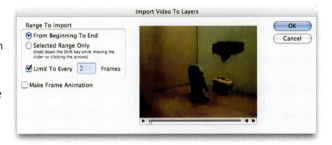

The Layers panel will be filled up with the imported video frames. Each one needs a little lightness and saturation adjustment, all the same. Rather than try to do this manually for each layer, just set up a new Photoshop Action to record the adjustments for the first layer so you can apply them to each subsequent layer in turn.

First make sure that the current layer is visible and not obscured by other layers; alt-click the visibility icon next to the layer thumbnail to hide all other currently visible layers. (Doing this again toggles the visibility of the other layers that were just hidden.) Open the Actions panel by choosing *Window > Actions* or type **alt** **F9**, then pick New Action from the panel's popup menu. Name this 'Video fixing' or something similar; we'll delete this after using it on all the different frames, so the name doesn't matter much. What does, though, is the keyboard shortcut that can be used to trigger this later on. Pick a particular function key (f-key) from the popup menu before clicking OK in this window.

Choose *Image > Adjustments > Hue & Saturation* or type ⌘ U ctrl U and drag the Saturation slider to the left, to the – 40 level, to lower the overall color saturation. Click OK and then open *Window > Adjustments > Levels* ⌘ L ctrl L and set the three input values to 0, 1.40, and 165. This boosts the light point dramatically to increase the overall brightness, and it lightens the mid-tones as well. The overall effect is to enhance the dull lighting that was used in the original video clip. Click OK, then open the Actions panel again if it isn't visible and click the Stop button.

Now open the Layers panel again. First right-click or control-click to the left of the thumbnail image of one of the hidden layers and choose Show/Hide All Other Layers so that all layers have the visibility icon (the eye) showing. Being careful not to process anything more than once, work through each layer, applying the new action by typing that f-key keyboard shortcut each time.

With the entire set of frames in Photoshop layer form you're free to do what you like with it in terms of photo editing, on a frame-by-frame basis. However, at this point we'll turn the set of frames back into a simple animation by turning the Photoshop layers into animation frames.

Open the Animation panel by choosing *Window > Animation*. If you used to use ImageReady this should feel quite familiar. The Animation panel can show its contents in two different ways; the frame animation-oriented view and the timeline animation form. When in timeline mode you'll see one or more horizontal bars, while the frame mode looks very much like a horizontal version of the Layers panel. The mode is switched using the small button in the lower-right corner of the panel; click this to step to the frame mode if it is in timeline mode to begin with.

The Animation panel will begin by showing a single animation frame. With all the layers ready for use, open the Animation panel's popup menu and choose Make Frames From Layers. After a few moments each layer will be converted to a separate frame.

The timing for each frame needs to be set. The source movie's frame rate is 25 frames per second, or 0.04 seconds per frame. Because the video content was captured with every other frame being skipped the timing of each frame needs to be set to double that to make the playback run at the original pace. In the Animation panel's popup menu, choose Select All Frames, then click on the timing data for any selected frame and choose Other. Set the delay to 0.08 seconds and click OK.

(PAL-source video content runs at 25fps, while NTSC runs at 30fps. Many computer-based video and animation content is created at or converted to slower framerates to reduce the data throughput and final file size. To figure out the decimal fraction of a second for a single frame in Photoshop's Animation panel to match a particular frames-per-second rate, divide 1 second by the number of frames per second; 1 second divided by 25 gives 0.04 seconds for each frame.)

NOTE: Of course, this dictates the speed of playback in Photoshop, nothing else. When the animation is exported as a movie once more you'll have to pick the appropriate frames-per-second rate there so that the end result also plays back smoothly. If you're not sure of the correct 'decimal fractions of a second per frame' value just experiment until it looks reasonable for your Photoshop preview. In the end, what matters is setting the correct fps rate for the final movie, and this is a simple matter of dividing the original fps rate by the number of frames skipped when importing into Photoshop.

Adding a Title

Next, we'll apply a title to the video frames. First, click the first frame in the Animation panel. Choose the Text tool **T** and click in the image to make a new text layer. Type 'claynation' and set the text so it runs across the full width of the image. Here, we've used Univers 63 Bold Extended at 60pt. Use the Layer panel to set the layer transparency to 50%, then choose *Layer > Layer Style > Outer Glow* to give the type a small glowing edge.

The type layer will be applied to all the frames in the animation automatically, but the style added to this layer won't be. Open the Animation panel's popup menu and choose Match Layer Across Frames. You get the opportunity to match the layer's position, visibility and style; only the style is important here as the other settings are no different from the layer's existing state. When you click OK the layer style will be replicated across all the animation frames.

Once all this is done, click the First Frame button at the base of the Animation panel and then click the Play button. The animation will playback, custom layers settings and all, as closely as it can to each frame's timing.

You can add all sorts of items to video frames like this. If you prefer InDesign's object-oriented DTP environment for building up layouts then go head and use them instead of making layouts in Photoshop. Once you've prepared your carefully typeset text or object arrangements in InDesign, copy and paste them into Photoshop. They'll be placed as Smart Objects that can be scaled without pixelation. (Bitmap images aren't resolution independent of course, but the pasted Smart Object contains the full resolution of the original item in the InDesign page.)

When this simple titling work is done and the timing is fine-tuned to your liking, choose *File* > *Export* > *Render Video*. This can generate a series of still frames or a movie file. For this project a QuickTime movie is what's needed, so name it 'Curiosity-2.mov' and select which folder to render to (pick the Interactive Project folder that's managed by Version Cue), set the frame rate to 12.5fps and then click Render. The edited video frames will be rendered into the new QuickTime movie, ready to be used in the interactive multimedia layout.

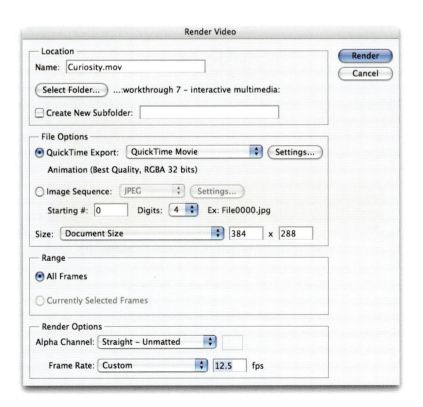

Placing Movies in Layouts

Placing a movie in your layout is as simple as placing a still image. On page 1 in the InDesign document we made earlier, choose *File* > *Place* and select the movie we just exported from Photoshop. Click on the page to place the movie. Now make sure the grid is showing type ⌘ ; ctrl ; if it isn't) and drag it into the upper-left section of the page, as defined by the grid.

It doesn't fit the grid structure, of course – it is a fraction too large, and cropping movies is a bad idea as they don't playback cropped. It is possible to scale the movie in the page – this involved resizing the frame and then, using the Direct Selection tool, the movie itself. The commands for fitting graphic content to a frame don't work well with movies. Rather than do that, however, it is best to live with the standard movie size and work the layout design around it. (Of course, another solution would be to use Photoshop's Image Size or Canvas Size controls to produce frames that were the precise pixel/points dimension.)

Should the movie play when the page opens? Should it play once and stop or loop continuously until something interrupts it? Should the standard movie controller bar appear or not? And how about showing the movie in a floating window instead of embedded in the page? These are all options that are available for movie content placed into InDesign and destined for PDF deployment.

In this case this movie should behave as an entirely embedded image that will playback without any extra visual interruption; no controller and not in a separate window. Choose *Object* > *Interactive* > *Movie Options* – or just double-click the movie – to open the Movie Options window. In the Options section set the Mode to Repeat Play and click the Play on Page Turn checkbox. When this page in the final PDF is viewed the movie will start automatically, and it won't stop until it is clicked.

Now switch to the Type tool , draw out a new text frame and place it to the left of the movie. Type 'www.' and set it in the same font and size as the type in the movie, but filled in black and set to 80% opacity. Align it with the content in the movie and send it behind the movie choose *Object* > *Arrange* > *Send Backward* or type ⌘ [ctrl [. Repeat with a text frame on the right side of the movie, but put '.co.uk' in there instead.

The www part of the text doesn't fit on the page, so you have a choice. You can change the font so you use a less extended version of Univers bold, but that wouldn't match the text in the movie so well. Alternatively, you can simply move everything across to the right to fit it all on. Take the latter approach, placing the movie and text frames so everything is centered on the page. Nudge everything down slightly so the type baseline sits on the grid.

There are caveats to bear in mind when working with multimedia content in InDesign. First of all, when using movies on the page their appearance in the layout can be changed using the blending mode and opacity settings in the Effects panel, but these edits don't show in the final PDFs. Cropping movies can also be done in the InDesign page but won't be cropped in the final PDF; if you do this the whole movie will still show in the final product. Scaling a movie in the page does work, but making a movie bigger doesn't increase detail so it is generally best avoided.

Adding Audio

Sound can add a lot to a multimedia project, when used appropriately of course. We'll add some audio to this page and make a couple of buttons to control how it is triggered. Start by choosing *File > Place* and selecting the Background Loop.aif audio file from the media CD. Click to place it on the page, then double-click the icon (or choose *Object > Interactive > Sound Options*) to see the options available.

Play on Page Turn is the trick for making the sound play automatically as the page opens; select this. There's no need to show the audio icon either, especially as the sound will be triggered as the page is shown, so set the Poster popup menu to None or just click Do Not Print Poster. Make sure the Embed Sound in PDF button is checked so it will be built into the PDF when it is created, then click OK.

The audio item will appear on the page as a small square frame. This will be a clickable item in the PDF, so make it smaller and cover it up with another object if you don't want someone triggering it like that. If you place it off onto the pasteboard, even partially, it won't work, so make sure it is entirely on the page.

It isn't possible to make a project play a single audio source continuously as different pages are shown. Well, not unless the audio is handled as part of a QuickTime movie and that's played in a separate window. That is an option, but you still don't have any significant control over it; the user could easily close it by mistake. It is best to design your multimedia productions so that each page handles its own audio; don't try to make it run through from one page to the next without a cut.

There are occasions when using the same audio file in multiple ages can give an approximate effect of continuous playback, for example if some ambient background audio is wanted to give a general mood to a production. If there's no distinctive rhythm or structure, place a copy on each page and set it to play 'on page turn'. But do also be aware that you can't set an audio item to loop, so when it finishes it simply stops. To get sound to loop you'll have to convert the audio file into a movie with no visual content and handle as video content instead. Or simply make it so long that it plays for longer than someone will ever look at the page, if you aren't worried about file size issues.

(InDesign is able to import AIFF and WAV audio files, but MP3 and AAC formats aren't supported. If you need to edit sound files and convert them to a suitable format then visit audacity.sourceforge.net to download Audacity, a free and full-featured sound editor available for Mac and Windows.)

Testing the PDF

At this point it is time to make a test export of the layout to PDF to see how these multimedia elements actually behave. First check in your document into the Version Cue project to make a new document version. Then choose File > Export and choose where the PDF will be saved.

Next comes the Export Adobe PDF window. Rather than go through and set up all the options by hand, start off by selecting the PDF preset that's the closest to what you'll need so you don't have as many settings to alter. In the Adobe PDF Preset popup menu at the top of the window, Smallest File Size produces PDFs that are optimized for on-screen display – RGB rather than CMYK – and downsample high-resolution image data.

This preset isn't quite perfect, however. When exporting a multimedia-enhanced PDF you'll have to make sure it is set for compatibility with Acrobat 6 and later, nothing earlier. Previous versions of Acrobat couldn't show multimedia content, but those versions are rarely used these days. In the Compatibility menu near the top of this window, make sure the Compatibility checkbox is set to Acrobat 6 (PDF 1.5) or later rather than the preset's Acrobat 5 (PDF 1.4).

In the General section, use the Include checkboxes to build your interactive elements into the PDF. When Interactive Elements is checked, the Multimedia popup menu can be used to embed or link all multimedia content or to leave things up to the individual item's settings. Leave this at Use Object Settings for this project; we've already chosen to embed the movies, making the PDF easily transportable as a single, self-contained item.

Finally, check the View PDF after Exporting option so that the new PDF is opened in Acrobat for you automatically, no need to track it down and double-click the file yourself.

In the Compression section, color and grayscale images are set to be downsampled to 100 pixels per inch if they're over a certain output resolution; 150ppi for color content and 225ppi for grayscale. Monochrome images – 1-bit graphics with no gray tones – are downsampled to 300ppi if they're over 450ppi.

Of course, these settings don't apply to vector EPS graphics; those are stored at resolution-independent vector graphics within the PDF, showing at their best whether on screen or in print – not that print is a big concern for this document. You could drop the output resolution even lower, but as PDFs can scale when shown – and in Acrobat 9 this happens whether you like it or not – you should keep some extra resolution 'in hand' for when your work is shown a little larger than planned. Set the Image Quality options to Medium.

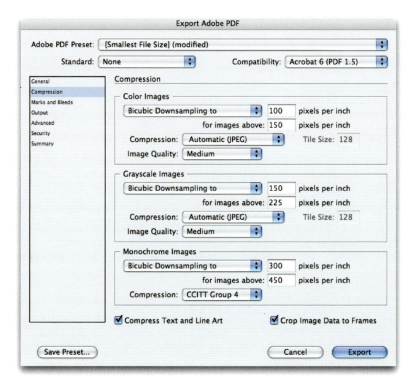

Click Export, and your PDF will be made using these carefully chosen settings and then opened in Acrobat.

At this point you probably expect both the movie and the audio to play automatically. Unfortunately, due to security requirements, Acrobat will not play any multimedia content until the user gives it specific permission. This is something that every Acrobat user will be faced with, so be aware of how this works.

You have two options – or three if you count 'Cancel', but that's not a helpful one. The first option is to play the multimedia content, meaning any and all of the multimedia items you've placed onto any pages in this document, just this one time. The next time you'll be asked again. The alternative is to have this PDF remembered as a 'trusted document', allowing it to play multimedia content in future without this annoying hassle. In general, though, it is a good idea to leave this setting on so that you're reminded of what the end users of this PDF will see when they first open it up.

The movie will have a thin outline, but this disappears when you click the page. If you click the movie it will stop playing. Double-click it to play it again, or go to another page and back again. If things don't look quite as you expected then close the PDF and go back to the InDesign layout.

Making the Index Page

Add the Flood and Flood 2 movies to two different pages in this document, using the steps followed for the first movie. Now you need an index of the different video clips. Each of the movies has a corresponding thumbnail image stored in the 'thumbnails' folder on the media CD, and these will be imported as regular still images. Use Bridge to browse to the images, select them all, and choose *File > Place > In InDesign*. Click once each to place the images in the page.

Resize the frames to fit one grid space each and then use the Selection tool **V** to select each in turn and import the movie thumbnail images. Choose *Object > Fitting > Fill Frame* Proportionately to scale the images so that they fill the frames completely without any gaps. Because the images aren't exactly the same size ratio as the frames there will be a small amount of each image that's cropped off, but in this case it is more important to fill the rectangles completely.

Select all these frames and choose *Object > Effect > Drop Shadow* or type ⌘ ⌥ M ctrl alt M to open the Effects window with the Drop Shadow settings shown. Change the opacity to 50%, the X offset to 0pt and the Y offset to just 2pt, and make the shadow size 2pt as well. Click OK when you're done, and all the frames will have their own small drop shadow setting applied.

Once this is done, switch to the Type tool (T) and draw out a type box fitted into the grid rectangle to the left of one of the image frames. Choose *Object > Text Frame Options* or type ⌘ B ctrl B to show the Text Frame Options window, and set the vertical justification alignment for this frame to Center.

Now click inside and type the name of the movie. Set this in Arial Black at 24pt, and give it the same pale tan color fill as the page. Switch to the Selection tool to have the frame rather than the type selected, then choose *Object > Effects > Inner Shadow* and use the same settings as applied to the graphic frames. The result will look like the type is cut through the image, showing the page beneath.

Button Control

Now we'll make some buttons to allow some simple interactivity in the layout. InDesign has a tool for creating buttons, but in fact any object in an InDesign layout can be converted to a button. For the first button we'll use the standard Polygon tool to create a triangle – a shape not offered as standard for buttons – and convert the custom shape to a button afterward.

Make sure you're working on the page that contains the Curiosity movie. Click and hold on the Rectangle tool in the Tools panel and select Polygon Tool from the three options that are shown. Click on the page to the left of the first movie and the Polygon window opens. Set the width and height to 40pt and the number of sides to 3. Leave the Star Inset at 0%; that's not needed for this

shape. Click OK and a triangle will be made, fitted within a 40 × 40pt area.

Double-click the Rotate tool (don't just select it) and the Rotate window will appear. To turn the triangle so that it points to the right, put 270 into the Angle text field. Click OK, then switch to the Selection tool **V** and drag the triangle so that it sits in the upper-left of the grid rectangle to the left of the movie.

Open the Swatches panel *Window > Swatches* or type **F5** and fill this with the same color as the frame that fills the page. If there's a visible stroke then set its color to None.

At this point the triangle will be virtually invisible; choose *Object > Effects > Drop Shadow* type **⌘ ⌥ M** **ctrl** **alt** **M** to open the Effects window. Set the opacity to 50%, the X Y offsets to 6pt and 2pt, and the size to 5pt. Now the triangle's sides will be defined by a drop shadow that sits slightly to the right.

The triangle still isn't a button, so choose *Object > Interactive > Convert to Button* to make the frame into a button object.

To make the second button, select the Button tool and click on the page. Clicking rather than pressing and dragging lets you set the new object parameters precisely; make this new button 40pt high and wide, and click OK. Drag it into position a little below the triangle and then give it a drop shadow using the same settings.

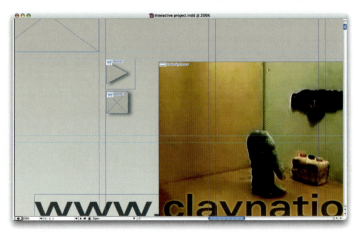

The two buttons have no embedded instructions yet, so double-click the first one (or choose *Object* > *Interactive* > *Button Options*) and click the Behaviors tab in the Button Options window. Choose Mouse Up for the Event and Movie for the Behavior, and in the section below this pick the Curiosity.mov movie and set the Play Options to Play. Click Add to add these to the list on the left. (This 'add' step mustn't be left out or you won't have actually set up a behavior.)

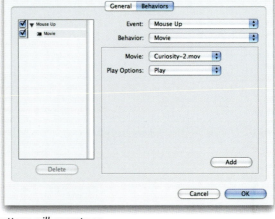

Double-click the second button object and switch to the Behaviors tab. Set this up as a Mouse Up-triggered event with a Movie behavior targeting the same movie, but set Play Options to Stop instead. Click the Add button and click OK. The two buttons will operate as basic play and stop controllers for the Curiosity.mov movie.

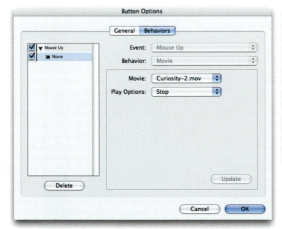

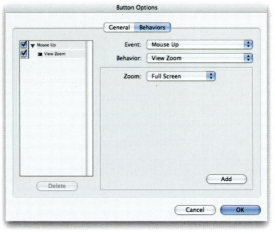

Draw out a new button, fitted to the top-left grid rectangle in the page. Double-click it to open the Button Options window, go to Behaviors, and set Behavior to View Zoom and Zoom to Full Screen. There's no need to set up an alternative one to take the user out of full screen mode because unlike most of these behaviors, the Full Screen zoom acts as a toggle when clicked a second time. Don't forget to click Add or the behavior won't be applied. For the moment, make sure it has no fill or stroke. Later on you could place this over some text that reads 'Toggle full screen view' or something similar.

Generate a PDF from your layout again and try out the movie controls. Once you've allowed the multimedia content to play, the stop and play buttons should control the playback of the movie content very nicely. Click where the full-screen button is to try it out as well.

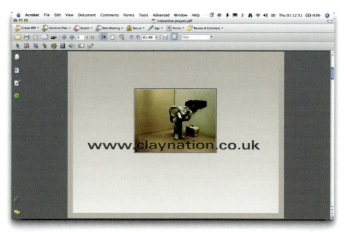

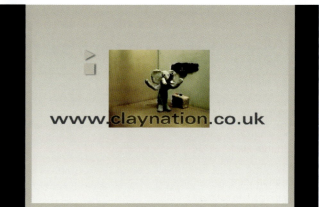

Hyperlinks

Buttons can be very useful for adding extra control and producing rollover-style behaviors, but hyperlinks in PDFs are a simpler way to make PDFs easy to navigate. These are made using the Hyperlinks panel, so select *Window* > *Interactive* > *Hyperlinks* or click the Hyperlinks icon in the panel dock. The most obvious use of hyperlinks is to make a table of contents or index into a clickable navigation interface, but anything that can be selected in an InDesign layout can be made into a link.

Draw out a text frame in the right-hand column, one row down, and type 'Jump to the index', 'Contact details', and 'Back page' in there, with a return between each item. Set it as 18pt Helvetica, colored white.

Select the first line and then, in the Hyperlinks panel's popup menu, choose New Hyperlink. In the window that opens up, you can name the hyperlink – InDesign will name text hyperlinks using the selected text, but remember to give object links meaningful names – and choose its destination. In this case, make sure page 2 is selected. In the Appearance section set Type to Invisible Rectangle and Highlight to Invert, and click OK.

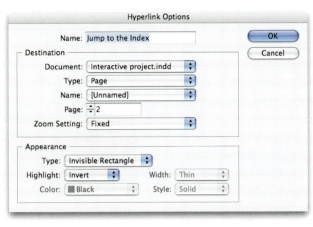

Basic page links can be set up with no prior preparation; just pick the page number and go. But it is good practice to set up named destinations rather than relying on simple page numbers, especially with longer documents and multiple documents.

To set up a hyperlink destination, first go to the destination page. You can have the link anchored to a portion of text rather than a page itself, allowing the target to be moved to another page if necessary. Go to the page with the thumbnail images, draw out a text frame in the top-right grid rectangle, and type 'Index', styled in Arial Black 24pt text, colored white. Select the text and choose New Hyperlink Destination from the Hyperlink panel's popup menu. Set the type to Page, name it 'Index page' and click OK.

Now go back to the first page, select the first line again, and double-click the 'Jump to the index' hyperlink that's now selected. In the Name option in the Destination section, choose Index page. You should also pick Inherit Zoom from the Zoom Setting options so that the destination page will always appear at the same zoom scale as the previous page. While you're here, go to the Index page and set each picture to link to the page with the corresponding movie.

External Hyperlinks

Hyperlinks to external destinations are simple to create, and they let users jump to locations and even files stored online. These will normally be web-sites, but they can also be different PDFs, images, or any other kind of file. Make sure you use absolute URLs including the http:// protocol so that the link will work correctly. (You can use ftp:// (with or without embedded name and password data) and all other URL protocols too. The end user's operating system will decide how to handle them, whether this is Windows Explorer or the Macintosh Finder, or some third-party program. You can even

use file:/// and file:// URLs to point to local content rather than online destinations, but the availability of these on uncontrolled systems are rather less easy to guarantee.

Select the word 'www.' in the first movie page, then open the Hyperlink panel (choose *Window > Interactive > Hyperlinks* or click its icon in the panel dock) and choose New Hyperlink from the panel's popup menu.

In the New Hyperlink window, set the Type to URL and enter 'http://www.claynation.co.uk' into the URL field. Set the appearance type to Invisible Rectangle and pick Invert from the Highlight menu. The selected word will be made into a link in the PDF, but it won't be obvious; the only clue will be the cursor changing to a hand when it passes over this word. (If you prefer a more visible indication consider giving the word a simple underline style. This is less esthetically clumsy than the visible rectangle option offered here and has the added advantage of looking like a web page link, something everyone recognizes.) Repeat this for the '.co.uk' text, but use a different link name.

Bookmarks

Bookmarks are rather simpler things to implement than hyperlinks. The main reason for this is because they are in fact simpler things altogether. But they're not really the poor cousin, they have their own distinct and important role in PDF navigation. PDF bookmarks can be shown as a text list in a panel to one side of the PDF page display itself, and clicking a bookmark item takes the reader to that location in the document. They aren't as visually integrated into the layout as hyperlinks; they don't provide true in-page interaction. But this also means that they won't be lost in a visually complex layout as they're always held in a separate panel.

Making a bookmark is child's play. Open the Bookmarks panel (choose *Window > Interactive > Bookmarks* or click the Bookmarks icon in the panel dock), go to the page you want to bookmark – in this case, go to the first page – then choose New Bookmark from the panel's popup menu.

A new entry will appear in the Bookmarks panel's list. Rename the item to something a little more informative than just 'Bookmark 1'; call it 'Claynation front page'. Click the item's name once or choose Rename Bookmark from the panel's popup menu if necessary. Now go to page 2 and make a new bookmark. Call this one 'Index'. Go to each page in the document and add a bookmark using the appropriate name. 'Movie 1', 'Movie 2', and so on is fine for the individual movie pages.

Try out the bookmarks by double-clicking them in the panel's list. You can use these bookmarks to jump around the document as you work in InDesign as well as later on in the PDF, so as you build up the document remember to add new bookmarks. Make sure they're in a logical order, as whatever order they're in here will be how they're shown in the PDF.

If you make a bookmark while an existing one is selected, the new one will be made as a 'child' of the selected one, shown using a disclosure triangle. For documents with numerous pages in distinct sections this can be very handy, as it lets sets of bookmarks be shown or hidden at once. But for this project this isn't necessary – so if you did this accidentally, just grab and drag it out to the left to un-nest it.

Fine-Turning the PDF

Once you've made all the movie pages, set the buttons and made the links you're now ready to produce the final PDF, so go to *File > Export* and choose where the PDF will be saved. The Export Adobe PDF window should retain the settings you created earlier; Smallest File Size [modified] should appear in the Adobe PDF Preset menu. Down in the Include box in the General section, click the Bookmarks and Hyperlinks checkboxes so these parts of the production will be included in the PDF. Click Export to generate the PDF. When it opens in Acrobat you'll be able to test the behavior and also fine-tune how it first appears when someone opens it.

Start off by going to *File > Properties* ⌘ D ctrl D to open the Document Properties window. Click the Initial View tab to see the section that governs the way the PDF behaves when it first opens up.

In the Layout and Magnification section, select Bookmarks Panel and Page from the Navigation Tab popup menu so that your bookmarks are shown next to the page. Choose Single Page for Page Layout, and Fit Page for the Magnification setting. Fit Page simply scales the PDF to the display, whatever resolution it is, although we can override this. Click OK, then save, close and reopen the PDF to see the new behavior.

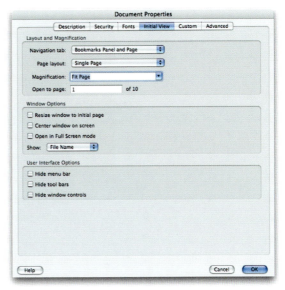

Do be aware that magnification settings in Acrobat 9 can be difficult to control. Although you can set the magnification scale, even require that it opens at 100%, it will interpret the scale according to its own pixel per inch settings – and these both don't follow standard publishing rules and can vary as well. The best solution is to learn to design with this scaling in mind, however difficult it may be.

Fortunately, this kind of work is meant to fit to the screen rather than use a specific pixel dimension.

The initial view for this PDF is to open as a regular PDF document, but be switched – using the rollover button we made earlier, into full-screen mode for use as a presentation-oriented document. When it is in full screen mode the Bookmarks panel won't be visible, but it is when the PDF first opens up. More importantly, the user is given the choice of how to view the document rather than being forced into full-screen mode from the start.

Information Express

Trees in London's Richmond Park, Photographed as part of an immersive panorama

Finding your way through all the features that are in Creative Suite 3 can sometimes feel like a mammoth task. How do automatic page numbers work in InDesign? What does 'variable data' do in Photoshop? How do Fireworks pages work?

Fortunately, the answers to these questions are already on your computer as part of the Adobe Help database. Choosing the Help item from any Creative Suite 3 program's Help menu opens the Adobe Help Viewer utility, primed for providing assistance with the program that you were just in, but equally able to offer assistance with all the other CS3 programs as well. Browse the contents or index in the left-hand column or use the Search box at the top to track down all the stored information on a particular keyword or phrase. Search results are grouped by program, so you can see instantly which programs contain details on a particular phrase. Clicking one of those results groups shows the titles of the sections that contain the searched-for term, so drilling down to precisely the right information is a quick and easy task.

As well as access to the Adobe Help Viewer, the Help menu provides access to a wealth of other material, from information on extending the application to links to online help resources, support and development centers, 'getting started' information, forums, and more. Combine all this with the real-world practical information and advice contained in this book, and your Creative Suite 3 experience should be a good and productive one.

Sometimes the information in Adobe's Help Viewer collection of articles just isn't enough or doesn't provide the full picture. If you want to gather a full spectrum of opinions so that you can make your own fully informed decisions, use Google or any other major search engine and try out a few relevant phrases. It is best to include "Creative Suite" or "Creative Suite 3" in the search phrase you use to help make sure that results are going to have some relevance to the Adobe Creative Suite.

Most search engines let you tailor your search query to get better results. Put quotes around words that should be considered as a phrase in the search, and put a plus (+) in front of words or quoted phrases to indicate that they absolutely must be in the search results. Similarly, use a minus (−) instead to indicate that results must not contain a certain word or phrase. For example, searching for 'Creative Suite 3' variable text −Dreamweaver +print in Google will generally return just a few hundred results, but those results will all contain information about variable text use in a 'Creative Suite 3' context, but only for print use and never with reference to Dreamweaver. With just a few moments spent tailoring your online searches you can cut out almost all of the irrelevant pages from the results and get on with finding the right information.

Finally, don't forget the virtual companion to this book. The Creative Suite Integration website is at www.creativesuiteintegration.com, and it contains further details about Creative Suite 3, downloadable resources to supplement the disc that comes with the book, and a user forum for discussions and questions regarding Creative Suite 3 itself and the Creative Suite Integration book. Here, you'll be able to contact the author directly as well as join in peer-group discussions, take part in regular creative and production challenges, read user tips and offer some of your own, and find details of updates to Creative Suite 3.

GLOSSARY

1-bit A bitmap that uses just one bit of information for each pixel, producing either black or white with no intermediate shades.

8-bit Color produced using 256 different tones or hues. This can refer to limited, palette-based color such as that required by the GIF image format or the brightness levels of each color channel in an RGB image (where red, green, and blue each have 256 different strength levels).

16-bit Color produced using 16 384 different tones or hues. In RGB terms, this normally describes color images that have 16-bit tones for each of the RGB color channels, storing far more tonal detail than standard '8-bit per channel' color. Not all image file formats support this color depth.

24-bit Common term for standard '8-bit per channel' RGB color. With 8 bits used for each of the three colors in RGB, the total is 24 bits.

32-bit Traditionally, this is 24-bit RGB color with the addition of an extra 8-bit channel for transparency information, although it is often used as another term for 24-bit color. Photoshop CS3 now supports 32-bit per channel RGB color, useful for handling HDR (High Dynamic Range) images.

48-bit RGB color where 16 bits are used for each RGB color channel.

A

AAC Advanced Audio Encoder, the audio-encoding technology from the MPEG-2 standard, and the format used by Apple's online music store. AAC audio can be read by iPods and iTunes and some other devices and software, but support for this newer format isn't as wide as support for MP3.

ActionScript The scripting language in Adobe Flash, used to create dynamic, interactive Flash media.

Adobe RGB (1998) An RGB color space developed by Adobe in 1998, designed to produce most of the colors achievable with CMYK printing using RGB displays. This is generally the best RGB color space to use for print and general image manipulation work.

AIFF Audio Interchange File Format, a flexible audio file format widely used in the professional music industry.

AJAX Asynchronous JavaScript and XML, a scripting technique that includes features for loading data 'silently' from a web server without direct user requests.

AppleScript A powerful software control and automation language that operates on Macintosh computers.

B

Baseline Grid An invisible grid that can be used to control the placement of lines of text in a page layout.

Beziér A method of defining curves using adjustable control points, an important part of the PostScript page description language.

Bitmap A graphic made of a grid of pixels. Scanned images and digital photos are bitmap images.

Black Point Compensation A color management setting that adjusts for differences in black points when the image color is converted. This is done to ensure that the full range of the original color space is mapped to the destination's color space.

Bleed A part of a layout that extends past the border of the page. Including bleed when preparing layouts and artwork ensures that slight misregistrations when trimming the final print won't lead to white borders appearing.

C

Calibration The process of adjusting how a device such as a monitor behaves in order to produce a more accurate result.

Camera RAW See RAW

CMYK Cyan, yellow, magenta, black (black is referred to as 'key'), the standard colors used in four-color, or process, printing. Using techniques to convert tones into dots, CMYK printing can reproduce colors fairly well, although not with the same saturation levels of RGB color.

ColorSync Developed by Apple, ColorSync was the first color management system that was produced as an open standard. It is integrated into the Macintosh operating system and is available to all Macintosh software, and works directly with ICC cross-platform standards.

Compositing The process of layering different elements together to create a composite end result.

D

Deprecated A term often used in the web production world, describing something, usually a method of coding, that is still supported but has been declared out-dated and is being phased out.

div In HTML, a page 'division' than allows content to be handled entirely separately from other content in the page.

Dot Gain The effect of halftone dots enlarging during the printing process due to paper absorbency or even dust on the press, causing an effective darkening of halftone tints. Specifying correct dot gain amounts will cause the final halftone output to be lightened just enough to counter this effect.

dpi Dots per inch, used when referring to the output resolution of a printer.

Duotone A monochrome image that is printed using two different inks, usually with different tonal adjustments made for each of the inks. Tritone refers to this process with three inks, and quadtone refers to using four inks.

E

Euroscale An older European standard for prepress production using CMYK, no longer used.

Every-Line Composer Photoshop's equivalent of the Paragraph Composer.

EXIF Exchangeable Image File, the format used by digital cameras when generating JPEG or TIFF files, and also the information that is embedded in the file along with the image data.

F

FOGRA Fogra Graphic Technology Research Association, a member organization that researches and promotes print engineering and technologies, and helps establish standards in the printing and prepress industries. See www.fogra.org.

fps Frames per second, the speed that an animation or video runs.

G

Gamma A measurement of relative contrast, determining the way the middle tones are rendered on displays. Not the same thing as brightness or contrast. Gamma is described numerically, with a gamma of 1.8 (the Macintosh norm) being the closest to the way print appears, and gamma 2.2 (the Windows norm) being closer to the way television behaves.

Gatefold Spreads that use one or more extra pages. These are folded into the main spread in the final product.

Glyph The elements that represent the different characters in a typeface. A typeface may contain multiple glyphs for different shapes of a single letter, to be used in different typesetting conditions.

GREP General Regular Expression Parser, a method of performing highly complex search and replace operations in text. GREP is extremely powerful, but learning to write GREP commands can be daunting.

Gutter The gap between the inner margins of any two facing pages.

H

HDR High-dynamic range, a method of storing a greater range of detail across the brightness range than can be captured in normal images. HDR photographic images are often created by merging multiple exposures into a high-bit-depth composite image.

Hexadecimal A base-16 numbering system that is commonly used in computer programming and is used to specify colors in HTML and CSS code. The first two characters in hexadecimal color codes define the value for red, the second green, and the third blue. In hexadecimal, just two characters (0–9 and then A–F) are needed to count up to 256.

I

ICC The International Color Consortium, established to define industry-wide standards for color management.

Imposition The process of arranging multiple pages to be printed onto large sheets of paper, commonly on both sides, so that they sit and fold in the correct order once trimmed and bound.

J

JavaScript A scripting language that can be embedded in HTML pages or referred to from external files. JavaScript should not be confused with Java, which is an entirely different and more complex programming language.

K

Kerning The spacing between individual character pairs. Automatic kerning tables are built into most fonts, and ensure that particular letter combinations are spaced slightly differently to avoid unsightly space appearing. Manual kerning is done to change the spacing of a specific pair of letters on the page.

L

Letter spacing Letter spacing is a general term sometimes used to refer to tracking and kerning. Flash refers to kerning and tracking as letter spacing.

Ligature A special combination of two or more characters, customized to produce a more pleasing shape. Common ligatures include fi and fl.

Loupe A small magnifying glass used to examine small details in an image.

lpi Lines per inch, a term used for discussing halftone screen frequency. Halftones used to be made photo-mechanically, using screens etched with parallel lines.

M

Metadata Data that describes other data, for example information on the location, exposure, and lens used for a particular photograph.

MP3 MPEG-1 Audio Layer 3, a lossy audio compression format widely used for storing music. MP3 compression can be set at high levels, producing lower-quality audio at small sizes, or low levels, reducing higher-quality music at correspondingly larger file sizes. MP3 files are never exactly the same as the original sounds, but at the best quality levels it can be effectively impossible to tell.

Multiline Composer Alternative term for Paragraph Composer.

N

NTSC National Television Standards Committee, a video standard used in the US and some other countries.

O

OpenType Modern type format that can contain many thousand 'character alternates', or glyphs, within a single typeface, helping to produce high-quality typesetting with little or no manual interference.

OPI Open Prepress Interface, a form of image-swapping technology that allows low-resolution images to be used in layouts during the design process and then be swapped for the high-resolution equivalents during the final artwork generation process.

P

PAL Phase-Alternating Line, a television and video color encoding standard used by a large part of the world.

Paragraph Composer Type setting feature that takes into account all of the words and lines in a paragraph when determining the overall word and letter spacing and line breaks in order to produce text that appears well balanced throughout all of the lines.

PDF Portable Document Format, the dominant cross-platform format for exchanging documents and producing high-quality artwork.

PDF/X A specific range of PDF production settings that produces PDF output to certain industry-wide standards for prepress and print production.

Perfect Bound The binding process that glues cut paper edges together to create a bound magazine or book, commonly used for paperback books or larger magazines.

Pixel The common term for the 'picture elements' in a raster image, the individual squares in a bitmap graphic.

PostScript The page description language that is used by almost all high-end image setters. PDF is a development of the PostScript language.

ppi Pixels per inch, the correct term to use when referring to the resolution of a bitmap image.

Profiling The process of recording any particular weaknesses of an input device (camera or scanner), display or printer so that color handling is compensated accordingly by the color management system. Device profiling is a requirement for any serious color management scheme.

Q

QuickTime Apple's rich media compression and decompression standard is used for high-quality video and audio production and playback. QuickTime forms the underlying format for the MPEG 4 video standard. It is built into the Macintosh and is free to install in Windows.

R

Range Kerning This is a term used in Fireworks to refer to tracking.

Raster The two-dimensional array, or grid, of pixels that makes up a bitmap image such as a digital photograph or a scan.

RAW High-quality digital camera image format, taken directly from the data captured by the camera's sensors with no post-processing or compression applied. RAW images must be converted to other more standard image formats before being used in layouts. Different camera manufacturers use slightly different RAW formats, but Bridge CS3 and Photoshop CS3 can read the vast majority of these.

Rendering Intent Determines how color will be handled when moving images from one color space to another, particularly with regard to colors that lie outside the gamut of the destination color space. Rendering intent options are Perceptual, Saturation, Relative Colormetric, and Absolute Colormetric. See page 158 for details.

Resolution The number of pixels that will be produced in a linear inch when it is printed. The higher the resolution, the more detail can be resolved in an image. Scaling an image to a larger size in a page layout will produce a corresponding drop in the output resolution. This is referred to as 'effective resolution' in InDesign.

RGB The additive form of color produced by adding red, green, and blue light, used for all computer displays.

Rich Black A printed black that is made of standard black plus one or more other colors in the CMYK set. Rich blacks produce darker, deeper blacks than can be achieved by just the single black ink.

S

Saddle Stitched The correct industry term for binding pages together using wire staples.

Single-Line Composer Type setting feature that works out the word and letter spacing and line breaks on a line-by-line basis rather than looking at the whole paragraph. See Paragraph Composer for Adobe's more sophisticated alternative.

Slice The process of slicing a web graphic into multiple parts, often done in order to use different compression methods on different parts of an image or to use part of the image as a rollover.

Smart Filters A process of applying filters to Smart Object layers in Photoshop, producing effects without permanently altering any image data.

Smart Objects Self-contained graphics that live within a Photoshop document as individual layers. These can be made from native Photoshop layers that have been converted to Smart Objects or they can be items pasted in from Illustrator or InDesign.

Spot Color A color printed using a custom ink rather than some halftone mix of CMYK inks.

Spread Facing pages in a layout.

Spry A JavaScript library framework that helps web designers create rich, AJAX-enhanced web pages.

sRGB An RGB color space developed by HP and Microsoft for use as a base-level color standard. This is best used when producing and using content for web use, but it is more limited than the Adobe RGB (1998) color space and shouldn't normally be used for print.

SWOP Specifications for Web Offset Publications, a color proofing system and production standard that describes the normal characteristics of printing using web offset printers.

T

Tracking The spacing of a run of text. Zero tracking means no space added or removed from the original typeface settings. Tracking is applied to selections of text, and is independent of kerning.

V

Variable Data A feature that allows contents within a layout or document to be replaced by data taken from a database or other content source in order to create multiple customized prints or PDF output.

VBScript A subset of Microsoft's Visual Basic, a scripting language designed to simplify software control and automation, operates on Windows-based computers.

Vector Shapes that are defined mathematically and are resolution independent, so that they print to the maximum resolution of any output device.

W

WAV Waveform Audio, an audio file format common on Windows computers.

WebDAV Web-based Distributed Authoring and Versioning, a web server extension that allows users to work on files collaboratively.

Web-Safe Color Common term for the 216 colors that can be displayed cleanly on both Windows and Macintosh computers running in 8-bit color. No longer considered a requirement for web design, but still considered a useful definition of colors.

Web-Safe Fonts Typefaces that are generally found on Macintosh and Windows computers and therefore can be specified in HTML and CSS styles. Web-safe fonts include those installed with operating systems and with very common software such as Microsoft Office.

X

XMP Extensible Metadata Platform, a technology that embeds metadata into documents, helping to organize and manage files.

INDEX